London's Arts Labs and the
60s Avant-Garde

London's Arts Labs and the 60s Avant-Garde

David Curtis

British Library Cataloguing in Publication Data

London's Arts Labs and the 60s Avant-Garde
CURTIS, David
A catalogue entry for this book is available from the British Library

ISBN: 0 86196 748 3 (paperback)
ISBN: 0 86196 979 1 (ebook-EPUB)
ISBN: 0 86196 980 7 (ebook-EPDF)

Published by
John Libbey Publishing Ltd, 205 Crescent Road, New Barnet, Herts EN4 8SB,
United Kingdom e-mail: john.libbey@orange.fr; web site: www.johnlibbey.com

Distributed Worldwide by
Indiana University Press, Herman B Wells Library—350, 1320 E. 10th St.,
Bloomington, IN 47405, USA. www.iupress.indiana.edu

Printed and bound in Great Britain by Short Run Press Ltd, Exeter

Contents

Acknowledgements

The Arts Labs were an experiment in collaboration, and this book – while in part 'a personal memoir' as Andrew Wilson notes – is the product of many minds, so remains true to that spirit. Researching the subject has happily put me in touch again with dozens of people who were involved, too many to list here; their contributions make the book, and they have my profound thanks. My unsorted collection of Arts Lab and London Film Co-op ephemera was first given some order by the Canadian/ Australian scholar Peter Mudie, followed later by musician/scholar Mark Webber, and it is probably due to their interest that it has survived. That material can now be found at the British Artists Film & Video Study Collection at Central Saint Martins (Film Co-op) and the Tate Archive (Arts Labs). Jim Haynes has written his own memoirs and his papers are now held at Napier University Edinburgh thanks to the dedication of theatre-scholar Martin Belk. Biddy Peppin, my co-conspirator then and now, has extensively helped shape this narrative (and has also shortened my sentences). Andrew Wilson's encouragement and John Libbey's enthusiasm for this project have been an invaluable spur. John and I are indebted to The Paul Mellon Centre for Studies in British Art for its generous support for this publication, which has allowed us to illustrate it in colour throughout, enormously helping to evoke the period.

DC July 2020

Foreword

'IT'S NOT EASY':
'the best Arts Laboratories are play pens'[1]

For many, the idealism and dreams of the 1960s – of both counter- and broadly popular/mainstream culture – can be identified as a 'coming together'; a coming together of people, of ideas, a breaking-down of boundaries, a questioning of identities. Within communities often driven by single-issue politics, a degree of coexistence was needed in the face of wider socio-political differences; disciplines within the arts dissolved; market economies were questioned and reshaped. Yet a place, a space, a crucible that might help catalyse and allow change to take root was always a goal.

One early example of this was the Institute of Contemporary Art founded in 1947 which continues to provide a shifting model of the interdisciplinary arts space as meeting place; another was Centre 42 – 'a cultural hub' according to its launch brochure – that drew its name from Resolution 42 of the 1960 Trades Union Congress that acknowledged the importance of the arts in the community and urged unions to participate in and support cultural activities in an age of increased leisure. For the playwright Arnold Wesker, the architect of Centre 42, this should be 'a place where artists are in control of their own means of expression and their own channels of distribution; where the highest standards of professional work will be maintained in an atmosphere of informality; where the artist is brought into closer contact with his audience enabling the public to see that artistic activity is a natural part of their daily lives'.[2] In 1962, before this 'hub' could be created, Wesker organised a country-wide roving art festival. Soon after, he identified the Roundhouse in London's Chalk Farm as having the potential to be Centre 42's multi-purposed arts venue and acquired the building's lease in 1964. Two years later and still empty the building bore a sign 'Centre 42 needs £250,000 to be launched'.[3]

At about the time of Centre 42's initiation, the theatre director Joan Littlewood conceived of the notion of the Fun Palace as a laboratory of fun. In 1964 this was visualised (though never actually built) by the architect Cedric Price as a dynamic architecture of linkages – of people, spaces and ideas. Other initiatives, at different scales, give context to

Littlewood and Price's vision, as well as Wesker's: the poet Michael Horovitz's *Live New Departures* since 1962, again a roving festival of music, poetry, light shows and art; Bob Cobbing's 'Arts Together' Hendon Arts Club that found a place for a wide range of activities at Better Books in the mid 1960s; in 1964 Alexander Trocchi called for the creation of a Spontaneous University as part of his Invisible Insurrection of a Million Minds realised through Project Sigma – not so much a place but a critical state of mind albeit modelled in part by Black Mountain College, it did however lead to the creation of a Sigma Centrum in Amsterdam in 1966; the London Free School announced its formation in 1966 as 'essential to our daily life and work' as an information centre for the local community in Notting Hill that was 'not political, not racial, not intellectual, not religion, not a club. It is open to all'.[4] Providing a wide range of courses, the LFS was essentially a community resource, as the activist and co-founder of the LFS Courtney Tulloch recollected: 'the community comes together, defines its needs and begins to work to establish something'.[5]

The foundation of the Drury Lane Arts Lab by Jim Haynes in the autumn of 1967 is at the heart of this cartography, alongside the creation the following year of the short-lived Anti-University; the move made by the ICA from Dover Street to The Mall; the creation of Space Studios initially in Saint Katharine's Dock by artists Peter Sedgley and Bridget Riley that configured the framework for an interdisciplinary arts space as work place; and the foundation by John 'Hoppy' Hopkins (another co-founder of LFS) of the BIT information service. At last with David Curtis's book on the history of the Arts Labs, which is as much a focused personal memoir as it is also a deeply researched account, its significance can be more fully grasped. This significance cuts two ways, in terms of historical record[6] but also for the ways in which this connects with more contemporary preoccupations. The ultimate failure of the Arts Labs after three years of activity can be revealingly contrasted with the inability of Wesker to realise his vision of Centre 42 as a viably resourced arts centre at the Roundhouse.

The history of Centre 42 traces, by circumstance, a shift from the provision of a wide range of cultural activity throughout different communities in Britain – a network of festivals – to delivery of a range of activity within one large building in London. Given the demands for renovation and conversion of the Roundhouse, its history is one of failed fundraising between 1964 and 1970 as funding targets consistently shifted upwards. The continuing hiatus caused by this establishment-focused fundraising effort contrasts with a counterculture that enterprisingly found its way into the building to make things happen. In October 1966 the *International Times* held its launch party there with both Soft Machine and Pink Floyd

Drury Lane's first logo, designer unrecorded.

The Arts Laboratory 182 Drury Lane London WC2

playing, initiating the building as a band venue (after which the GLC granted a licence for this purpose); the following year the UFO Club moved there briefly from the Blarney Club in Tottenham Court Road and it also housed the Dialectics of Liberation conference 'Towards a Demystification of Violence'. This latter led one writer in *Freedom* magazine to characterise the plan to fundraise for a two-year renovation of the building as a 'grim and sad contrast to the use the Roundhouse was put to' for the Dialectics of Liberation conference; 'the openness and freedom to all – whether local kids or Herbert Marcuse – the sense of play and the impromptu pursuit of creativity were alien to what the Roundhouse might become as Centre 42'.[7]

The demands of the building – coupled with the demands that fundraising makes for compromise and stability – killed Centre 42's viability even before it had started; an arrested birth that lasted virtually the decade. David Curtis's account makes clear the comparable difficulties and compromises that both the Drury Lane and Robert Street buildings created for all those that worked there as they created and delivered the programme of activities.

Both Arts Labs were a part of the counterculture that held to an ethos of immediacy of decision-making and an urgency of action, and they perhaps had their greatest effect in being the model for other Labs springing up across Britain and Europe. That catalytic effect was first identified through the National Arts Lab Conference in January 1969 – a gathering of about 150 Arts Lab groups that reflected the shift that 'art and social living should be more closely linked'.[8] As Richard Neville suggested 'It is by interlacing the country with such outposts of cultural revolution that the Underground has consolidated itself in the past two years'.[9]

David Curtis gives a clear indication of the Arts Lab's breadth and range of programme – largely a liquid merging of the categories of film, art, music, theatre, performance, and literature. His account challenges the myth that Jim Haynes as director followed the straightforward approach encapsulated in his later claim: 'my artistic policy was to try never to say

Robert Street letterhead, designer unrecorded.

3

no'.[10] This attractive idea chimes with an avant-garde belief in prioritising content and communication over questions of aesthetic (or market) judgement. Such a view was at the heart of the Independent Group's tension within the ICA in the early 1950s and has driven most worthwhile avant-garde or experimental art both before and since.

In a similar sense, Haynes' activities in Edinburgh with the Paperback Bookshop and the Traverse Theatre, taken together with his participation in the group in London that founded *International Times* and the UFO Club, provides a frame for understanding the ambition he had for the Arts Lab. For him, the Arts Lab was 'a non-institution … a Lab's boundaries should be limitless',[11] and Drury Lane's activities between gallery, performance space, film space, café space and living space proved this. The breakaway Robert Street Arts Lab continued this vision (and arguably was more successful in delivering it) in a building that mixed spaces of production with exhibition, screening and performance.

Being without boundaries entails being open to a full diversity of art and culture reflecting different identities in turn. The Drury Lane Arts Lab opened with performances by the People Show while in the gallery the Exploding Galaxy staged a fusion of poetry and dance led by David Medalla. Not long after, a week was designated Black Power Week and included contributions by Ted Joans, Michael X and in the gallery the first solo show of Winston Branch. This pattern continued as the Arts Lab later became a place of refuge for Latin American exiles and played host to Helio Oiticica, Caetano Veloso, Gilberto Gil and Leopoldo Mahler. Like a number of avant-garde art spaces of the time (Signals gallery 1964–1966 being one such example), the Arts Labs were avowedly international in their outlook and through the networks they forged; they were also supportive of sexual and ethnic diversity and liberation. In 1969 the first play to come out of the women's liberation movement, Jane Arden's *Vagina Rex and the Gas Oven* had its first performances at the Drury Lane. Yet although it was one of the Arts Lab's most notable theatrical successes, support for the feminist cause was in many ways predictably underscored by a male perspective on sexual liberation. David Curtis is honest in this book about the gender inequalities within the emerging avant-garde film-making community, and yet his support for women filmmakers such as Sandy Daley, Annabel Nicolson and Sally Potter is clear.

Within the first year of the Drury Lane Lab's existence, the prevailing character of the scene had markedly shifted from the pursuit of ideals of personal liberation to organised political activism. If the counter-culture of 1967 – the year of the so-called Summer of Love – can be characterised through an idea of inner searching, then 1968 marked the moment in

which a belief that social, political and artistic change might happen naturally was exchanged for an understanding that such change had to be organised for, willed and made to happen, and that the achievement of 'power to the imagination' was indeed possible. If the Drury Lane Arts Lab was very much a reflection of the idealisms of the time, IRAT embodied a new post-1968 social consciousness. Its concentration on 'research' within 'technology' and 'art' was stimulated by a sense of purpose and results – looking out rather than in. For instance, the presence of the London Filmmakers Co-op and especially its creation of a space that could provide a tangible framework for artists to make, share, show, discuss and develop their use of film within a broader context of cultural activity, was essential to the growth of artists' film into the 1970s and beyond. Alongside this TVX was searching for a way to make video a community tool as a way of circumventing and supplanting the need for reliance on mainstream media that otherwise left a large proportion of the population both manipulated and with no voice.

Whether or not Haynes' policy of never saying no was ever properly followed at Drury Lane, the mix of programme was in reality a product of the group of people that Haynes had gathered around him. For art this was down to Pam Zoline and Biddy Peppin, for film to David Curtis himself, for music Hugh Davies and for theatre initially Jim Haynes, Jack Henry Moore and later Will Spoor, with a privileged position given to the People Show. Ultimately, the programme was being formed by or among practitioners – it wasn't a reflection of an activity being carried out elsewhere, it was the activity it was generating itself. As a 'Lab' this was an essential distinction and became even more inscribed into the Arts Lab concept once it became IRAT. For Hoppy, the activities of TVX and the belief in community video also entailed the merging of viewing and making – the conflation of the two marking both a critical activity on which a 'TV for the people' might be founded and so create actual social change. This was also the case with theatre. At both Labs the People Show consistently broke down the barriers between audience and actors; at IRAT this was expanded by the way in which new tech-nologies were brought into a theatrical experience of performance in events such as *Sensepak!*

This sense of proximity – of artworks being formulated, presented and received within an interdisciplinary arena – gives scope to Richard Neville's notion of the Arts Lab as 'play pen', where an unwritten licence to do what you will leads to a site where anything goes. Fun may have been had, though this was not always the audience's experience as David Curtis's account admits.

David Curtis is clear that much of the immediacy and meaningfulness

of the Labs miraculously emerged and continued despite a lack of funding or adequate income.[12] This was very different to the failure of Centre 42 which perhaps could never have been funded enough – given Wesker's vision, the demands of the building and the particular pressures that being in receipt of mainstream backing exerts. In one sense the Arts Council in the 1960s still saw support and provision for the arts as a top-down exercise that couldn't easily accommodate support for the critical experimentation that the Arts Lab and IRAT embodied; Lord Goodman's antipathy for the avant-garde reflects this. However, the example of the Arts Labs did feed into later support for experimental practices and the small-scale gallery sector. From this and other viewpoints, to describe the Arts Lab as play pen is really little more than shallow – if understandable – journalism. At the time of IRAT Sue Miles (who managed the café at Drury Lane) was compiling and editing an anthology of texts (never published) that brought together a range of writers to consider the 1960s which was already being historicised before the decade was out. She revealingly chose as her title 'It's Not Easy' reflecting on her own experience and that of others that that the fight for effective social and artistic change was both long and hard.

The most detailed aspect of David Curtis's account reflects his own activities with running the film programme. This involved embedding the London Filmmakers Co-op within the Arts Lab and so also ensuring a framework for the practice of film by making available production facilities with viewing and distribution, and again (as with much of the Arts Lab) not just breaking down boundaries between disciplines but also between artist and audience as participants in a broader process. For film this was far-reaching and depended much on David Curtis's commitment in creating a platform for and making visible (both to itself and others) British experimental filmmaking as art. When he was screening films at the UFO Club in 1966 there was little sense of film as an identifiable art practice despite a history going back to the Film Society of the 1920s. The subsequent screenings at the Arts Labs created a history for British experimental filmmaking within broader international narratives, but also created an environment in which filmmaking could flourish. He outlines the beginnings of this in his book while also making it clear that there is still inevitably unfinished business in terms of institutional recognition of this history.

David Curtis's account of the Arts Labs at Drury Lane and Robert Street provides much needed texture to existing histories of the art and culture of the late 1960s and early 1970s. Although priority is inevitably given to film and video and their relationship to experimental art practice of the time – notably his accounts of the early developments of Malcolm

Le Grice's work or the *Unsculpt* project of Ian Breakwell, John Hilliard and Mike Leggett – this is not without reason. The dominant presence that film and video has exerted over artistic practice since the 90s owes much to the nurturing platform it received at the Arts Labs. However, perhaps more important are the many shifts in art practice since the 1990s that can be recognised in part within the activities that took place at the Arts Labs fifty years ago: the realisation of a post media condition within art; the degree to which performance has increasingly taken on a determining role in destabilising and extending any accepted condition for art as object-dominated; how a new understanding for an art of participation, an art practice focused on the archival as much as research, on community rather than the individual, has emerged. In no way is David Curtis's book a primer for today, that would be ridiculous, but it does enable recognition of where the seeds for much current practice can be found.

Andrew Wilson,
Curator Modern & Contemporary British Art and Archives, Tate.

Endnotes

1. Richard Neville, *Playpower*, London 1970, p.225

2. Cited in Robert Hewison, *Too Much, Art and Society in the Sixties, 1960–75*, London 1986, p.19.

3. Jim Haynes, *Thanks for Coming!, an autobiography with …*, London 1984, p.141.

4. Flyer announcing the formation of the London Free School, 8 March 1966.

5. Courtney Tulloch, cited in Jonathan Green, *Days in the Life, voices from the English underground 1961–71*, Heinemann, London, 1988, p.103.

6. Despite their undoubted influential position defining artistic practices of the late 1960s, the Arts Labs have been woefully served by historical research. Although, namechecked in all the accounts of 60s counterculture and avant-garde art, the surface is barely scratched so that the expansive range of activity undertaken at Drury Lane and Robert Street is never outlined. For instance, Jim Haynes' 1984 memoir *Thanks for Coming!* skirts over the detail in favour of a name-dropping, entertaining scrapbook of newspaper cuttings and letters.

7. Anne Marie Fearon, 'Adventure Playground for Grown-Ups', *Freedom*, vol.28, no.24, 12 August 1967, p.4. https://freedomnews.org.uk/wp-content/uploads/2018/02/Freedom-1967-08-12.pdf (accessed 8 December 2019).

8. *Report on National Arts Lab Conference, Cambridge 25 – 26 January 1969* (organised by Pamela Clark, Philippa Jeffrey, Andrew Page and Ruby Rae; sponsored by Philippa Jeffrey, New London Arts Lab and Cambridge Arts Lab; guaranteed by the Arts Council of GB), duplicated sheets, unpaginated.

9. Richard Neville, 1971, op. cit., p.41.

10. Jim Haynes, cited in Jonathon Green, 1988, op. cit., p. 169.

11. 'The Arts Lab Movement', *International Times*, n.66, 10 October 1969, p.16.

12. Hoppy writing from TVX at IRAT to Sue Miles in New York, 10 June 1970, explained that 'The Lab is broke of course. Quite healthy for us all, I've decided.' 'It's Not Easy' papers, 1970–1971, private collection, courtesy Andrew Sclanders.

Introduction

Towards the end of the '60s, two artist-run spaces opened in quick succession in central London, and were home to some of the most innovative developments in the arts of the period. The Drury Lane Arts Lab (1967–69) was popularly associated with Swinging London's 'underground', John and Yoko, The Exploding Galaxy and Andy Warhol's film *Chelsea Girls*, but also was central to the development of fringe theatre in the UK. The more hard-core and cerebral Robert Street 'New Arts Lab' (1969–71) was home to some of the first experiments in computer-based arts, artists' filmmaking and public access to video technology. The galleries at both Labs offered exhibitions unlike those on show anywhere else. The New Arts Lab's cumbersome alternative title 'The Institute for Research in Art and Technology' (IRAT) signalled that research would be as important to its programme as exhibitions and performances; it was a space in which to make, try out and share work. Both Labs were shaped by the changing ambitions of artists and the changing expectations of audiences of the time, and reflected a developing internationalism and multiculturalism in the arts.

As the first attempt to document London's Arts Labs, this book's primary purpose is to reconstruct the programme of events they offered, using surviving schedules, fliers, posters and letters and the recollections of some of those who were involved.[1] Fifty years on, there are many gaps in the record and this account, compiled by one of the participants, inevitably reflects a partial viewpoint. Hopefully, there is enough here to stimulate further interest in Arts Labs and their contribution to a period of intense cultural experiment.

Lacking public funding, both Arts Labs were short-lived, yet they seemed

Heading from a schedule of Spring 1970, designer Biddy Peppin (with a nod to Chester Gould's Dick Tracey).

at the vanguard of a movement, and by the time of the Drury Lane Lab's closure in October '69, there were a dozen more Labs scattered across Britain, each different.[2] That same month, the New Arts Lab opened in Robert Street, set up by a group that included several of us who had broken away from Drury Lane following a bitter disagreement about policy. Announcing Drury Lane's demise, its founder, Jim Haynes, sent a letter to friends offering his own assessment of its importance. He concluded: "... a few asked, 'What's the product? What's its name?' The real answer was Humanity: you can't weigh it, you can't market it, you can't label it, and you can't destroy it."[3] For Jim, bringing people together was always the primary objective. Others of us involved might point instead to the vital role played by the Labs in the development of our chosen art forms, many of them *new* art forms, as artists came together around a common vision.

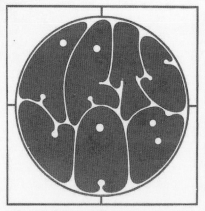

The Arts Laboratory 182 Drury Lane London WC2

The Arts Laboratory promises to be a don't miss thing.
Steve Kraus in East Village Other

At 182 Drury Lane, you can eat a snack, watch a movie, see a play and a dance performance, buy a book, look at (or buy) a picture and argue your head off about the contemporary arts scene all under one roof ... but it is more than a fringe house of entertainment. It is what it calls itself, a laboratory ... for experimental playwrights, film-makers and musicians to have their work produced before critical audiences.
B. A. Young in Financial Times

The week was saved for me by a superb performance of Kafka's 'Lecture to an Academy' by Tutte Lemkow at Jim Haynes' three-month old Arts Laboratory, which is now installed in a converted warehouse ... '
Philip French in New Statesman

The Will Spoor Mime Theatre, from Amsterdam, which has opened a season at the Arts Laboratory Theatre ... has a spontaneity and liveliness I have never seen before in this kind of show.
John Percival in The Times

(Music Festival in January) Richard Toop proved an outstanding pianist, and he launched the series with a complete performance of the father figure, Satie's Vexations which lasted 24 hours.
William Mann in The Times

Hugh Davies ... and the dozen performers ... amount to a whole second generation of British musicians who can be trusted with experimental music.
International Times

The Lab contains ...
A small open space free form theatre, (seating approximately 100), a mixed media theatre, a cinema and concert area, an art environmental area, a bookshop, office and dressing rooms, snack bar, as well as a home for a film production unit. We are a club open to our members and their guests.

Covent Garden is an excellent area for this project; it is central and in the best sense classless. The Covent Garden Planning Board assure us that they will include us in any future developments of the area.

The Arts Laboratory is exactly what its name suggests; an Arts Laboratory. We experiment with theatre, cinema, television, video tape, music poetry readings, happenings, lectures and exhibitions. In addition we concentrate on finding and encouraging new playwrights and filmmakers.

We would like your support, please become a member. Would you also give us the names and addresses of anyone who you think might like to become a member or support this project ? Your subscription will help, but if you can help in others way as well, please do not hesitate to contact us.

Main productions.
The People Show;
'Something Else' no. 10. 'Nice Quiet Night' no. 11. 'The Cage Show' no. 15. 'The Cultural Re-Orientation of the Working Class' no. 16. 'The Boxing Show' no. 17.
Graciela Martinez and the Sensual Laboratory (Mark Boyle, Joan Hills, John Claxton) in 'Dream Studies'
Tutte Lemkow in Kafka's 'Lecture to an Academy', and Moma Dimic's 'The Very Long Life of Tola Manoylavich' (British Premiere)
Will Spoor Mime Theatre from Amsterdam
'Complexions' and 'The Border' by Jan Quackenbush
Groupe de Pancho Barrera
Moving theatre (Amsterdam) Frits Vogels
Penal Settlement – Kafka (Adapted by Steven Berkoff)
Crossmembers – Baz Kershaw with Will Spoor
Hello Goodbye Sabastian – John Grillo (Brighton Combination)
These Foolish Things – People Show no. 19 with the People Band

Cinema

A Movie – *Conner*	*Films by Breer*
Relativity – *Emshwiller*	*Films by Heliczer*
Cosmic Ray – *Conner*	Report – *Conner*
Alone – *Dwoskin*	Thanks a lot – *Kaplan*
Films by Wirtschafter	Marvo Movie – *Keen*
Fireworks – *Anger*	Chien Andalou
Vivian – *Conner*	– *Dali/Bunuel*
TV – *Kren*	The Tragi-Comedy of
Like the Time is Now – *Keen*	Marriage – *Pike*
Leda and the Swan – *Kren*	The Seashell and the
Castle 1 (the light-bulb	Clergyman – *Artaud/*
film) – *Legrice*	*Dulac*
Echoes of Silence –	Claes Oldenburg Hanging
Goldman	a Picture Filmed by John
Films of Bernard Fiedler	Jones – *Jones*
Ander	Geography of the Body –
Skullduggery – *Vanderbeek*	*Maas*
Nine Variations on a Dance	Reflections on Black –
Theme – *Harris*	*Brakhage*
Towers open Fire –	The inauguration of the

Drury Lane promotional leaflet, Autumn 1968.

Endnotes

1. Documents are held at the British Artists Film & Video Study Collection at Central Saint Martins, UAL, Tate Archive and The Jim Haynes Archive, Napier University, Edinburgh.

2. Nicholas Albery of BIT compiled a list of over 50 'Arts Labs & Related Phenomena', published in *IT* n66, 10 October 1969 – see Appendix 1.

3. Letter, 28 October 1969, [Napier]. The last advertised event at Drury Lane would seem to have occurred on 11 September: 'Video of Isle of Wight Festival, at least 2 hours', *IT*, n64, 1969.

PART I

Drury Lane Arts Lab

Wally Fawkes, creator of the Daily Mail's
Flook, *responds to Drury Lane's 'soft'*
cinema (date unrecorded).

Setting-up

The first Arts Lab at 182 Drury Lane, Covent Garden, held its formal opening in September '67. Jim Haynes's initial vision had evolved from ideas first developed at his earlier arts venture, the Traverse Theatre Club in Edinburgh. But in London this vision was enhanced by the input of his new team of collaborators, and not least by the context of London's emerging underground culture. Jim, originally from Haynesville, Tennessee, had arrived in Scotland in 1956 while serving his US military draft. He had cleverly arranged permanent night duty which allowed him to simultaneously enrol at Edinburgh University. While there, his passion for books led him to set up The Paperback Bookshop (the first of its kind in Scotland) at 22A Charles Street, where he also staged talks and performances.[1] The success of these events led to an invitation from Lord Harewood, director of the Edinburgh Festival, to organise, in partnership with the publisher John Calder and Sonia Orwell, the 1962 International Writers' Conference *The Novel Today,* at which authors gathered from around the world to discuss the state of contemporary literature. For five days, Norman Mailer, Henry Miller, Mary McCarthy, William S Burroughs, Colin MacInnes, Hugh MacDiarmid, Muriel Spark, Alex Trocchi, Lawrence Durrell, Stephen Spender, Erich Fried, Khushwant Singh, Rebecca West and many others fought it out, and Jim's soon-to-be celebrated address book began to fill.[2]

A chance meeting at the Festival with the future gallerist Ricky Demarco led Jim to establish the tiny Traverse Theatre Club and Gallery which opened in January 1963. In the same year, together with Calder and Kenneth Tynan, Jim co-produced The International Drama Conference for the Edinburgh Festival, an international gathering of 120 writers, producers and performers – again enriching the contents of his address book.[3] Jim committed the Traverse to the presentation of new plays,[4] and saw his own role as essentially that of an *animateur*; he neither directed nor produced, delegating these roles to a succession of young talents, notably Charles Marowitz,[5] Michael Geliot,[6] Ralph Koltai[7] and briefly Terry Lane (one of the few people in the world with whom Jim failed to get on).

At about this time, Jim met Jack Henry Moore, a fellow American then working in Dublin as a stage-manager and private detective, but eager

MICHAEL WHITE &
THE TRAVERSE THEATRE
present

YOKO ONO

NOV 17

JEANETTA COCHRANE THEATRE
10:30 P.M. CHA 7040

Ad from IT *n3, October 1966.*

Jim Haynes with rhinoceros, Edinburgh, early 1960s (photo Haynes archive, Napier).

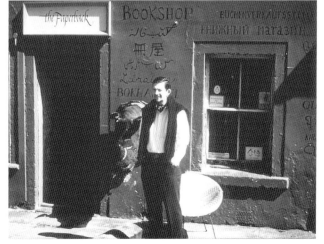

to become a theatre director. Despite being denied an Equity union card, Jack proved himself with a well-received production of *The Fantasticks*, and from then on became Jim's closest ally and collaborator. Jim's support for Jack, who was openly gay, would become one reason for a fall-out with the Traverse Theatre's Board, Jim's eventual resignation and his move to London.[8] Always keen to have a presence in London, Jim, together with Marowitz, Geliot and Koltai, set up The London Traverse Theatre Company at the Jeanetta Cochrane Theatre in Holborn, a venue facilitated by Lord Goodman, then Chairman of the Arts Council. At the Cochrane they had successes with Joe Orton's *Loot* (transferred from its Traverse premiere in Edinburgh) and *Three Saul Bellow Plays*, both produced by Marowitz. They also staged Yoko Ono's 'concert' *Music of the Mind*,[9] hosted the *Spontaneous Underground Film Festival* that launched the newly-founded London Filmmakers Co-op, and the spectacular Mark Boyle performance *Son et Lumiere for Bodily Fluids & Functions*.

Thus far Jim could do little wrong in the eyes of the literary and theatrical establishments. But he was unhappy with the lack of social space at the Cochrane, and started looking for alternative premises. He also was becoming closely involved with London's cultural underground, particularly with the alternative newspaper *International Times* (*IT*) that he co-founded and edited with Jack, Barry Miles (Miles), John Hopkins (Hoppy) and others.[10] He resigned from the Cochrane team, found and leased two warehouses in Drury Lane, and began to make plans to convert them for his new club project.

From Edinburgh Jim brought Jack as artistic co-director and his Traverse stage hand David Jeffrey as technical director.[11] The new London team comprised composer Hugh Davies (music organiser), artists Biddy Peppin and Pamela Zoline (exhibitions) and Sue Miles (food). I organised the cinema, David's partner Philippa Jeffrey looked after front of house; the Dutch mime artist Will Spoor soon became a constant presence and helped run the theatre during Jack's tour abroad with his group the Human Family; the actor Tutte Lemkow who had appeared in his one-man shows in Edinburgh became another stalwart. The Australian artist/potter Craig Gibsone worked alongside David Jeffrey and could make almost anything in wood; bookcases for the bookshop, fittings for the restaurant's kitchen, staged flooring for the seat-less cinema.[12] There were numerous others, part-timers and volunteers. Two company direc-

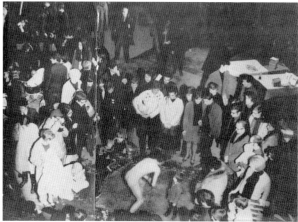

Biddy Peppin, Giant Jelly and a naked Mike Lesser,
Roundhouse, January 29, 1967 (photo Graham Keen).

Jim Haynes, poet Ted Joans and friend outside 182 Drury Lane in the Lab's
opening week (photo Haynes archive, Napier).

tors appeared on the letterhead alongside Jim and Jack – Mike Henshaw, the hip accountant, and Nigel Samuel, a young man sufficiently rich to act as financial guarantor to the Lab's lease and its inevitable overdrafts.

Having missed out on events in Edinburgh, those of us who joined in London drew on other sources of inspiration. During the spring and summer of 1966 Biddy and I had frequented events organised by Bob Cobbing and Miles at Better Books bookshop on Charing Cross road – installations by Jeff Nuttall and Criton Tomazos, performances by the People Show, poetry readings and the meetings of film enthusiasts that led to the founding of the London Filmmakers Co-op in October. While studying painting at the Slade, we had also had intense discussions with fellow student Gerry Fitzgerald about alternative ways in which artists might be active; one suggestion was a shop stocking 'unspecific' artefacts - unexpected things that were in themselves 'transporting'; another was to set up a Bauhaus-inspired workshop where artists working in different media could interact. None of us was keen to become embroiled in the commercial art market, and we wanted to find ways of making and encountering art outside established venues.

Biddy and I became occasional writers for *IT;* through Hoppy, we became involved in the UFO club, a weekly rave held on Friday nights in the Shamrock Club, a large basement space in Tottenham Court Road, with music, projections and performances: live sets by Soft Machine, Pink Floyd, Arthur Brown, the Bonzo Dog Doo-dah band and many other groups; light-show projections by Mark Boyle and Joan Hills; underground films selected and projected by me; recorded music selected by Jack Moore - often all happening at once.[13] We were all involved in the *IT* fundraiser the *Uncommon Market* held at the Roundhouse, where Biddy created her 34-gallon peppermint and almond flavoured, purple and green-coloured *Giant Jelly* (intended as a transporting 'edible sculpture') into which the young designer Mike Lesser was inspired to throw himself, naked (the jelly having collapsed as it was turned out from its mould). At another Roundhouse fundraising event her grass coat and boots, foam rubber jumpsuit and other experiments in 'wearable sculpture' were on show.[14] We were ticket-distributors for the celebrated the *14-Hour Technicolor Dream*, held at Alexandra Palace on 29 April 1967; (the phone number of our Greek St. flat which appeared on the poster was tapped, presumably by the police, for months afterwards). Pam Zoline, another painter and friend from the Slade, was becoming well-known in speculative fiction circles for her short story *The Heat Death of the Universe*, (*New Worlds* 1967); Hugh Davies had already served as assistant to Karlheinz Stockhausen in Cologne and performed with the Stockhausen Ensemble; he had been inventing musical instruments (some with artist John Furnival), and was in the process of setting up the studio for electronic music at Goldsmiths College, University of London.[15]

By April 1967, Jim had secured the lease of 182 Drury Lane and was soliciting funds and support. In a circular letter to the 'great and the good', he wrote "For some time I have been working on a laboratory theatre project which would be modelled along the lines of the Edinburgh Traverse Theatre Club. … [to be] centred around a small open-space free-form theatre (seating approximately 150 [in the event, it was closer to the Traverse's 70]).. and will contain space for a rehearsal room (which can double as an environment area and a concert room), an art gallery, bookshop, office and dressing rooms, a small restaurant and bar as well as a home for a film production unit …".[16] Operating as a membership club offered not only freedom from theatre censorship, but an additional income stream. Jim's fundraising efforts were successful to the extent that in May, *The Times* reported he had already raised £2,500, with founder members of the club including "Sir Laurence Olivier, Peter Brook, Oscar Lewenstein, Bernard Delfont, Michael Codron from the theatre, Doris Lessing the novelist, Mrs David Bruce the American Ambassador's wife,

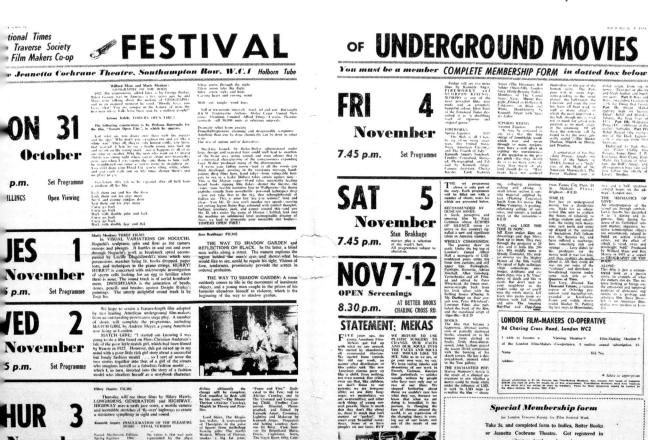

The Festival of Underground Movies *that launched the new London Filmmakers Coop, IT n 2, October 1966.*

John Wolfson an American businessman and former actor, and a figure of the London social world Mrs Diana Phipps".[17]

At this stage, Jim probably assumed that once established the Lab would receive Arts Council financial support as the Traverse had done, augmenting income earned from club memberships and tickets to theatre and cinema events. He initially hoped to run a bar which at the Traverse had made money; he also assumed that Sue Miles's restaurant would be profitable. Few of us – his new team – had any experience of running a business and we were happy to rely on Jim, though naivety about money existed on both sides. (I remember Jim's alarm when I quit my part-time teaching post at Birmingham College of Art; he'd assumed I would keep it on and work at the Lab for nothing!). The gallery was not expected to generate income, but to provide a stimulating visual environment; otherwise, there was an assumption that each area's earnings would cover

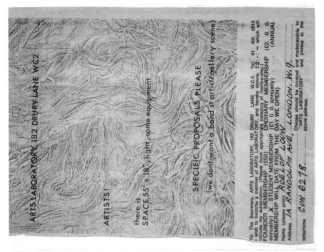

SCULPTURE PROPOSAL FOR THE ENTRANCE OF ARTS LAB NOT A JOKE

A pyramid of oranges about 5-6 feet high is erected near the entrance of the gallery.

Each visitor to the arts lab is invited/obliged to help himself to an orange, so diminishing the pile until it disappears. (An outline, to mark the floor space originally occupied, will remain.)

Of course if accepted the sculpture will be erected free.

Roelof Louw.

Soul City (1967) aka The Orange Pyramid. *Roelof Louw's proposal, and his photos of the diminishing sculpture (© The Estate of the Artist. Lower image courtesy of Richard Saltoun Gallery, London).*

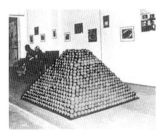

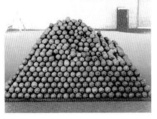

its programme costs. In the event, the absence of a bar and the closure of Sue's restaurant after just nine months contributed to a constant deficit. Nonetheless, Jim was happy for us to programme our respective areas with little interference, though as the Lab's visible figure-head, projects were often offered to him and he would pass them on, usually having already said 'yes, we'll do it', as was his nature.

Towards the end of July '67, still nearly two months before the Lab was fully open, *IT* would signal that 'films, people and poetry' could be found at the Lab on Sundays, though these events took place amid the chaos of building work.[18] In the same *IT* issue, Jack reviewed the work of the performance groups the People Show and The Exploding Galaxy 'soon to be seen at the Lab', and announced that the Lab's first theatre production would be Tutte Lemkow's *The Very Long Life of Tola Manojlovic*, based on the story by the Belgrade poet Moma Dimic, in a double bill with his *Report to an Academy* (Kafka's lecture given by an ape), seen earlier in Edinburgh.[19] It was to be followed by *Fish for a Face in the House of a Thousand Mirrors* by Arlene Colombe Hiquily, 'a long erotic poem for an actress and a thousand images'.[20] Jack also solicited contributions for 'an exhibition of head drawings' (an undefined genre, but implicitly drug-inspired), which would fill the gallery in early November, many drawn directly on the walls. And in an adjacent *IT* ad, Biddy and Pam issued a more general call for exhibition proposals: "Artists! There is SPACE 55 x 18 [feet], light, some equipment, SPECIFIC PROPOSALS PLEASE, we don't want a Bond St artists/gallery scene";[21] a call echoed in a letter they addressed to art school students seeking "exciting experimental work (you may define these terms) in any medium, Art and non-art ...".[22] The former immediately prompted a response from Roelof Louw in the form of a proposal to stage his conceptual work *Soul City* (1967), a

glowing, sweet smelling, six foot high pyramid of oranges intended to be consumed by spectators, now in the collection of Tate, which, according to Tate's catalogue, "raises questions about ephemerality, time and decay".[23] (At the time it helpfully supplied a lot of hippies with their daily dose of vitamin C.) A cone of gravel installed by Roelof in the rear gallery was less universally welcomed, since it almost filled one of the main socialising areas. Thereafter, it seemed there was little need for any Lab department to solicit work; the floodgates were open.

The reference in Jim's letter to a film production unit probably relates to aspirations I was voicing for the cinema space. In a contemporary interview, I expressed the hope that our initial repertory of avant-garde classics and camp feature films would be short-lived, continuing only until we were able to devote the whole programme to new work by British experimental filmmakers.[24] In fact, with so few active filmmaking artists around in the late-1960s, this Haynes-like commitment to showing new British-made work was an unfulfilled fantasy, though towards the end of the Robert St. Lab, such films would indeed form a substantial part of the programme.

But building a film production unit happened more quickly, thanks to Malcolm Le Grice's involvement. Malcolm, who like Biddy, Pam and me had studied painting at the Slade, got in touch soon after the Lab opened and showed me his extraordinary *Castle 1* (1967), a film of looped, found documentary footage extracted from Wardour St. editing-room waste-bins, which was projected with a light-bulb hanging in front of the screen flashing on and off, obliterating the image, (sometimes its own filmed image) – a ground-breaking work of anti-cinema, pro-film-'materiality'.[25] Soon he was designing and building do-it-yourself film-processing and printing equipment in one of the Lab's upstairs rooms, and we issued a call to filmmakers to share equipment, skills and projects. And month by month we were increasingly able to show new work by emerging filmmaking artists, though initially these artists mostly came from the USA and Europe.

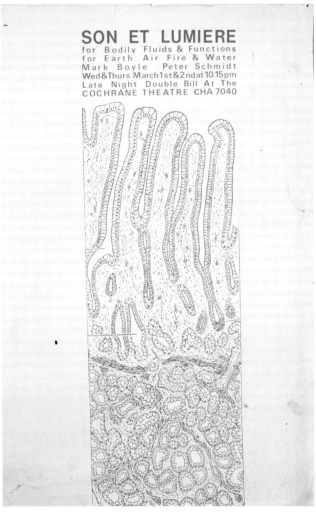

Poster for Mark Boyle / Joan Hills / Peter Schmidt's performances, Cochrane Theatre, March 1967.

Castle 1 (1967) Malcolm Le Grice (photo, a later performance, courtesy of LUX).

Endnotes

1. Christopher Gordon who attended some of these events remembers: "A large and half rotten stuffed rhinoceros head hung outside the door to show when the shop was open. It was sometimes taken in when the odour of illegal substances was a bit strong and needed to be overlaid." Email 13 January 2018.

2. By 1970, so extensive were his address book's entries that "a London publisher asked me during the Frankfurt Book Fair if I would like to have it published". JH *A Duplicated Letter in the form of an Annual Report to all of my Friends*. Undated c January 1971.

3. A 'happening' at the Drama Conference staged by director Ken Dewey, Mark Boyle, Joan Hills and others, involving the American actress Caroll Baker and a cabinet of phrenological heads, caused a scandal by its inclusion of a moment of nakedness as an art-school model was wheeled across a balcony above the stage.

4. He boasted: "Productions at the Traverse in 1965 included some 24 either British or World Premieres. My favourites were *There Was a Man* by Tom Wright, *The Master of Two Servants* by George Mully, *The Wen and Orange Souffle* by Saul Bellow, *Green Julia* by Paul Ableman, *Happy Days Are Here Again* by C.P.Taylor, *Oh, Gloria* by Robert Shure, and *Onkel, Onkel* by Gunther Grass – all world premieres!" www.jim-haynes.com.

5. Marowitz later worked with Peter Brook at the Royal Shakespeare Company then founded The Open Space Theatre in London.

6. Before the Traverse, Geliot worked at the Royal Court Theatre and was a staff producer at Glyndebourne and Sadler's Wells. At the Traverse he staged the first production outside Germany of Brecht's *Happy End*. He joined Welsh National Opera in 1966 and was associated with the company till 1983.

7. Koltai was a tutor at the Central School of Arts, and would have a celebrated career as stage designer for RSC, NT and others.

8. Unaddressed debts at the Traverse were another source of tension.

9. 17 November. Her performance included *Promise Piece (Mend Piece)*, *A Grapefruit in the World of Park*, et al. In this version of *Mend Piece*, a vase was broken on stage and the pieces distributed to audience members who were asked to promise to meet again in 10 years to reassemble them.

10. *IT* was launched with a party at the Roundhouse in October 1966. Like *Oz*, *Black Dwarf* and *Time Out, IT* was made possible by the newly-available offset litho printing technology, in which pasting-up and laying out camera-ready copy replaced the setting of 'hot metal'.

11. David Jeffrey recalled: "I was still studying [at University] but Jack involved me in various projects, including his memorable production of *The Fantasticks*, which I suppose I stage managed. I found Jack fascinating – I had never met anyone like him. I graduated in 1966 at about the same time as Jim and Jack moved to London, and they encouraged me to join them to found something like the Traverse." Email 25 October 2018.

12. They were joined in early 1968 by Martin Shann, 'master of works'.

13. November 1966 – October 1967.

14. They were reviewed by Ray Durgnat in *Art and Artists* (August 1967).

15. He was the Goldsmiths studio's director 1967–1986.

16. JH Undated – Drury Lane documents file.

17. *The Times,* 3 May 1967 'Mr Haynes finds support'.

18. Some of the pre-opening events were organised by Bob Cobbing from Better Books, after Hatchards, who were planning to sell the business, ordered the ending of evening performances there. A photo of Better Books shop window in August shows hand-made posters for 'Poetry Reading Wednesday August 23rd 9pm at Arts Laboratory'; 'Better Books presents Ted Joans, Adrian Henri, Michael Horovitz, Pete Stevens, Sun September 10'; 'Evening Activities … will now take place at the Arts Laboratory' and 'Next Friday's Films – European Avant-garde a historical survey' with an arrow pointing to a map of how to find the Arts Lab, clearly not yet an established venue. Reproduced in Rozemin Keshvani *Better Books / Better Bookz: Art, Anarchy, Apostasy, Counter Culture and the New Avant-Garde,* Koenig Books, 2019.

19. *The Report..* was sometimes billed as *Lecture to the Academy*.

20. Hiquily, American poet and painter, studied with George Grosz in New York in the late 1940s, was a friend of Ginsberg and Henry Miller and lived and worked in Paris from the 1950s.

21. *IT* 31 August 1967. The mop in the background was an early example of a Xerox photocopy image.

22. Drury Lane documents file.

23. Exhibited at Drury Lane for two weeks from 16 November; the quote is from Tate's on-line catalogue; Roelof was then teaching sculpture part-time at St Martins.

24. *Unit no 9,* December 1967, ed Tony Elliott, Keele University.

25. Given its first public showing on 17 October 1967 but under the pseudonym Mihima Haas, (Mickey Mouse).

The Building

E ntering the Drury Lane building, visitors were greeted on the right by an L-shaped desk along the former shop window, where membership cards were issued and checked, and event tickets sold. "Hello, are you a member?" was the greeting issued by whoever was 'on the desk', usually Philippa and sometimes Biddy, occasionally Jim, with a team including Dany Broadway, Solange Zamora, Ulla Driehaus and several others, taking turns. This crew was in effect the Lab's primary 'what's on' information board.[1] Immediately on the left were bookshelves forming Jim's bookshop, (conveniently placed for the light-fingered to help themselves as they departed, so it didn't last long).[2] This wide entrance space formed the front gallery, the primary exhibition space; it also served as the theatre and cinema foyer, so was also the main meeting and socialising area. Its mouse-brown felt carpet was soon covered with coffee stains, cigarette burns and general heavy use. People often sat on the floor among piles of coats, bags and (in the early days) shoes.

Una riunione all'«Arts Laboratory», il centro culturale hippy che ha in programma la creazione di un'anti-università e la concessione di una rete TV.

The front desk, with Spiros, ?, Dany Broadway and her friend Sue, as featured in the Italian picture magazine ABC, *3 March, 1968.*

A staircase on the left led up to two rooms that were used at different times for different purposes; Sue Miles's restaurant, Malcolm's workshop, a second theatre, occasionally a second gallery. When Sue's restaurant first opened, it offered one enormous table (formed of lots of old tables pushed together) making unplanned socialising unavoidable. There was one dish of the day and no alcohol licence, yet it always seemed full. Later Craig built separate tables seating four on fixed benches, a format not much liked by diners, but easier for waiters to navigate. Not long after this change, the restaurant closed, Sue dispirited by battles with the local authority over lack of a fire exit and hygiene issues associated with the kitchen's unsealed wooden surfaces.

Beneath this upward flight, stairs led down into the basement cinema, where the very low ceiling offered no possibility of raked seating. So we invented the soft floor, which rose in three shallow steps towards the projection box at the back, 'comfort' being provided by four inches of fireproof foam-rubber covered with three colours of carpet (remnants sourced by Biddy in a sale and laid by us in a late-night marathon just before the Lab's launch). We asked people to remove their shoes to preserve this soft seating surface, with sometimes unwelcome conse-quences. The tiny projection box at the back had a horizontal slit window onto the street at pavement level, supposedly the cinema's fire exit! The

projection box contained two matching 16mm projectors allowing continuous projection of feature films, David Jeffrey devising a clever cross-fading mechanism between them, to ease change-overs and prolong projector-lamp life. At the other end, a cinemascope-shaped screen filled the wall, floor to ceiling, prompting Malcolm's enthusiasm for twin-screen projection, and later perfectly accommodating Warhol's twin-screen – *Chelsea Girls*.

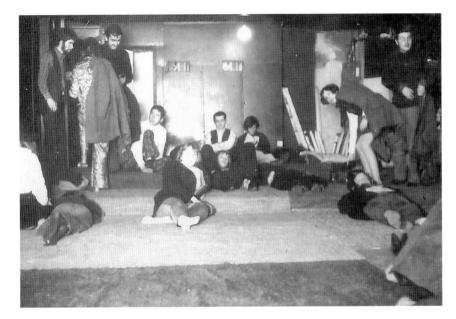

The cinema, with David Jeffrey (extreme left) setting it up for a sound performance. Visible are the projection box's tiny projection ports, and the soft floor's three shallow steps (photo Haynes archive, Napier University).

On the ground floor, the space narrowed towards the back but continued as a gallery, sometimes with a coffee/snack bar on the left. Double doors from this space led on the left into the theatre and towards the back into a two-story area, with lavatories below and Jim's and Jack's tiny living spaces, plus theatre props storage and changing rooms, above. The theatre didn't have fixed seats. Jim boasted: "in our theatre, when you bought a ticket you also carried in your seat with you. We had these beer cases that were stacked outside. Thus there were never empty seats – the whole psychology of playing to a half-empty theatre never existed – everybody played to a full house."[3] Music events and poetry readings didn't have a dedicated space and occurred in the theatre, cinema or gallery, wherever space could be found in the schedules. Visitors were often astonished by the rapid turnover of events. There might be three different performances in the theatre during one evening, the last often starting after midnight; gallery exhibitions changed weekly or at most fortnightly, running Tuesdays to Sundays with no gaps between shows; there were two cinema programmes each evening and additional late-night programmes at week-

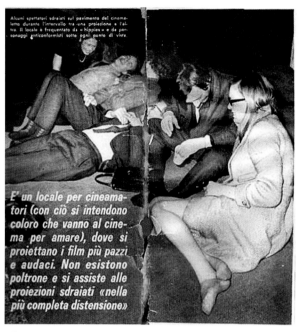

Alcuni spettatori sdraiati sul pavimento del cinema-lemo durante l'intervallo tra una proiezione e l'altra. Il locale è frequentato da « hippies » e da personaggi anticonformisti sotto ogni punto di vista.

E' un locale per cineama-tori (con ciò si intendono coloro che vanno al cinema per amare), dove si proiettano i film più pazzi e audaci. Non esistono poltrone e si assiste alle proiezioni sdraiati «nella più completa distensione»

The cinema, as featured in ABC's article
'Nel Cinema-Letto – il buio e' pericoloso'
[the Cinema-Bed – the dark is dangerous].

ends, with few repeated more than twice. The building was closed for just one day (Monday) each week. The distinctive name 'Arts Lab', devised by Jim, chimed with the optimistic spirit of the time, and seemed to have a wide appeal. Jim remembered: "One of the amazing things about the Arts Lab was the extraordinary range of people who used it, from Dick Gregory or James Baldwin to Mama Cass or Ronnie Laing or Christine Keeler. Everyone came to the Lab; it was like a melting pot".[4] Artists came – painter/maker Joe Tilson, inflatables-creator Graham Stevens, Curwen Studio printmaker John White and American pop artist Jim Dine;[5] students like artist-performer Merdel Jordine (sensational in gold and metallic-green make-up), or weekending 'suburban teenager' Rob La Frenais, who – like David Bowie – was inspired to start his own Lab (see Appendix 2); poets and writers known and unknown, professional and aspiring actors (one of the latter publicly stripped off his shirt to pose for Biddy and is immortalised in her *Kenneth Anger* poster), filmmakers, musicians and people who just came out of curiosity. Odd 'regulars' included Hugh Shaw of the Arts Council's Art Department who came in open-toed sandals summer and winter; pensioner 'Ginger' Wrigley, traumatised by internment in a Japanese PoW camp but at home among the young, Eric the genial tramp. People willing to help were welcomed too – desk workers like French/American Dany Broadway and Swiss/Peruvian Solange Zamora; film projectionists like 19-year-old Zoran Matic (originally from Yugoslavia) and his East End skinhead friend Dave Harrington.

Endnotes

1. Philippa Jeffrey remembers: "*Time Out* began as a sort of in-house magazine for the Arts Lab, and desk-workers needed to make sure that the diary was up-to-date with correct information to be passed on for printing. Initially, it was printed on both sides of a large single sheet of paper, folded into four, and its listings mainly covered the Arts Lab and the Covent Garden area. It was the inspiration of Tony Elliott – a student at Keele University". Email 2 May 2019.

2. For a while the bookshop was managed by Simon Losh.

3. Jim Haynes in Jonathan Green *Days in the Life*, Pimlico 1998.

4. *Thanks for Coming Encore* Polwarth Publishing LLP Edinburgh 2014.

5. John White was printing for Dine at the time. Email 22 July 2019. 'Trog' – (Wally Fawkes) the creator of the cartoon character Flook must also have visited Drury Lane, probably with his writer George Melly.

The Programme Mix

The Lab's opening-week programme was at best a partial success. In the cinema I launched with Peter Emmanuel Goldman's down-beat study of aimless 20-year-old New Yorkers, *Echoes of Silence* (1966), which was enjoyed by few,[1] but the People Show joined by trumpet-player Mel Davis and his trio (the future People Band) opened with *The Cage Show* in the theatre and brought with them an established audience. In the gallery, The Exploding Galaxy (of which Gerry Fitzgerald was now a key member alongside artist David Medalla) staged what they called 'an *Evolving Documents Show*', a fusion of dance led by Medalla with poetry by Michael Chapman. Also, somewhere, an event by the German 'language' artist (Herbert) Schuldt – *Poems, Prayer Mills, Deck of Cards, Public Notices, Doubt, Choir, Your Phrases Game* – on 26 September (no further details given), the first of many enigmatically-announced happenings to take place at the Lab.

More ambitiously, the second week in October was billed as *Black Power Week*, probably inspired by the presence in London of the American jazz

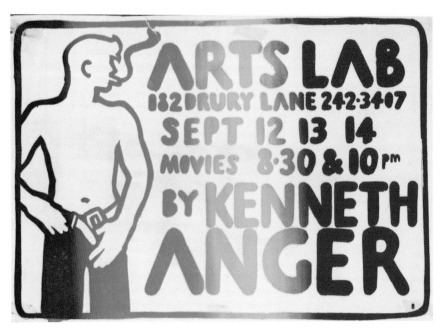

Silkscreened poster designed, cut and printed in a run of fewer than ten by Biddy Peppin.

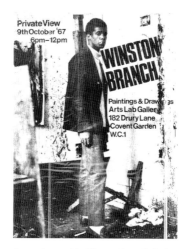

Poster designed by Winston Branch for his exhibition (courtesy Winston Branch).

poet Ted Joans.[2] I assembled a programme of Black films for which Ted provided the text of a flier: "Something old – *Hallelujah* [King Vidor 1929]; something bad – *Cry of Jazz* [documentary by Ed Bland 1959]; something blue – *Bessie Smith* [*St Louis Blues* Dudley Murphy, 1929]; something glad – *Fats Waller* [*Honeysuckle Rose* c.1934?]; something a-drag – extract from *Birth of a Nation* [D W Griffith 1915] and something new and true – *Black Flower* by R Morton" (this last a film? a poem? I can't remember). The gallery gave a first show to the St Lucian-born painter and recent Slade graduate Winston Branch; Ted gave readings; there was an audience with Michael Abdul Malik (Michael X) and guests, the latter including the hot young black actor Frankie Dymon Jr., who had just finished shooting *One Plus One / Sympathy for the Devil* in London with Jean-Luc Godard.[3]

And as if to show how diverse our programme was, or perhaps how fundamentally un-planned, at the very beginning of Black Power Week, on 10 October, Richard Toop installed a grand piano in the gallery and gave the first UK performance of Erik Satie's 24-hour piano piece *Vexations* (c 1893), 840 repetitions of the same complex 'motif', Toop bravely insisting that he undertake this marathon solo. (The only previous known performances, both organised by John Cage, had resorted to relays of players). Toop later recalled: "Three things stand out in my mind from the first performance. Firstly, the piano was in the [gallery] where there was an art exhibition, so that the music became a real *musique d'ameublement*. People walked round the piano, talked, sometimes stopped and listened... Secondly, I remember a man from *The Times* kneeling beside me as I played – it occurred to me at the time that not even Rubinstein

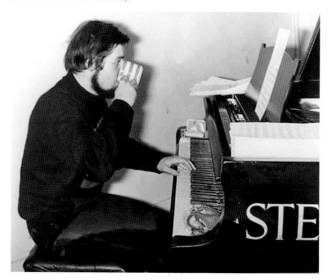

Richard Toop with stimulant (photo courtesy australianmusiccentre.com.au).

got that sort of genuflectory treatment. The third aspect was less fortunate: after about 16 hours I asked for some kind of mild stimulant in addition to the strong coffee I had been getting (I was expecting some kind of vitamin pill); what actually materialised was another cup of coffee with (as I only discovered later) a whole phial of methedrine in it. The effect was hair-raising: my drooping eye-lids rolled up like in a *Tom and Jerry* cartoon (one of the newspaper reports remarked on my 'slightly glazed' appearance at the end of the performance). The trouble was that my field of vision became completely fixed; each time I got to the end of a page I had to lift my head up and realign my vision onto the beginning of the new page."[4]

arts laboratory
182 Drury Lane London WC2

Artistic Director
Jim Haynes

Telephone
01·405 0512

3 November Friday
 Cinema: Films fr. India plus LES YEUX SANS VISAGE (Franju)
 LIVING DEAD (Germany 1932 – classic horror)
 Theatre: "Lecture to an Academy" (Kafka)
 "The Very Long Life of Tola Manoylovich" (Dimic) 7:30pm
 Gallery: "Head" Drawings –– bring some
 Poetry: Jalabala Vaidya reads Gopal Sharman 8:30 pm
 Concert: The Continuous Music Ensemble (Mel Davis) 9:45pm, 3/–
 Restaurant: Food – noon to 11 pm

4 November Saturday
Same as above

5 November Sunday
 Theatre: same as above
 Gallery: " " "
 Restaurant:" " "
 Cinema: " " " plus 6 pm showings and perverse late
 showings.
 Poetry: same as above

6 November Monday
 Closed

7 November Tuesday
 Cinema: Renoir's BOUDU and THE LOWER DEPTHS at 7pm and 10pm
 alternately
 Theatre: The People Show No. 10 & 11, "A Nice Quiet Night"
 and "Something Else" 8·30 pm 6/6
 Theatre: "Lecture to an Academy" (Kafka)
 "The Very Long Life of Tola Manoylovich"(Dimic) 7:30pm
 Gallery: Ron Rothfield is exhibiting: bring your eyes. (to
 the 19th)
 Restaurant: Food

8 November Wednesday
Same as above

9 November Thursday
Same as above

10 November Friday
 Theatre: same as above
 Gallery: " " "
 Restaurant:" " "
 Cinema: " " " plus 12:15 am THE FUGITIVE (John Ford)
 and CROSSFIRE (Dmytryk)

11 November Saturday
Same as above

12 November Sunday
 Theatre: same as above
 Gallery: " " "
 Restaurant:" " "
 Cinema: " " " PLUS special perverse (ie films are
 liable to be played with) showings after midnight
 Stereo Concerts: Repeat of John Cage Retrospective

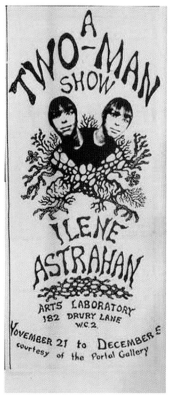

Ad from IT *n22, December 1968.*

One of the weekly, sometimes fortnightly, schedules of Lab events, typed onto wax-paper stencils and printed on a Gestetner printer.

November opened with *The Ying Yang Uprising,* 'a three day jamboree – Save Earth Now', an early manifestation of Jack's pursuit of universal love and Jim's very comparable belief that all one needed to do was to bring people together: "War, hatred, famine, evil, jealousy must be replaced by friendship, love, understanding and goodwill. This three day non-conference will contain games, laughter, music, poetry, people, dance, smiles and food." It promised the participation of a good round-up of current underground celebrities including Miles, Michael X, Lee Harris, Caroline Coon, Ted Joans, Richard Neville, Mick Farren, Colin MacInnes, Horace Ové and more (though what they would individually contribute was far from clear).

POEMS GAME

PRAYER MILLS

DECK OF CARDS

CHOIR PHRASES

PUBLIC NOTICES

DOUBT YOUR

SCHULDT Tuesday, Sept. 26th

ARTS LAB 8.30pm,

Admission 3s6d

182 Drury Lane, W.C.2

THE YING YANG UPRISING

Present

A THREE DAY JAMBOREE

at the

arts lab, 182 drury lane, w.c.2 phone 242 3408

On the 3rd, 4th & 5th November

In first steps towards

SAVE EARTH NOW

War, hatred, famine, evil, jealousy must be replaced by friendship,
love, understanding and goodwill. SAVE EARTH NOW This three day
non-conference will contain games, laughter, music, poetry, people,
dance, smiles and food. Plant seeds for non stop explorations. Out
of space be warned SAVE EARTH NOW

Hosts include Michael Abdul Malik, Jim Haynes, Roy Sawh, Caroline
Coon, Ted Joans, Richard Neville, Terry X, Frankie Dymon, Sue
Miles, Mick Farren, Calvin Herndon, Colin McInnes, Courtney Tulloch,
Miles, Lee Harris, Horace Ove, and surprises galore.

Tickets 10/- for all three days limited to first 100 to apply to Arts Lab.
Opens Friday noon with food, ends wee hours Monday a.m., worshipping
Eros (much happens/happiness in the middle).

A more certain offering, Tutte Lemkow's promised double bill, opened in November and played for two weeks, and involved Tutte in a rapid change of costume and make-up, ape to venerable stonemason, the latter an ironic witness to half a century of politics in rural Croatia. (Jim remembers the Yugoslav Embassy donating a case of slivovitz which was issued to audience members during the performances). Tutte's *Report* was an instant success. "*The Report* has Mr. Lemkow as a partially humanized ape, discussing with simian antics and academic gravity what it is like to be an ape transformed into a man. Kafka's purpose was to satirize the assimilation of Jews into the Germanic culture at the turn of the century, Kafka himself coming from an 'assimilated' Jewish family in Prague. The bitterness of the irony is intense, and Mr. Lemkow, his precise, high-pitched, scholarly sounding voice, and his wickedly apelike gestures and features, make Kafka's horridly comic diatribe into a theatrical miniature of real value."[5] That Tutte himself was an assimilated Norwegian Jew, possibly added to its force.

In the first week of its run, Tutte's *Report* was followed in the theatre by Mel Davis now with the Continuous Music Ensemble, and in its second, by another People Show, a double bill of *A Nice Quite Night*, and *Something Else*. Sets and lighting changes at the Lab were rarely complex; change-overs could be quick. Somewhere in the schedule in that second week there was also a 'stereo concert', a retrospective of works by John Cage organised by Hugh. Simultaneously, the American folk-rock musician Shawn Phillips spent time "turning-on the Arts Lab to his poetry, singing, sitar and guitar playing." In the gallery in November, following the 'head drawings' and Roelof's oranges, there was a show of paintings by New York artist Ilene Astrahan ("some amusing *tromp l'oeil* and colourful science-fiction" according to *The Financial Times*)[6] and a 'light environment' by People Show member Roland Miller.

In the cinema I more successfully combined old and new with Malcolm Le Grice's *Castle 1* and what was the first proper UK showing of *A Movie* (1958) and

ARTS LAB
182 DRURY LANE W.C.2
☎ 242-3407/8

Open every night 7.30 pm (earlier on Sundays) until 1.00 am or later. Phone for times, details of programmes etc. Frequent last minute additions to programmes. Closed all day Mondays.

THEATRE

Sept. 24th – 28th (Tues. - Sat.) 'POETICA' by Frank Castillo
Sept. 27th, 28th, 29th, (Fri - Sun) 'THE MASK ROUTINE' by Pip Sims
Oct 1st – Oct 13th (daily except Mondays) at 9 The People Show in 'RAILINGS IN THE PARK' by Jeff Nuttall.
(coming event – beginning Oct 22nd 'VAGINA REX AND THE GAS OVEN' a poperatic documentary by Jane Arden)
From time to time – Will Spoor 'ART OF THE FUGUE'.

CINEMA

Every Tuesday OPEN SCREENING (Bring films and rushes)

Sept 20th – 22nd (Fri - Sun) 'WAVELENGTH' Mike Snows prizewinning experimental movie.
Sept 25th – London Film Makers Co-op Show.
Sept 26th – 28th (Thurs - Sat) Modern Animation Programme: Phone for details.
Sept 27th, 28th – late show. Tribute to William Klien; 'QUI ETES VOUS POLLY MAGGOO' and 'BROADWAY BY NIGHT'.

Oct 2nd, 3rd (Wed, Thurs) The revised, completed screening of 'BERKLEY BATH BROTHEL' (the Naked Lunch) by Sandy Daley.

Oct 4th, 5th (Fri - Sat) 'THINGS TO COME' H.G. Wells/Korda.
Oct 9th, 10th (Wed- Thurs) Films from Holland
Oct 11th, 12th (Fri - Sat) Films from the Belgian Co-op.
Oct 16th – 19th (Wed - Sat) Warhol's CHELSEA GIRLS
Oct 23rd – 26th (Wed - Sat) Warhol's CHELSEA GIRLS
PHONE FOR FURTHER DETAILS OF PROGRAMMES.

MUSIC

CONCERTS EVERY SUNDAY AT 6 pm.
Sept. 22nd. Live performance – John Cage – Variations III
Sept 29th. Live performance – Instrumental and electronic improvisations
Oct 6th – No concert
Oct 13th – Experimental Music and happenings – with Malcolm Fox and others
Oct 20th – 'Sound Poetry' by Bob Cobbing and Anna Lockwood
TUESDAYS – 7-10 pm. – The AMM Improvisation Music Ensemble
Sept 27th (Fri) – The Gordon Beck Trio
28th Sept (Sat) – The People Band (late)
Oct 2nd – 'Music' trip 7 pm.
Oct 4th and 11th – 3rd Ear Band (Cosmic Raga) late.
Oct 15th – 'Purple Haze' (Dutch Blues Group) 8 pm.

OTHER EVENTS

Every Wednesday and Friday; at 7 HARE KRISHNA chant.
Every Tuesday at 10 pm. EXCHANGES – open discussion – Phone for details
Sept 28th, 29th (Sat, Sun) at 4 pm. (note early time) Mixed Media Event – BOX NO. 1.
by Guillermo Ramos Poqui – with films by Joan Duran, paintings
by Robert Anglada, poetry by Stephen Wade.
Oct 2nd and 9th (Wednesdays) 10.30 pm. THE SENSUAL LABORATORY – Mark Boyle Light Show.

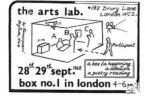

POETRY

EVERY WEDNESDAY 6 - 8 pm. POETRY WORKSHOP
Oct 6th (Sun) 7 pm. Poetry reading by Antonio Cisneros (Casa de las Americas, Havana – Prize Winner '68)

EXHIBITIONS

Oct 1st – Gallery 1 – Peter Bank's 'House' paintings
Gallery 2 – GOLDIEFINGERS, THE BEAR ONE AND OTHER TALES. Exhibition and performances by Fitzseed, Jubilee, and Banannabel.

EVENTS

THE ARTS LAB IS A MEMBERSHIP CLUB
PHONE FOR FURTHER PARTICULARS.

Facing page –
Above: Poster from the William Cobbing collection.
Below: Flier from Lee Harris's collection (image courtesy of Andrew Sclanders).

Left: Poster/flier designed jointly by Ellen Uitzinger and Biddy Peppin.

Jim with Jack as his Right Leg.
*Drawing by Mal Dean, from his
exhibition in December 1967 (collection,
Haynes archive, Napier University).*

other films by Bruce Conner, borrowed from Robert Fraser's Gallery, where Bruce had recently shown his remarkable assemblage-sculptures.[7] This was followed by an odd underground programme mixing the Austrian Kurt Kren with West Coast filmmakers Robert Pike and Paul Bartel, these being some of the very few films already in circulation through the new-born London Filmmakers Co-op. And we had our first real financial hit with four nights of films by Kenneth Anger, mostly hired from Anger's London producer, Jimmy Vaughan. Our pop feature films that month, all late shows, included 'Heroes of the Underground' – Marlon Brando glowering in *The Wild One* together with Michael Powell's creepy dissection of the urge to film *Peeping Tom*; 'Screen Erotica' – Kubrick's *Lolita* and Rita Hayworth glowing in *Gilda,* and two 1930s classics by Jean Renoir, *Boudu sauvé des eaux* and *Les bas-fond.* I soon encountered problems booking classic Hollywood films for the Lab, even after falsely promising that we were not openly selling tickets to what were supposed to be 'private' club screenings (ticket-selling at the door being forbidden by Kinematograph Renters Society / Central Booking Agency rules). Luckily the distributors of European art cinema were more willing to turn a blind eye to our 'instant' membership policy.

December saw the English première of Shirley Clarke's feature-length filmed interview with a charismatic but troubled black male hustler *A Portrait of Jason* (apparently shot entirely in one night), and in the gallery, pen drawings by jazz trumpeter/graphic artist Mal Dean, frequent contributor of graphics to *IT*, but now best remembered for his illustrations to Michael Moorcock's Jerry Cornelius stories. His drawing of Jim with Jack as his right leg seemed perfectly to characterise their relationship. This eclectic programme mix was typical of the Drury Lane Lab's offerings.

Endnotes

1. Yet much praised at the time by Jonas Mekas as a 'ballad of sexual dependency'.

2. Ted Joans (1928–2003) *A Black Pow-Wow Of Jazz Poems* (1969), *Afrodisia* (1970) *Razzle Dazzle* (1980). His poem *Smile* (1968) was inspired by – and dedicated to – Biddy.

3. *One Plus One* / aka *Sympathy for the Devil* featured The Rolling Stones creating the title track. Frankie Dymon Jr made his own short feature film *Death May Be Your Santa Claus* (1969) in which Merdel Jordine appeared.

4. Toop, in Gavin Bryars's detailed account of both concerts in *Contact* no. 26 (Spring 1983). Toop gave a second performance at the Lab a year later, filmed by the BBC. Cage's performances were at the Pocket Theatre New York in 1963 with a dozen players including David Tudor, Christian Wolff, James Tenney, Joshua Rifkin and others, and in Berlin in 1966 with six players including Cage himself and Charlotte Moorman.

5. Clive Barnes, 'Stage: Kafka Double Bill; Tutte Lemkow Provides Eerie Mixture of Theater, Film and Lecture' *New York Times*, 7 June 1975. (The film was Kafka's *Metamorphosis* (1969) by Carlos Pasini-Hansen, made while at the Royal College of Art, featuring Tutte in the solo, non-speaking role). At the Lab, Tutte's double bill was acclaimed by Hilary Spurling in *The Spectator*, 19 January 1968, which led to its long run.

6. Partner of *East Village Other* writer Alex Gross, she was later better-known as a pioneer of computer-generated imagery. She contributed the cover artwork to *IT*, 22 November 1967.

7. The Michael English poster for the 27 January UFO suggests I had previously shown at least one Conner film there.

Theatre

The opening People Show, *no. 14 – The Cage Show,* written, or rather conceived by Jeff Nuttall, was characteristic of much that followed on the Lab's stage in its mix of aggression, physical performance and improvisation. On this occasion, Jeff was apparently disappointed by the group softening the intended audience-attack. "An early show at the Arts Lab included four cages wrought of chicken wire and old bed springs. The audience [members] were locked into the cages and were to be let out one at a time to be interrogated. … Their interrogation was intended to be something of an ordeal, the interrogator (Sid [Palmer]) accusing each person of being 'Mrs Meadows' and insisting that they prove otherwise. There was to be a telephone on hand for people to call witnesses. [But] Sid turned the interrogation into a farce, skimped over it to make room for a whimsical sketch about the man in the moon."[1] The Mel Davis trio's musical improvisations were intended to stoke-up the tension. Nuttall also complained that the actors sometimes subverted his proposal that offal be showered into the cages, instead simply firing at the audience with water pistols. But the young writer (then Better Books sales assistant) Paul Buck remembers at least one occasion when offal was present: "Once the doors were padlocked we were set upon and harassed by the actors, insulting and abusing us verbally, whilst also poking offal through the cage walls, and rags soaked in Dettol. There is no greater, stomach-churning smell than an excess of this disinfectant. Female members of the audience were selected, taken out and seated at a desk for interrogation. Most of the time we were afraid, not knowing what personal harassment we would each receive."[2] The next People Show in the schedule *The Cultural Reorientation of the Working Class* and those that followed continued this audience-assault. As Buck remarks "Each People Show production went beyond the limits. One never felt comfortable".[3] Later performances included in June *People Show 19* and *People Show 23 Shouts and Murmurs*, and in November *Shop! Mrs Butterworth*, another scripted by Nuttall.

Added to the theatre roster in December '67 was *Studies Towards an Experiment into the Structure of Dreams*, the first in a series of collaborations between dancer Graziella Martinez and the Mark Boyle/Joan Hills Sensual Laboratory which ran to 70 performances over the next few months. Initially intended as an interpretation of dreams supplied fresh each night,

The Cage Show *(image courtesy of Mark Long, People Show).*

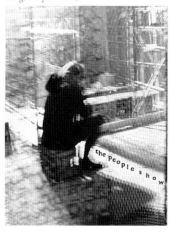

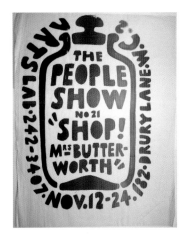

Silkscreen poster designed and printed by Biddy Peppin.

the dreamer in *Studies* failed to sleep, so the work became a double improvisation, dance prompted by – and in turn influencing – the Boyles' remarkable lightshow. The show was enthusiastically reviewed by Lorenzo Ado in *IT* in the language of the times: "The basic black room with platform and canvas backdrop fades away into obscurity and from the void emerge triple images of swishing colours. ... Each projection sequence supplies you with a subtle word from the language of the emotion of light. This emotion reaches its climax ... in the last sequence in which dancer, light, sound and props leave the banal reality of the stage and take you wherever you want to go – your imagination being your own limit."[4] David Jeffrey remembers the Boyles using glass projection-slides that had been smoked black, into which they slowly scratched a line with a pin, allowing white trails to grow and envelop the dancers, a visual entanglement. Joan Hills recalls another collaboration – *Lullaby for Cata-tonics* – in which in one sequence Graziella spectacularly emerged from a bath tipped on its side, with 'water' provided by her and Mark's fluid projections. Un-remarked by any of us at the time (did it really happen? the only evidence is a surviving poster) was the participation in at least some of these Boyle/Martinez performances of a young singer/dancer/mime artist – David Bowie.[5]

Mime had a real presence at the Drury Lane Arts Lab. Many shows were associated with the Will Spoor Mime Company. *The Art of Fugue* (from February '68) and *Animations* (October '68), featured Will himself and his partner Ellen Uitzinger, and together they led participatory workshops in mime throughout the Lab's existence. The young mime artist Baz Kershaw recalled his first encounter with Will's *The Art of Fugue*: "I was amazed by what I'd stumbled into. ... I watched the show in delighted disbelief as it unfolded in a combination of high-precision movement and low-cost technical invention. It was brilliant: irreverent, witty, subversive, rude and above all stunningly skilful and inventive."[6] Will was a true team player and enthusiastically collaborated with other younger physical theatre exponents – Baz Kershaw in *Cross Members* 'a modern parable in mime and sound'; Kershaw and Mike Dean in *Hakuin and Events in Uncle Harry's Head*, and Tony Crerar in *Experimental Mime*. Will took *The Art of Fugue* and *Experimental Mime* on tour into Europe, taking Ellen, Tony Crerar, the saxophonist Evan Parker and Lab workers-now-actors David and Philippa Jeffrey, Craig Gibsone and Martin Shann to Amsterdam and later Arezzo. David remembers: "Will had had an invitation to a mime festival in Prague in August 1968, but when we saw the Russian tanks in Wenceslas Square we guessed it was cancelled. Our fall-back was this invitation to a one-act-play festival in Arezzo … So we went – and that trip has gone down in history."[7] Will and Craig

Graziella Martinez and bath with liquid projections by Mark Boyle and Joan Hills (photo courtesy of Joan Hills).

spent a few days in an Italian prison charged with obscenity, the Christian Democrat Town Council of Arezzo being unprepared for mimed male sexual arousal. (See Appendix 3.)

Similarly, the American-born Adam Darius created what he called 'expressive mime' at the Lab by fusing classic mime with dance, and introduced contemporary themes: "drug addiction, the brainwashing of the individual by a monolithic consumer society, … subjects [that] go beyond sentimentality and nostalgia …".[8] He gained a degree of notoriety by occasionally performing completely naked. The gloriously flamboyant Lindsay Kemp, perhaps the best-remembered mime of the period, had already established himself in Edinburgh and London by the time he visited the

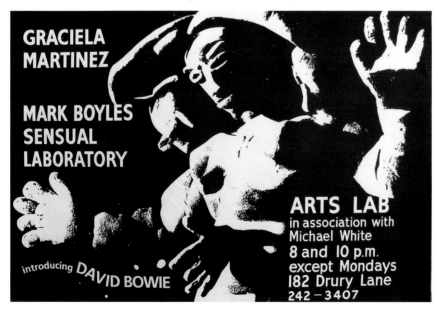

GRACIELA MARTINEZ

MARK BOYLES SENSUAL LABORATORY

introducing DAVID BOWIE

ARTS LAB
in association with
Michael White
8 and 10 p.m.
except Mondays
182 Drury Lane
242-3407

Designer unrecorded (image courtesy Andrew Sclanders).

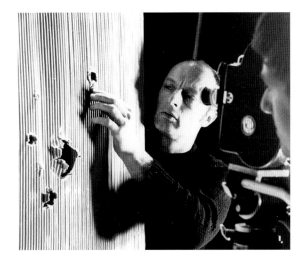

Lab, often with Bowie in tow, initially just to rehearse, later to stage his *Turquoise Pantomime* in March '69 and *White Pantomime* in May.[9]

The Lab provided the launch-pad for many other now-familiar theatrical talents. Steven Berkoff had his first solo appearance as writer/performer in his production *In the Penal Colony* in May '68, which, since it played at just 40 minutes, Jim paired with a repeat of Tutte's *Report to the Academy*, forming a Kafka double bill.[10] Berkoff expressed his delight at the success of his gamble of going it alone: "the money left at the box office, and the sheer unadulterated pleasure of thinking that I had done this myself. Nobody had handed it to me on a plate. I had ripped it out of the frustration of unemployment, and when I took my share of the takings, I just felt great".[11] He also ensured that Peter Brook, then co-director of the RSC, came to see him perform at the Lab, together with a mime hero from Paris, Jean-Louis Barrault.[12]

Above and below: Will Spoor in Cardboard Column Canon, *a part of* The Art of Fugue, *being filmed by Arthur Cantrill (photo Corrine Cantrill).*

John Grillo had Cambridge *Footlights* experience before he played at the Lab in July in his own *Hello Goodbye Sebastian* and later in another of his plays *Gentlemen I*, now with Portable Theatre.[13] He would go on to become a popular actor on stage and screen. Portable Theatre, founded by David Hare and Tony Bicât, later joined by Howard Brenton, staged its first ever production *Inside Out* at the Lab in October '68, again adapted from Kafka's writings and diaries. Bicât has described their approach: "The story was cinematic, in the sense that it consisted of a

number of short scenes with blackouts; there was no set except for four chairs, and only a few simple sound and music cues. This black and white, simplified style, with its declamatory speeches and choral sections, initially became the house style".[14] Pip Simmons set up his own company the Pip Simmons Theatre Group at the Lab, and mounted a rapid-fire sequence of productions that only a venue as flexible as the Lab could accommodate: *The Masque Routine*, adapted from *The Protagonist* by George Kaiser in September '68, followed by *Sand* written by Murray Mednik in November, *The Sonata and the Three Gentlemen*, and *Conversation Sinfonietta* (both by Jean Tardieu) through December and January, and *Ticket Office* (another by Tardieu) in May '69.

One of the most influential groups formed at the Arts Lab was Freehold, initially called Wherehouse Company.[15] Freehold was inspired by New York's La MaMa Experimental Theatre Company and initially featured Beth Porter from La MaMa, but then became associated with actor/director Nancy Meckler's own approach to physical theatre. In Autumn '68 Jim offered the new company free rehearsal space at the Lab. The actor Stephen Rea recalled the group's ambitions.[16] "The aim ... was to explore theatre in a physical, non-naturalistic way, to find means of exploring texts not dependent on language-based practices."[17] Meckler's summary of their working philosophy might equally have applied to many of the companies appearing at the Lab: "Everything was collective, that was the emphasis. Even to the point where, when we performed, we never printed the parts the actors were playing [in the programmes]. We were all anti anything to do with careers, or anything vaguely materialist ...".[18]

Wherehouse / Freehold's first production, *Mr Jello*, was staged in November/December '68, just as the Lab team was splitting, which must have added to their challenges. This was followed by *Group Juice* in May '69 and *Antigone* in August, this last staged as the Lab was winding down and the bailiffs were hovering, so again their timing was unfortunate, but they survived. Moving Being began life at the Lab as the Geoff Moore Dance Company. Moore paired up with Peter Mumford, and their first Lab show in April '68 was simply billed as 'a new experimental theatre work', but they contributed one of the last shows to be performed at Drury Lane, *Benedictus*, in August '69.[19]

Apart from Will Spoor's group, the other home grown resident company at the Lab was Jack Moore's Human Family, which began showing what was billed as *Work in Progress* in April '68. The Family was perhaps Jack's own celebration of 'humanity'; an exercise in collective self-empowerment and an expression of his own parental instinct – he saw the group very much as his own tribe. In *The Observer*, Kenneth Tynan supportively reviewed one early performance: "A dozen strong, they squat in the middle of the theatre and free-associate. Words like 'tender' 'baby' and 'lonely' lead inevitably to 'the Cosmos'. A man pointlessly smashes a cucumber; a girl invites me to close my eyes and receive a present which turns out to be a

Flier probably designed by Ellen Uitzinger (image courtesy Andrew Sclanders).

Silkscreen poster designed and printed by Ellen Uitzinger.

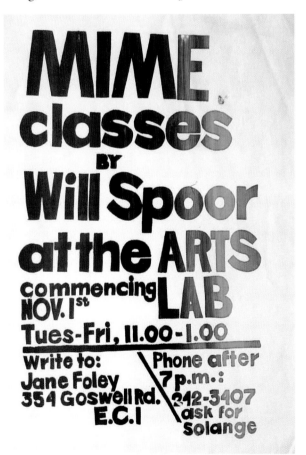

Dany Broadway and other Family members in the Human Family Bus (photo David Kilburn?).

Poster designed by John Hurford for use during the Human Family's European tour – with a space for venue details and performance times to be filled in, but in the event never used (courtesy John Hurford).

paper-clip. In whispers at first, the group reaches a deafening climax by chanting several hundred times over, the phrase 'Who are we to be here together, separated by being here together?' Members of the audience join in until this anthem of alienating sound resounds through the building". He concludes, generously: "Although I don't relish this kind of participation, I cannot deny its power".[20] Jack soon took his young troupe abroad, travelling in a bus bought by Jim and with a hired geodesic dome for performances, following the itinerant pattern of performances established by New York's The Living Theatre. In a Lab promotional leaflet printed before The Family set off, Jack wrote "The company is ... passionately devoted to anti-professionalism, underground philosophy and certain anarchist theatre techniques. The company is in no way into politics, art, drama or literature".[21] This was a sufficient rallying call for some. Jim recalled "They would pick up hitchhikers along the way who would become part of the show; they would set up the dome and show videos, people were free to stand and relate their experiences to the audience, it was rather like Living Theatre's *Paradise Now*".[22] "Today's hitchhiker is tomorrow's soloist" another flier announced; and "the ultimate aims are an Arts Laboratory on wheels".[23]

The Family's tour was certainly accident prone. John Collins witnessed one confrontation in Spoleto: "They put up their dome in the main square in a position which would have interfered with the televising of the closing concert of the Festival, refusing to move it when asked. So the authorities started removing it, and the Family tried to stop the lorry taking it away. At least one of them is in hospital".[24] Two months later, on their journey home, they were also arrested and peremptorily deported from Holland, no reason given. (Jim reports that they almost immediately set off again, heading for Lyon in France).[25] Jack himself has left no account of The Family's achievements and the group seems to have had little lasting impact on the contemporary theatre scene, but participation was probably a liberating experience for many individuals. But the Family's final return to London in November '68 led to internal disagreements about resources and policy at the Lab, described later, and following the resulting split, Jack turned most of his energies towards the new medium of video. More immediately he organised the fund-raiser *The Alchemical*

Wedding at the Albert Hall in December '68, and in one of his last and most successful engagements with serious theatre, helped stage Jane Arden's *Vagina Rex and the Gas Oven* at the Lab.

The young American playwright Jan Quackenbush's *Complexions* (February '68) was an experiment of a different kind. It featured a woman seated at her dressing table mirror, interrogating her own image, and "by means of time-compression … followed her life from childhood to death, mostly in alternate monologues as the chunks of years rush by".[26] Quackenbush had been inspired by one of the Arts Lab's neighbours – Muriel Gantry – an elderly theatrical costumier and hat maker who frequented the Lab, thoroughly at home in its bohemian atmosphere. He discussed his play with her in her tiny flat in Drury Lane, a few doors down from the Lab, hoping she might be prepared to act in it. "I noticed her makeup table with mirror, which led to my having a sudden inspiration: 'we could perform right here, in your apartment, it's a more perfect setting for the play than would be the stage'… Muriel seemed quite keen on the idea. She would read the play. Consider the prospect of performing it." He continues: "Muriel's small apartment performance space could reasonably contain just a six-eight person audience, with two sometimes standing against a wall … The show began with my knock on her door, announcing that her audience had arrived, her opening of the door, ushering us inside, settling us. She would turn off the light. We could hear her in the pitch black darkness. She was using a child's voice. When she turned on the light, she was at her make-up table, smearing gobs of rouge in circles on her cheeks – an experimental eleven-year-old. The play built from there. … Muriel had quickly memorized the script – about twenty pages. She performed solo 'off-book', seldom ad-libbed, and was so subtle in delivery – every range of emotion in her voice – that those of us in the audience could, and often did, feel fearful that we were in the presence of someone deranged! Her confining apartment, our closeness, all contributed."[27] Another audience member, James Allen, was equally unsettled, but saw "a sad old woman … proceed to deliver a gruesome, though apparently true [!] account of her life – to an audience baffled as to whether it was 'real life' or theatre".[28] Muriel loved the play and performing in it, though Biddy remembers her affinity with Arts Lab habitués being shaken when one of them stole a cherished ornament from her room.

Jan's *The Border*, a one act play about the incidental pain inflicted on ordinary people by the policing of geographical borders, played in the theatre in March directed by Jack. But before it opened, Jan himself had returned to the USA for the La MaMa production of *Complexions*, and within months had been called up and would soon be serving in Vietnam.[29] In September '69, his two short plays *Still Fires* and *Rolly's Grave* from

Contemporary portrait of Muriel Gantry (courtesy of Counter-Currents.com).

Shiela Allen in Vagina Rex *(uncredited press photo).*

the series for child actors *Once Below a Time* (1968) together with *Three Actors and Their Drama* (1926) by Michel de Ghelderode were shown at the Lab, staged by Royal College of Art alumnus Gavin Owen.

There were many one-off productions in the theatre too. *The Local Stigmatic* in June '68 was Heathcote Williams's own reading of a piece commissioned from him by the BBC. Heathcote later described it: "It's about our obsession with celebrities, which this man Alan [the protagonist] demonstrated in no uncertain way. I think it was resentment on his part, envy, tall poppy syndrome – whatever you want to call it. ... As I look back on it, this was the very beginning of the celebrity culture we now live in."[30] In July, there was a production of *The Girl with no Arms* by Richard Crane, later the National Theatre's first resident playwright; in September, *Tests* by Paul Ableman, a collection of surreal sketches written for Peter Brook's Theatre of Cruelty, and performances by members of Exploding Galaxy – Fitzgerald and friends' *Goldiefingers, Bear One and Other Tales*[31] and *Tales of Mike Chapman.*

There were plays that were immediately topical. August's *The Pope and the Pill* by Ron Seymour reflected contemporary hopes that Pope Paul VI's birth control commission of 1966 might recommend ending the Roman Catholic Church's ban on contraceptives. It did, but in July '68 the Vatican released an encyclical reaffirming the ban, hence Seymour's invective. David Jeffrey remembers the production, and "Will Spoor as the Pope doing a theatrical reading of the encyclical, attended by a burly Swiss Guard, and ending with him masturbating in front of a crucifix. Oh happy days!"[32]

There were visits by groups from overseas: The Pancho Barrera Group from Chile in April '68, appreciatively reviewed by Tynan: "Images are back-projected onto a vast white sheet – balloons, butterflies, landscapes and townscapes. Dancers appear in silhouette, their outlines synchronised to match the projections. Immense elegance … The sort of act we used to see at the Fontaine des Quatre Saisons in Paris …[and] never see in London night-clubs."[33] Bewth Improvisation Group (Bewegingstheater / Movement Theatre) from Amsterdam with an unnamed production in June '68; the Edith Stephens Dance Company in August, its appearance noted in an anonymous *IT* column: "Edith Stephens Dance Theatre from New York performed for one week at the Arts Lab, and fortunately have left town." (If authored by Jack, its rudeness was not uncharacteristic).

And in December, and undoubtedly more successful, a production by Lillia Teatern (Little Theatre) Lund, Sweden, of *Fuck Nam – a Morality Play* by Tuli Kupferberg of The Fugs.

Fuck Nam was one of several contemporary alternative theatre productions welcomed by D A N Jones in a survey article in *The Sunday Times* in its new *Colour Magazine*. "The theatre sometimes seems to be the only place where views different from the [Government] front benches can get a hearing. I'm not thinking about [Rolf] Hochhuth's *Soldiers [An Obituary for Geneva* (1967)], that stodgy German play which puts, so feebly, the case against Churchill's bombing policy, but a play about 'the rape of Vietnam' which I saw recently at the Arts Lab ... *Fuck Nam*. The Swedish actors in this interesting play swore like real Brooklyn soldiers and they wore between their legs objects which the Greeks called *phalloi* ... [It] was seriously intended to make the suggestion that the American presence in Vietnam was the result of the kind of violence that comes from sexual inadequacy."[34] Lee Harris writing in *IT* enjoyed "a hilarious scene with an American officer and his coarse wife having a meal. They spew out loud vulgarities and end up eating their own child." But, he also observed, "many in the audience were so busy trying to show that they weren't shocked by the nudity and open sexual play that I feel they must have missed the point ... Are we becoming immune in our 'coolness'?"[35] Jones, too, commented on the Lab theatre's sometimes unresponsive audience: "I wanted to talk to some actors, professionals in the Portable Theatre Company who were performing in a surrealist play by John Grillo [*Gentleman I*] ... Grillo was playing a man with two servants who believed himself to be a Roman emperor and sometimes a woman. It was funny and weird. ...'Hippies', one said, 'they ... don't enjoy themselves. They just sit and stare blankly doing their own thing'."[36]

Artists and performers from abroad often gravitated to the Lab. The curator Tanya Barson has suggested London at that time was particularly a magnet to Latin American exiles and emigrés. "[They] congregated also around the Arts Laboratory in Drury Lane. Along with [Hélio] Oiticica and Brazilian musicians Caetano Veloso and Gilberto Gil, it also attracted the Argentinean Leopoldo Mahler, who was responsible for adapting Leon Ferrari's textual-collage work *Otras palabras* into the performance *Listen Here Now!* which was staged at the Arts Lab in [October] 1968".[37] Mahler's spoken collage of political news-stories was billed as 'a news-concert for four voices and a soft drum'.

One of the most spectacular theatre productions was Arden's *Vagina Rex and the Gas Oven*, first announced in the autumn of 1968, but finally appearing in January 1969. This strongly feminist piece featuring Sheila Allen and Victor Spinetti was directed by Arden's creative partner Jack

Bond and had music by Shawn Phillips and his band The Djinn.[38] Again, Lee Harris reviewed it for *IT*. "In weaving together womblike images, using song and creative light projections, we see a regressive fantasy of woman in search of her being, only to find the strangled foetal womb. ... The most successful moments are the organic fantasies where the group becomes amoebae and nude babies crawling out of a womb. ... Sheila Allen, as the woman, the resigned sufferer, the ventriloquist's dummy, the seductress stripper, personifies beauty and intelligence."[39] The *Observer* critic Ronald Bryden was struck by the birth scene: "... an entire naked company tumbling, in writhing psychedelic lights, from the paper loins of a moaning mother-goddess almost into the audience's laps. There was talk of taking [*Vagina Rex*] into the West End, but there it would have seemed sensational. At the Lab it seemed simply true."[40]

In May '69, Lee Harris staged his *The Love Play a Lyrical Fantasy*. The *Sunday Times* described it: "there is no formal plot save that which begins and ends with a muffled, downbeat dialogue between two lovers. In between we get a series of unrelated scenes (the lovers' dreams?) with couples in several sexual permutations. ... Described as 'total theatre' ... it *does* have a bit of everything: cool, live jazz, multi-coloured lights, some stylised movement (not quite choreography), and assorted images projected on the backcloth, ...[concluding] it feels as if written to work off an obsession ...".[41] It was followed each night at 11pm by Lindsay Kemp's solo show *The White Pantomime* (stage managed by one 'David Jones', aka Bowie).

In late May was *Party* by Robert Walker, a play 'with lights, film and sound', then in June *The Striptease* by Polish playwright Slawomir Mazurek and *Revolution – de Sade – Improvisation* by North End Troupe. Later in June/July, were premieres of *Death of Kikoss* and *Ladies Day* by Gail Rademacher and a staging of *Come and Go* by Samuel Beckett (but performed by what company?). The *IT* listings for the end of the month offered just "lots of goodies, nobody quite sure what at the moment", ('goodies' being a term for which Jack had a particular fondness).

After the Lab closed, and looking back on its two years of productions, the theatre historian Peter Ansorge, wrote: "... the Arts Lab spawned a new generation of young actors, directors and writers who were refusing to work within the context of conventional theatre institutions. ... The contrasting talents and activities of the Drury Lane groups formed the basic diet of England's underground theatre network.[42] Bryden recalled "at least half of my visits I suppose were in connection with attempts to get some small grant of public money for the place, and revealed how rickety the whole financial basis of the experiment was. People working for nothing or a share of the night's takings, and the rent was always in

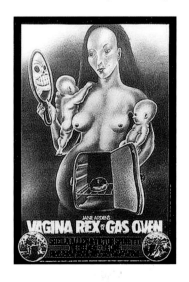

Poster designed by Alan Aldridge (© estate of Alan Aldridge, courtesy Miles Aldridge).

arrears. …. Still the half-dozen performances I saw here were of kind you wouldn't have seen anywhere else, or if you had, might have found aggressive or embarrassing."[43]

Charles Marowitz was less impressed and particularly deplored Jim's openness: "in the sixties, when we collaborated … I would find myself squirming with contempt at what I had labelled as his 'anything goes philosophy' ... Jim … has an almost boundless love of human beings … It is a sentiment that, being uncritical and undiscriminating, is irreconcilable with art. Art demands as much contempt as affection"; (a statement that perhaps reveals as much about Charles as about Jim).[44] Jim, of course, was unrepentant: "At the Arts Lab, I always believed the presentations, no matter whether they were theatre, cinema, concerts, dance or exhibitions, were secondary to the primary purpose of bringing people together".[45] 'Humanity' again.

Cast of The Love Play *photographed on the Drury Lane gallery's roof. Rear – Clive Colin-Bowler, Merdel Jordine; front – Maggy Maxwell, Jenny Harrington, (?) (photo courtesy of Andrew Sclanders).*

Endnotes

1. *London Calling: A Countercultural History of London Since 1945.* Barry Miles. Atlantic Books 2011.

2. Email 2 October 2019.

3. Buck, Ibid.

4. www.boylefamily.co.uk 'Graziella' is sometimes 'Graciela'. Graziella and the Boyles participated in Tinto Brass's interracial erotic film *nEROSubianco*, aka *Attraction* (1969) where her dance partner was Graham Stevens, who also contributed inflatable-tube sculptures as an environment in which to dance. Graham recalls: "Graziella's costume was made of multi-coloured foam rubber; mine was my body bandaged from head to toe, beneath which were concealed sachets of liquid colour. We would contrive to burst these so my costume became stained with mixing colours". GS in conversation 21 February 2019.

5. Joan Hills doesn't remember Bowie's participation, but believes it could easily have happened. Bowie had apprenticed himself to Lindsay Kemp, who paired him with the dancer Hermione Farthingale. At the end of 1968, Bowie, Farthingale and bass player John Hutchinson formed the group Feathers, and appeared at the Lab in their own right. Bowie set up his own once-a-week Arts Lab at the Three Tuns pub Beckenham in 1969.

6. Kershaw: 'Excesses of Performance', *The Radical in Performance, Between Brecht and Baudrillard,* Routledge, 1999. A rare record of Spoor at work exists in the form of two short films by the Australian filmmakers Corinne and Arthur Cantrill, *Moving Statics – Will Spoor* and *Dream: Rehearsal at the Arts Lab* (both 1969).

7. Email 31 October 2018.

8. http://www.berengarten.com/site/Essays.html Darius founded the Mime Centre in 1978 where he taught Kate Bush among others.

9. Bowie played 'Cloud' and contributed songs to Kemp's TV short *Pierrot in Turquoise* (Scottish Television 1970).

10. Berkoff's later plays include *Sink the Belgrano!* (1986), *Shakespeare's Villains* (1998). His film appearances include *A Clockwork Orange, Barry Lyndon, Octopussy, Beverly Hills Cop,* etc.

11. *Free Associations* Faber & Faber (1996), Berkoff's autobiography. His other Kafka adaptation *Metamorphosis* premiered at Roundhouse in 1969.

12. Berkoff studied in Paris at L'École Internationale de Théâtre Jacques Lecoq – which trained many later exponents of physical theatre.

13. *Hello Goodbye Sebastian* was first produced in Cambridge in 1965; at the Lab it was staged by The Brighton Combination.

14. Tony Bicât, 2007, unfinishedhistories.com.

15. "A play on 'warehouse' – the Arts Lab premises being ex-warehouse spaces – and 'where it's at'." David Cleall, unfinishedhistories.com.

16. *The Company of Wolves* (1984), *The Crying Game* (1992) etc.

17. Rea, unfinishedhistories.com

18. Nancy Meckler interviewed by Cathy Turner, June 2001 quoted in unfinishedhistories.com.

19. Their company became resident at the Chapter Arts Centre, Cardiff in 1972. Mumford would later become a celebrated stage designer and a noted director of dance films.

20. Tynan 'Shouts and Murmurs' *The Observer*, April 1968.

21. Yellow Lab flier, 1967–68 Drury Lane documents file.

22. JH – from 'notes' in unfinishedhistories.com. Jim admitted "There was a tension at the Arts Lab about the money that was spent on the touring bus rather than the Arts Lab, but Jack wanted to do the bus and I allowed him to do it", ibid. Was Jack's European bus adventure also inspired by Ken Kesey's 1964 trip across America with his Merry Pranksters in the psychedelic bus *Furthur*, soon mythologised in Tom Wolfe's *The Electric Kool-Aid Acid Test* (1968)? The dome 'a geodetic marquee' was hired from Spandrel Domes Ltd for £100 a week. [invoice, Napier.]

23. 'The Human Family in Orbit' 25 June [Napier].

24. JC postcard to the author 11 July 1968. John was travelling in Italy with a programme of films from the Filmmakers Co-op.

25. Letter I October to John (Hoppy) and Susie (Creamsheese/Zeigler) [Napier].

26. Description from the La MaMa archives website. *Complexions* also played at La MaMa NY in 1968; I played his short film *The Pigeons According to St Herbert* in the cinema, in a rare instance of departmental synchronicity.

27. JQ Email 28 March 2019. See also Appendix 4. (In *Thanks for Coming, Encore* Jim mis-attributes this play and erroneously names it *Tea with Miss Gentry*). David Jeffrey remembers Muriel declaring "the love of her life was Ivor Novello, [but] for reasons to do with his sexuality nothing came of this infatuation, and in her sixties she would shock by announcing she was 'still a virgin – and could prove it'." The complex love-lives of the Ancient Greeks were the subject of her novel *The Distance Never Changes* (1965). Towards the end of her life she wrote a memoir *Valhalla, not Elysium, My Friendship with Savitri Devi*, unpublished. She died in 2002.

28. James Allen 'The Arts Lab Explosion' *New Society*, 21 November 1968.

29. Jan's Vietnam experience is reflected in his prose-poem *Simeon in Memorium*, commissioned by John Calder for the anthology *Signature 20*. (Calder & Boyars, 1975). After Vietnam he wrote more than 20 plays.

30. Interview by Nancy Groves *Guardian*, Thursday, 12 May 2016. It was commissioned at Harold Pinter's suggestion and had played at the Traverse before the BBC's broadcast.

31. The collective author now billed as 'Fitzspeed, Jubilee and Banabel'. Fitzgerald was soon afterwards re-born as Agoshaman Ceribel.

32. Email 29 October 2018. Seymour was an Australian critic and author of the play *The One Day of the Year* (1958), a bitter take on Anzac day. He came to London in 1961 with his life-long partner, Ron Baddeley, and worked for BBC.

33. Tynan 'Shouts and Murmurs' ibid.

34. D A N Jones, 'Taking the Fringe Seriously' *Sunday Times*, Spring 1969 [undated].

35. Lee Harris *IT* 48, January 1969 rep *Echoes of the Underground*, Barncott Press 2014.

36. 'Taking the Fringe Seriously', ibid.

37. http://www.coleccioncisneros.org/editorial/statements/latin-exchanges-connections-between-and-reception-latin-american-art-britain. See also Mahler's 'Real Insurrection', his article about Colombia's 'underground' newspaper *Olvidate* (*Forget it!*), *IT* 21, November 1967.

38. Arden's *The Party* (1958) was staged in the West End by Charles Laughton. She wrote/appeared in/directed *The Logic Game* (BBC TV 1965) the films *Separation* (1968), *The Other Side of the Underneath* (1972) and *Anti-Clock* (1979).

39. Lee Harris *IT* 52, March 1969 rep *Echoes of the Underground*, ibid.

40. Ronald Bryden 'Epitaph on a Young Seedbed' *Observer* October 1969. Bryden was also a sympathetic member of the Arts Council's Drama Panel.

41. John Peter, *Sunday Times*, 18 May 1969. Before the Lab opened, Lee had staged *The Fletcher File* at the Roundhouse (5 February 1967), "based on a transcript of the murder trial. … I edited and adapted the script … and the presentational supervision was by Jack Henry Moore. …We called for the release of Roy and Alice Fletcher and the arrest of the Home Secretary. By the end of that year they were let out after serving six years of a life sentence, and the case became an underground *cause-celebre*." www.leeharris works. In 2016 Lee put himself forward as CISTA (Cannabis Is Safer Than Alcohol) candidate for Mayor of London. For 40 years (till 2016), he ran Alchemy 'the most classic headshop' in London's Portobello Market.

42. *Disrupting the Spectacle – Five Years of Experimental and Fringe Theatre in Britain* (Pitman Publishing, London 1975), based on an article originally published in *Village Voice*.

43. Bryden *Observer*, ibid.

44. *Thanks For Coming Encore*.

45. *Thanks For Coming Encore*.

Poetry & Talks

The schedule of talks and other events is probably the least well documented of the Lab's offerings, and what is listed here, culled as before from surviving weekly schedules and the 'Happenings' columns of *IT*, should be seen as indicative only of its diversity. Events tended to be programmed at the last minute, taking advantage of the coming and goings of an international roster of speakers and performers, so the schedules were often out of date as soon as they left the Gestetner on which they were printed. Jim, for example, remembers the extraordinary evening when Christopher Logue, Michael McClure and Rip Torn came together and read poetry. And this performance certainly happened, for Nicholas de Jongh also remembers the occasion and says they "spoke Blake and Shakespeare to an audience of 70", but no paper record of it appears to have survived.[1] (None of us involved in planning events at the Lab felt any need to keep records; we had little interest in saving materials for posterity, and in any case we were just too busy.)

DICK GREGORY relaxes after his press conference at the ARTS LAB with his old friend JAMES BALDWIN. Baldwin in and out of London the last few weeks is now in Hollywood to discuss his film script of the life of MALCOLM X but will return shortly to his house in Chelsea.
Photo: Horace Ove

News report from IT *n26 February 1968.*

But Jim's interest in books and ideas combined with the contents of his address book ensured there was a steady stream of contributors. Following Ted Joans, poets who read their own work at the Lab included Robin Lee[2] together with T G Thomas, listed as "reading from current and projected 'head pieces'"; John Esam, one of the organisers of the Albert Hall *International Poetry Incarnation* (1965) reading from *Orpheus and Eurydice* in June;[3] the Australian poet and children's author Nigel Gray in July;[4] Len Grant, a poet discovered by John Peel in September and in October two Better Books stalwarts – concrete poet Bob Cobbing and composer-poet Anna (Annea) Lockwood, these last indicative of the many potential crossovers between the spoken word, performance and music in the schedules. In early February '68, the comedian Dick Gregory held a press conference at the Lab to announce his bid for the US Presidency,[5] attended by James Baldwin (they were photographed together by Horace Ové, and a year on, Horace's film *Baldwin's Nigger* based on Baldwin's lecture at the West Indian Student Centre attended by Gregory, would be given one of its first screenings at the Lab.[6]

In July '68, the poet-publishers Asa Benveniste and Stuart Montgomery

43

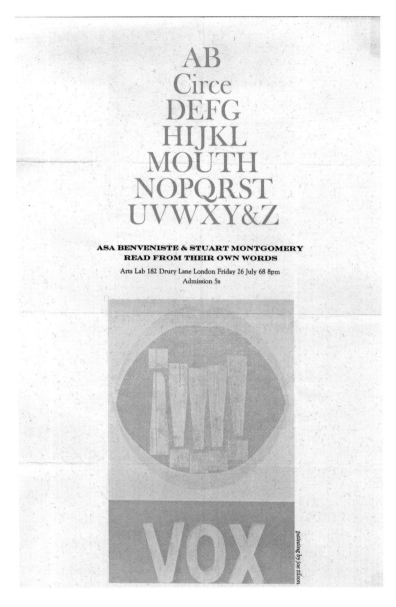

AB
Circe
DEFG
HIJKL
MOUTH
NOPQRST
UVWXY&Z

**ASA BENVENISTE & STUART MONTGOMERY
READ FROM THEIR OWN WORDS**

Arts Lab 182 Drury Lane London Friday 26 July 68 8pm
Admission 5s

VOX

painting by joe tilson

Poster designed by Joe Tilson. Haynes Archive, Napier

'read from their own words', and probably offered for sale some of their recent publications.[7] In the same month, Exploding Galaxy member Michael Chapman's poetry reading became a happening: "I … commissioned Graham Stevens to make me a large inflatable mud-bath, into which I deposited one ton of prime earth. The one meter high pool was placed in the foyer and slowly filled from a hosepipe to produce a thick muddy paste. The event was accompanied by a recording of the *Hippopotamus Song* by Flanders and Swann. Anyone around was invited to take off their clothes and jump into the mixture to enjoy the experience."[8]

'An evening of Ghetto Poetry' in August '68 featured work by Courtney Tulloch and Marc Matthews.[9] There were also poets from abroad. The Peruvian poet Antonio Cisneros read in October '68; he would later be showered with awards in Peru, Chile and France, and his appearance at the Lab is further evidence of its attraction to artists from South America. May '69 saw readings by the Liverpool poet Brian Patten,[10] the Camden-based poet-publisher Dinah Livingstone[11], Hugo Williams, a good friend to The Exploding Galaxy and also a *Times Literary Supplement* columnist and critic;[12] Libby Huston, poet, also a celebrated botanist and rock climber,[13] and another publisher, Peter Mayer of Avon Books, later CEO of Penguin Books. Edward English, the 'vagabond black poet' from Selma Alabama, appeared in June.[14]

The talks at the Lab tended to be more predictably 'underground' in subject matter, more closely reflecting the appetites of readers of *IT* and *OZ*. Typical offerings included *The Nature of Consciousness*, a joint lecture by painter/cosmologist Tammo de Jongh and author/alchemist Richard

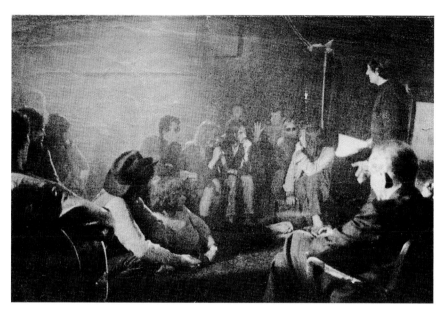

Photo by Paul Keeler accompanying 'Felix Scorpio's news report 'Alex Trocchi Gives a Party', IT n 55, May 1969.

Gardner in July '68 ,[15] and another in the same month by T C Stewart, listed mind-bogglingly as '*The Beginning and the End', Uroboric Incest, the Structure of Myths*![15] August saw a 'Macrobiotic Congress with 30 visitors from Japan' and a meeting called by the Yippies to plan a London demonstration to coincide with the Democratic Convention in Chicago. In the same month, The Antiuniversity made the Lab its temporary base.

In September, there was a series of three lectures on *Drugs and Higher Consciousness* by Dr Allan Cohen, a Meher Baba enthusiast and former student of Timothy Leary and Richard Alpert at Harvard.[16] There were many more, now undocumented. Just one such occasion in April '69, billed as *Alex Trocchi's State of Revolt*, has left a permanent trace, at least in fragment, thanks to a grainy black and white video record, probably shot by Jack. Present were R D Laing, William S Burroughs, Ken Kesey, Dan Richter, Feliks Topolski, Shawn Philips and others. One can divine little of Trocchi's own 'revolt' from the video – he apparently just read poems – but an *IT* review reports that Burroughs joined in and talked about 'underground media in the USA' and Laing about 'soft drugs', the event apparently carrying on for some hours. Phil Shepherd, then working as a theatre technician, remembers "bringing the lights up, and Burroughs walking on stage, the 'invisible man, explorer of souls and cities', as Ginsberg called him. How often did he speak in public at that time, let alone in London? The room was packed with counterculture freaks from far and wide, a full house. Burroughs read from *Junky* and *The Naked Lunch*. There was a Q&A of sorts. Question from the floor: 'William, can you tell us, what should we do?' Burroughs (after a pause): 'Put on

a suit and disappear.' Nervous laughter in the room; I was left wondering what he knew that we didn't."[17]

In May '69, Jim announced what would prove to be the last series of six Sunday talks. These should have been memorable (if they happened), for they featured the noted '60s activists the *OZ* editor Richard Neville, the writer and Black Panther activist Eldridge Cleaver, London Filmmakers Co-op founder-member and McCarthy anti-Communist trials witness Harvey Matusow[18] and professional bohemian Jay Landesman, Jim listing himself as adding 'verbal happenings' on the remaining two dates.

Endnotes

1. 'Lights Out for the Arts Lab', *Guardian* 21 October 1969. McClure was in London to see his play *The Beard* directed by Rip Torn, playing as late shows at the Royal Court Theatre.

2. *The Posthumous Report* (1968).

3. Published as *Orpheus: Eurydice – Songs Late and Early 1954–2006* (2009).

4. *Laugh, You Buggers, Laugh: Selected poems 1967–1979*.

5. Jim was apparently his European campaign manager.

6. Horace Ové b 1939: *The Art of the Needle* (1966); *Baldwin's Nigger* (1969); *Reggae* (1971, for BBC); *Pressure* (feature film, 1975), et al.

7. Besides his own published poetry – *Poems of the Mouth* (1956) *Count Three: Poems*, (1969) – Benveniste was a noted book designer and his Trigram Press published works by B. S. Johnson, Tom Raworth, Jim Dine, Jeff Nuttall, Ivor Cutler and many others. Montgomery's Fulcrum Press published the works of the Modernist poets including Basil Bunting, Gary Snyder, Allen Ginsberg, Ed Dorn and Lee Harwood and two collections of his own poems, *Circe* (1969) and *Shabby Sunshine* (1973). Montgomery was also involved in the contemporary Antiuniversity of London, 49 Rivington st., where (during its brief life) he, Bob Cobbing, Joseph Berke and others organised talks and events in a very arts lab like environment.

8. Michael Chapman interviewed by Jill Drower in *99 Balls Pond Road,* Scrudge Books, London 2014.

9. Courtney Tulloch had been involved with Hoppy, R D Laing and others in The London Free School in Notting Hill, and helped set up the first Notting Hill Gate Festivals with Michael X and the novelist Colin MacInnes. He also initiated Defence, the Black legal advice project, set up the community newspaper *The Hustler* and briefly edited *IT*. Marc Matthews became closely involved with the Caribbean Artists Movement in the 1970s alongside Linton Kwesi Johnson and others.

10. *Little Johnny's Confession* (1967).

11. Katabasis Press *Beginning* (1967), *Tohu Bohu* (1968), etc.

12. *Symptoms of Loss: Poems* (1965).

13. *A Stained Glass Raree Show* (1967). She was married to Mal Dean till his early death in 1974.

14. A true bohemian, English died in 1973 aged 58, leaving a verse-text autobiography *Nature's Creation, This is Edward H. English's Life Story. Vagabond Poet.*

15. *Purpose of Love*, (1970).

16. He later went on to publish the more sober sounding *The City as an Image of Man: a study of the city form in mythology and psychology* (1970).

17. Entitled *The Art of Self Discovery*; *Occultism v Mysticism*; *On the Journey to the East*.

18. PS Email 8 August 2019. The event was proposed to Jim by Lynne Tillman, whom Jim had met at Shakespeare & Co in Paris, and had "invited to come to London to assist me in running the Lab." [www.jim-haynes.com]. It was reviewed for *IT* (25 May) by Felix Scorpio [Felix de Mendelsohn] as 'Alex Trocchi Gives a Party'. Felix, too, describes Burroughs' contribution: "His suggestion that the time had come to shave off beards, cut hair and generally get out of uniform, to become invisible like the French Resistance, was very central to the idea of Revolt and the tactics it requires".

19. Matusow was also famous as inventor of the stringless yoyo, which made him independently wealthy. He was then married to the composer Anna Lockwood.

Music

The Lab's music programme was equally eclectic, reflecting not just Hugh Davies's interest in Modernism and commitment to first performances of new music by young composers, but also the Lab patrons' enthusiasm for anything unusual or experimental. A schedule from July '68 rationalised the spread: "We are planning to have music every evening at 10.30. Tuesday Jazz, Wednesday folk, Thursday pop, Friday Indian and other oriental music, Saturday various kinds of music, Sunday new music … We are planning to use these evenings for the musicians to talk about their music and experiment with new ideas, providing a music workshop where people can go and listen as well."

Among Hugh's Sunday offerings was one in May '68, tantalisingly billed as 'Morton Feldman, Earle Brown, Christian Wolff in person'; all three 'in person'? Or more likely, it was Wolff playing works by all three, but who knows? Such were often the ambiguities of the Lab's printed fliers. Frequently, crucial details were missing. 'Sun 14 July '68 – Concert of Experimental Music by English Composers, Improvisational music, Electronic Music, Happenings, piano music etc.,' this repeated on the two following Sundays. These were live performances, as one surviving programme note informs us,

```
          ARTS LABORATORY SCHEDULE
       182 DRURY LANE  W.C. 2.
              242 3407/8

EXHIBITIONS
Phenomena  by Nick Riddihaugh and Reg Beach  until July 21st
Paintings by Barbro Lindt until August 4th.

THEATRE

Hello Goodbye Sebastian by John Grillo from 10th July
until 14th July at 10.00 from 16th July until 21st July
at 8.30 double billed with The Girl with no arms by
Richard Crane.

Will Spoor Mime Theatre with Tony Crearer at 8.45 until
21st July

Lecture to an Academy by Franz Kafka with Tutte Lemkow
at 8.30 on Fri, Sat and Sun nights.

People Show, Shouts and Murmours for 2 weeks from July 23rd.

MUSIC

Indian Dances at 10.30 one night only on Sat 13th July
14 dances by Nrityalamtar T.R. Azad, 14 dances b y
Ushar Divakar.

Sun July 14th at 6.00 --8.00 a Concert of Experimental
Music by English composers.  Improvisatinnal music,
Electronic music, happenings , piano music etc.

Sun. July 21st at 6.00 - 8.00 Concert of Expeimental
Music by English composers.

Sun July 28th at 6.00 - 8.00 Concert of Experimental
Music by English Composers.

We are planning to have music every evening at 10.30

             Tuesday will be Jazz
             Wednesday       Folk
             Thursday        Pop
             Friday          Indian and other oriental
                             music.
             Saturday        Various kinds of music.
             Sunday          New music.

We are planning to use these evenings for the musicians to
talk about their music and experiment with new ideas,
providing a music workshop where people can go and listen
as well.

POETRY

Poetry Reading by Nigel Gray at 11.00 on Sat 13th July

Poetry Reading by Michael Chapman at 8.00 on Sat 21st July.

Poetry Reading by Asa Benveniste and Stuart Montgommery
at 8.00 on Fri. 26th July.

There will be poetry  readings every Sunday evening in
Theatre No. 2.
```

25 AUG 1968

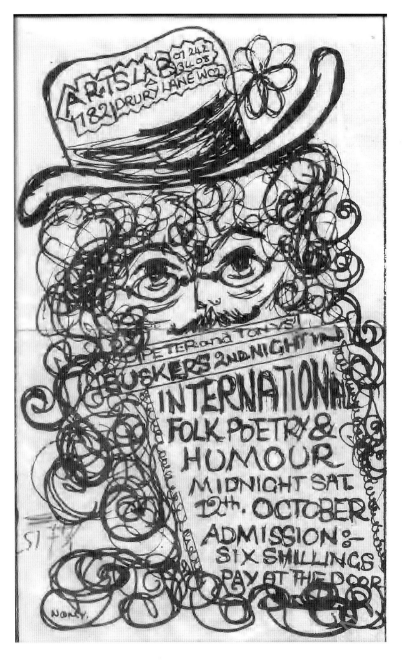

Flier from October 1968 (Haynes Archive, Napier).

but there were similar entries throughout September and October, so it seems probable that some were of recorded music only.

An entry for 24 August cryptically lists 'Experimental, phonetic and concrete by Lily Greenham', seriously underplaying the significance of the event. Greenham was already a senior figure in the European avant-garde, a generation or two older than most artists who appeared at the Lab. In the '50s she had been part of the Wiener Gruppe in Austria, performing experimental theatre and poetry; in the early '60s she had been in Paris making op art pieces as part of the Groupe de recherche d'art visuel. In London, where she would base herself permanently from 1972, she began to record her own sound-poems, electronics and multi-tracking and tape-loops working with Hugh, Max Eastley, Bob Cobbing, the BBC's Radiophonic Workshop, and many others.[1] So this was a rare and early UK appearance.

In October, there were 'Buskers … International Folk, Poetry and Humour'; Ron Geesin in Concert, and Toop repeating his Satie *Vexations* marathon, which possibly prompted, in December, 'the first performance of a new composition by Charles Mitchell lasting 24 hours', a composition then unnamed and now probably lost to history. Before that, and surely more memorably, there was a piece by George Brecht, *Suitcase Eclipse* performed by the remarkable line-up of Mark Boyle, Cornelius Cardew, John Tilbury and Christopher Hobbs, presumably assembled by Hugh.[2] It was followed by Brecht's *Water Yam* with many of the same performers a month later.

AMM,[3] the improvisation group founded in 1965 which was led initially by guitarist Keith Rowe[4] and later joined by Cornelius Cardew, played frequently at the Lab in the autumn of '68. So did the People Band, which had grown out of Continuous Music Ensemble, and which played at the Lab in September '68, just days before they recorded their eponymous album at the Olympic Studios.[5] Indeed the last few months of '68 at the Lab might have been called an autumn of musical improvisation. In addition to AMM and the People Band, there were regular gigs by the Spontaneous Music Ensemble (SME) and the Third Ear Band, two further dedicated *improv* exponents. SME (founded in '66) was a jazz/new music group with a changing membership; key participants at the time were John Stevens (drums / cornet) and saxophonist Evan Parker.

The Third Ear Band had its origins at the London Free School and then the UFO Club, appearing at the latter as The Giant Sun Trolley, and typically inviting members of the audience to participate in the music-making in the spirit of the Exploding Galaxy and the Human Family. Their improvisations drew upon Eastern as well as European folk forms, mixed with contemporary experimental techniques, and they were championed on-air by John Peel, who played jaw harp with them on more than one occasion.[6] Peel himself contributed a regular late night show of recorded music to the Lab's schedules from August '68 in parallel with his new BBC Radio 1 show and his *IT* column, *The Perfumed Garden*. The last experimental music performance at Drury Lane would seem to have been that given by Musica Electronica Viva visiting from Rome in May '69, an acoustic/electronic improvisational group noted for their

Ad in IT *n 21 November 1967.*

Below left: *Occarinas made by John Taylor.*

Below right: *Silkscreen poster designed and cut by John Taylor and Biddy Peppin.*

use of the new MOOG synthesizer linked to the human voice.

Folk singers at the Lab included Judy Fisher, Alfredo Ponce 'Mexican folk singer' and Ian Hardie, who offered 'mainly traditional English songs' in September '68.[7] In the same month 'Smudger, folk guitarist' offered *Ballads of Bod & Bottle,* and Gary Farr appeared with his with his R & B group. Fisher appeared again in a double bill with the jazz group The Gordon Beck Trio in late shows in September, while in October, Purple Haze, a Dutch blues band played. In April, the Persian artist 'Susha' offered an evening of poetry and songs. There was also music accompanying dance: in July, 'Indian Dancing'; in September dance and music by 'Eranga and Prianga from Ceylon', and in October, 'Indian music for veena and mridangam', Hare Krishna chanting and a flamenco concert by Demetrios Kastaris, (apparently better known for his Latin-Jazz fusions).

At the end of October '68, John Taylor gave a harpsichord recital together with the poet John Tungay who read Basic Bunting's *Briggflatts* (1966). Taylor was a noted instrument maker of harpsichords and ocarinas, and an exhibition of his instruments was held at the same time. In December '68, David Bowie appeared with his short-lived multi-media trio *Feathers*, performing songs by himself and Jacques Brel, and experimentally featuring tape recordings and mime.

Endnotes

1. Her best-known composition *Relativity* was recorded in 1974.

2. 17 November 1968.

3. The basis of this acronym is shrouded in mystery.

4. Malcolm Le Grice was a friend of Rowe and would continue to work with him throughout his career, notably in later live film/computer-imagery/music collaborations. "Keith Rowe and I were at Plymouth Art College together (1959 to 1961) ... We both played in the Mike Westbrook Jazz Band in Plymouth and in London at the Mercury Theatre in Notting Hill. I returned to link up with AMM at the short-lived Kingly Street Gallery where I played two gigs with AMM – using repeating sound with live recording and playback – Cardew was on piano at those gigs – I also rigged a lighting system driven by my amplifier loudspeaker output. I also showed *Castle 1* at Kingly Street where Jeffrey Shaw showed his projections through translucent screens." Email June 2018.

5. Produced by Rolling Stone Charlie Watts with a line-up including pianist Mel Davis and trumpeter Mike Figgis. Figgis would later direct *Leaving Las Vegas* (1995), *Timecode* (2000), *The Battle of Orgreave* (with Jeremy Deller, 2001) et al.

6. They also opened *The Rolling Stones Free Concert* at Hyde Park on 5 July 1969.

7. (Can this be the Ian Hardie [1952–2012] who would become one of Scotland's best-loved folk fiddle players? He would have been 16 at the time, but apparently took to the road early on).

The Gallery

Perhaps surprisingly, painting and graphic imagery featured strongly in the gallery's schedule at Drury Lane, which may reflect Biddy and Pam's own practice at the Slade, though their curatorial policy was deliberately eclectic. Biddy later recalled "after the authoritarianism of the Slade, Pam Zoline and I felt that 'art' could / must manifest itself in a wide diversity of forms, so we tried to avoid any narrow ideological or aesthetic involvement".[1] Also, "we tried to show only work that was too uncommercial in its approach, too informal, or too far out to be shown anywhere else".[2]

Head Drawings *aka* Drawings on the Wall, *November '67.*

The *Head Drawings /Drawings on the Wall* show (November '67) was democratic exhibition-making taken to extremes, but any hope that a home-grown Robert Crumb (or Cy Twombly) might emerge from among the offerings drawn on the walls was disappointed, though there were some striking images, and we were largely spared toilet-wall graffiti. Other attempts at participatory exhibition-making included '*Masks* – please make one, any sort, and bring it along' (June '68) and a four week

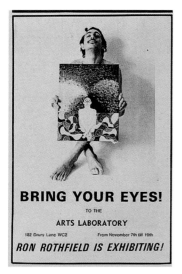

Ad from IT *n 20, Nov '67.*

Head Drawings *aka* Drawings on the Wall, *November '67.*

Silkscreen Printing Co-op was advertised for the gallery in September '68, but may not actually have taken place. The idea was probably inspired by June's 'Special from Paris – *Exhibition of Student Revolutionary Posters* for two weeks', a display of the urgent silkscreened slogans and graphics generated as part of Les évènements de Mai '68.[3]

Ron Rothfield's *Bring Your Eyes!* in November '67 and a show of paintings by Terry Pastor in January '68, recognised some of the imaginative imagery associated with the '60s music scene. Rothfield, who showed detailed psychedelic paintings, seems to have abandoned image-making almost immediately, for he found fame and a new name just a year later as the flute player Raja Ram.[4] Terry Pastor's disturbing biomorphic paintings were produced mainly with the then still novel technique of the airbrush. But he very quickly became well known for his record-cover artwork, notably for David Bowie's *Hunky Dory* and *Ziggy Stardust* albums.[5] A show listed as *House paintings by Peter Banks* (October '68) may have been juvenilia by the guitarist and founder-member of Yes, who was known to have been interested in art. June Cramer, musician and landlady to many rock stars, showed drawings in the restaurant in March '68.

Some of the exhibitions of paintings were the result of direct or indirect contacts with the Slade. Pam Zoline showed her own large image-text paintings *World Apple* including *100 Dollars*, a collage of 100 1-Dollar notes in January '68; the Australian ex-Slade painter Rosemary Johnson showed in April; in August there were large paintings by the Indian artist Vivan Sundaram, who had been a pupil at the Doon School in Gujarat before attending the Slade, and worked with R B Kitaj while in London. Malcolm Le Grice showed paintings and films in October/November '68, in a pivotal show for him entitled *Location? Duration? Films Films Paintings Plus* marking his transition from canvas to screen. Nearly 50 years later, Malcolm would recreate the show's mix of media and evoke its impact in his contribution to the exhibition *Film in Space* curated by fellow film artist Guy Sherwin (Camden Arts Centre, 2013).

In January '68 there were sculptural installations by Andrew Greaves and Roderick Stokes who later worked together in design. February saw *Soft Sculpture by Maureen Robinson* / aka *Soft, Hard, Electric*, which, in a rare acknowledgement of the Lab's unusual context, she accompanied with the sign: 'use things as you wish. They make

splendid seats'. In March, the Swedish metaphysical painter and sculptor Peter Tillberg showed paintings of details of interiors, close-ups of radiators and grilles, appropriately shown stapled directly onto the walls. Another painter from Sweden, Barbro Lindt, showed in July and in August there were *Photopaintings* by Bruno Schweikert.[6] Geoff Edwards, then at the RCA, showed paintings in November (he later taught painting at Chelsea School of Art), and at the end of the month *Paintings and Constructions by Craig Gibsone*, Craig's swansong before leaving for the Findhorn Community.

Several exhibitions were billed as 'environments' (then a new term). The first, untitled, in February '68 was by young architects Saleem Bukhari and Dave Robson, which consisted of – if I remember correctly – an assemblage of white blocks. (Saleem's memory is equally vague: "we had discussed using architectural models and sketches to show/model reality. Maybe we put up some architectural models).[7] On another occasion, Saleem was struck by the enormous size of contemporary printed posters and organised a show of 'Street Art'. "I had managed to get some actual posters and plastered them on inside walls of the Lab. I suppose it was in imitation of Duchamp/Warhol?" Similarly, in the spirit of the age, he showed 'Soap Bubbles'. "I had worked out a way of making large soap bubbles, drawing them out like socks. So we played around making these one evening"[8] Another environment, in July, was simply listed as '*Phenomena* by Nick Riddihaugh & Reg Beach'. And yet another, 'An Environment from the Kings Lynn Festival by Sandy Robertson' appeared in October. What were they? – I haven't been able to find out.

Among the most memorable installations was one by Jeff Nuttall in July '68. Like his occasional frenzied cartoon-strips in *IT*, and like his aggressive scenarios for the People Show, Jeff's environments and sculptures made from stuffed garments and discarded and broken objects, with their references to dismembered bodies and instruments of torture, were intended to disturb. There was no boundary for him between one medium and another, so the sculptures often found another role as settings for his plays. Seen on their own, they were also shambolic, clearly improvised and impermanent, which increased their impact. Describing his multimedia involvement with the People Show, Jeff had written earlier: "I'm perpetually groping for some idiom which may contain my various ways of working – the visual thing, the word thing, the sound pattern thing, the residue of the old jazz-band days, the bomb obsession and sex obsessions … looking for an act of ritual *through* and *at* which people can *become*. Definitions applied to art piss me off. I paint poems, sing sculptures, draw novels."[9]

Another environment that required an element of performance, so took

Ad from IT *n 32 May–June '68.*

Silkscreen poster with applied film-stills (and sometimes an added hanging black plastic strip) designed and printed by Malcolm Le Grice and Biddy Peppin.

Peter Tillberg Interior, *stapled to the gallery wall (photo David Kilburn).*

Assemblages from Jeff Nuttall's untitled exhibition, July '68, some photographed on the pavement outside by David Kilburn.

place in the theatre, was *Cocoon – a Soft Environment by Peter Dockley* (November '68). Peter recalls "I hung four large cotton tarpaulins from the ceiling, each one parallel to one of the four walls; they were hung in a tent-like manner, with the tops narrower than the bases so that they bulged towards the floor. The tarpaulins had previously been painted with a thick black tar-based paint, so the smell in the cocooned room was strong. Hanging in the centre of the space was a net 'bag' containing a female figure [Merdel Jordine] in the foetal position. During the course of the performance she unfurled, released herself from the net bag, and then 'danced' while still suspended from the ceiling."[10]

Ian Breakwell's early work *Face History,* staged in January '69, also took place in the theatre. This was a slide-tape piece that developed into a process-art performance: "Onto the screen were projected a series of slides taken from a photograph album showing Ian Breakwell's face from the age of one year old to the age of 25 years old; while they were being projected a tape recording of instructions for learning the French language was being played and continued throughout the event. [Then] another 30 slides of Ian eating a meal were projected onto the screen. Then a 12ft square slide projection of Ian Breakwell's 25 year old face appeared on the screen in close-up; Ian then left his seat in the audience and using a needle and black ribbon, proceeded to stich and sew the projection screen, stitching the face on the screen until no more black ribbon remained, and the event ended."[11] Film-maker Mike Leggett took photos during the performance which were later blown up to a similar size for exhibition and sale. (Ian's sequence of self-portrait images would feature again and again in his work over the next four decades).

Sketches from a Hunter's Album, an installation by St Martins sculpture students, was staged in May '68.[12] Mo Throp remembers: "One of our group, Ian Duncan, found a supermarket that was throwing away its display cabinets so we 'acquired' them and used them to display our work. Seven of us: John King, Ian Duncan, Mo Throp, Sandria Wheeler, Terry Kester, Ken Newlan and Sheila Dempsey made work in response to this opportunity to produce work outside of the oppressive and negative experience of our course. ... We did not supply a catalogue or text. Terry Kester made polyester resin foot and hand prints which he installed in the

toilets. Ian Duncan made tiny landscapes which one needed a magnifying glass to see. Ken Newlan made polyester resin casts of chicken's eggs in various colours which looked like boiled sweets. Mo Throp made wooden cut-out clothes which she hung on the display cabinet rails and Sandria Wheeler made resin casts from jelly moulds. ... The overall impression was of a rather down at heel supermarket selling goods [...] in stark contrast to the gallery art of our tutors at St Martins."[13] John King adds: "... For my part I had gone back to absolute basics, dust, to be precise. Sawdust, piles of hair, broken bits of plaster – pretty rubbish! Hoped to sell it by weight – of course no one purchased any. ... All things seemed to be up for challenge in the world at that point, so why should sculpture be any different? Why did it have to be bits of steel welded together or fibre-glass painted with Dulux and called something mythological?"![14] (Biddy recalls that the supermarket shelves seemed to invite visitors to help themselves to whatever was displayed on them, so that by the end of the week few of the original objects remained) (see Appendix 6).

Face History *(1969), contact sheet of Mike Leggett's photos (courtesy Anthony Reynolds Gallery).*

Poster designed by St Martins students for their exhibition in May '68.

Drama in a Wide Media Environment, an earlier show by Malcolm Le Grice in August, was probably the first gallery installation in the UK to explore the mixing of live and transmitted video imagery.[15] Malcolm was then working part-time at Goldsmiths College which had invested in a CCTV unit which he managed to borrow for the show, which he described as "two weeks of constant performance",[16] in other words, continuous live exploration. "[Included was] an improvised 'happening' with newsfeed from the Russian intervention in Czechoslovakia."[17] There was also a performance element. "The idea of the feedback loop was central to the installation, where the audience encountered across two separate spaces two posed tableaux of performers ... In each space one group was present in person and the other on the monitor transmitted in live replay by a camera from the room next door. An image mixer was used to control the destination of the images, converging them and superimposing them, fading them in and out from screen to screen." As he was to describe, with an accompanying diagram, in the German art magazine *Interfunktionen 4*: "all present, except the image mixer, are asked to divide into two groups and go to separate spaces where neither group can see the other ... a number of scripts and notations were used during the two weeks".

Roelof Louw's *Soul City* was the first of several conceptual shows. In April '68, John Latham showed *Disappearing Images*, a collection of his motorised roller blind paintings in what was probably their first public showing. These large works, shown vertically and horizontally, were made to be seen both rolled-up, unrolled and stages in between, and in their movement, and with their faintly sprayed vertical bands of colour, forced the issue of 'time' in static painting. The Lisson Gallery, which now sells them, gives this description: "[T]he near-invisible tiny dots made by the [spray] gun hover on the verge of existence, suggesting 'a coming into being' when they accumulate with others; and by rolling the canvas up and down, Latham was able to make painting a temporal exercise in a process analogous to memory, aimed at exemplifying the experience of past, present and future".[18] Latham's own interpretation is characteristically even more thought-provoking (surely, the purpose of his art?): "By rolling the painting over a barrel one finds the painting revealed in the way we experience a 'now'. The 'then' and the 'to come' are not

John Latham, Untitled (Roller Painting) *1964. Photo David Kilburn (© Estate of John Latham & Lisson Gallery).*

manifest. But with this way of presenting a work, the 'always there' is actually there, physically."[19] At the time, these works appealed to Pam and Biddy as examples of art that was both questioning and manifestly un-sellable; they are now prized, wholly commodified museum specimens. During his show, we screened his film *Speak* (1966) in the cinema, itself an enigmatic splattering-of-dots-in-time.

In late May '68, the Lab staged what has proved to be one of its most written-about exhibitions, though at the time it was scarcely noticed. *Four Thoughts* aka *Build-Around*, was John Lennon and Yoko Ono's first joint show, taking place just weeks after the couple began living together. Biddy recalls Yoko's proposal: "She was not prepared to say what John's work, or hers, would be like, and insisted that everything must be shown anonymously. We were happy to agree, since to have John and Yoko showing at the Arts Lab was fantastic, even if no-one was to be allowed to know that the work was theirs.[20] We agreed that the exhibition was to be put up on the morning of a specified day. I arrived on time, but the pieces had already been delivered, not by Yoko in person, but by someone else, who had then left. John's piece consisted of parts of a broken drawer ... the front and two sides. I can't remember

anything about Yoko's pieces, except that they, too, were 'found objects'," possibly a version of *Mend Piece;* deliberately broken crockery displayed alongside tubes of glue.[21] Biddy continues: "There were no instructions as to how any of them should be shown. … Artists who showed at Drury Lane were responsible for their own displays. Normally they were very happy with this arrangement, and put a lot of effort into presenting their work in unusual ways. … Without instructions from Yoko or John, and without resources such as exhibition stands, we put the pieces, unlabelled, on the floor. During the week of the show … my main concern was to prevent the works from being mistaken for rubbish and thrown away."[22] As seemingly discarded objects littering what was the Lab's primary meeting space, the intended conceptual challenge of mentally 'building around' the drawer-wreckage and 'mending' the divided objects, was all too easily overlooked. (Biddy reflects that this episode at least taught her something about the importance of exhibition contexts.)

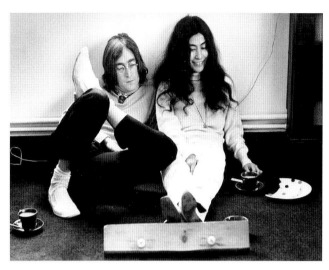

John & Yoko with Build Around *photographed by Jane Bown not at the Arts Lab but in the Apple offices.*
© Guardian News and Media Ltd 2020.

Another conceptual show in September, the two-day *Art event Box 1* by the Catalan artist Guillem Ramos-Poqui, involved 'a box, a happening, a selection, a poetry reading'. Included were what he called 'photographs of ideas', collections of found-things linked together by their placement in shallow boxes. These were (relatively) safely displayed on tables and in a display case of a sort, an abandoned glass-fronted commercial chiller cabinet (left by the St Martin's group?), wholly appropriate to his show's theme.[23]

A visually spectacular show was February '68's display of *Signals* by the Greek artist Takis (Panayiotis Vassilakis). Takis had started to show a range of his kinetic works at the Indica Gallery, which closed in 1967 leaving one of his backers, Jeremy Fry, with a number of unsold flashing-light sculptures. Fry, a friend of Jim and a wealthy entrepreneur, liked the idea of art being sold as multiples in unlimited editions and set up *Unlimited*, to design and manufacture Takis's *Signals* to be sold cheaply and in quantity.[24] The Lab show was their first outing. Selling was of course a compromise for Biddy and Pam, but the notion of 'unlimited' appealed, and set Biddy on a quest to see if an exhibition might be mounted in which *all* the objects on display were multiples and preferably produced in unlimited editions. This eventually resulted in an Arts Council touring show, *Three to Infinity – New Multiple Art*, first shown at the Whitechapel Gallery (November 1970 – January 1971).[25]

Lab-worker Dany Broadway with Takis's Signals, February '68.

Spectacular too, in a wholly different way, was *The Self x 12* in March '68. This was a show of paintings and drawings by psychiatric patients organised by art therapists John Henzell[26], Rupert Cracknell, Carol Schmorleitz and Elizabeth Weir. Almost as moving as the vivid, disturbing images, some clearly agonised self-portraits, were the testimonies and stories by some of the artists (many identified by initials alone), gathered in the roughly Gestetnered eight-page gallery-guide. They were introduced with this preface: "*The Self x 12* is about the artistic experiences of twelve patients at hospitals on the outskirts of London. These experiences are unique to the self who interpreted them in paintings and sculptures, but as a totality they are not any different from any artistic expression, only maybe a little more 'real'. The hospital is a microcosm of society where a [person] goes to grapple more directly with Who am I, Where am I, What am I doing ... here."

Disgracefully, I cannot remember much about the works on display in June's *The Film Exhibition* which the schedules tell me had contributions by Tony Scott ('Scottie', I suspect, not the future Hollywood director), Tony Sloman (film editor and later BFI governor), Malcolm, John Collins, Raymond Selfe and me. There were old projectors on display, I'm sure; classic film posters probably, and I do remember silk-screen stencilling the Lab's felt flooring with a bright yellow version of the Paramount Pictures logo – the mountain and circle of stars – for which I had a particularly fondness at the time.

In the middle of that show, and again in August, Scottie (noted for dressing in pyjamas and sporting a fine 'afro' of bright orange hair) installed a portable 35mm projector in the Gallery and showed his *Longest Most Meaningless Movie in the World* (1968–), a roughly five-hour random assemblage of footage garnered from Soho cutting room waste bins, endlessly repeated shots included, which became a marathon of reel-changing as the single projector could only accommodate 10-minute spools. This (Situationist-inspired?) performance was the film's world premiere, and was accompanied by a display of his *Swiz Magazines*, assembled from newsagents' waste bins on the same principle. They now serve as a vivid reminder of all that is best forgotten about '60s visual culture; then, I suppose, they mocked consumerism.[27]

In October '68, the gallery hosted 'Hornsey Students at Work', presumably some form of reflection on the now celebrated Hornsey sit-in protest of May '68; perhaps indeed an opportunity to make work, as classes had

yet to recommence at Hornsey.[28] In the same month there was a show of *Antique One Armed Bandits and Fruit Machines* – organised by one Olli Iny. In November, John Taylor's exhibition of musical Instruments took place, and billed separately, his *Tzintzantzun: Aztec Ocarinas and flutes*. There were probably other exhibitions of which we have little trace. The last planned by Biddy and Pam was *I Never Said Exactly* by Greek-Cypriot architect, poet and artist Criton Tomazos, a display of artwork from the 16 pages of image and wordplay that made up his eponymous graphic poem (now held in the British Library) and a related event.[29] The silk-screened posters were printed by Criton and Biddy at the Lab and were displayed, but the show itself didn't take place, for Biddy and Pam were no longer around to help install it, as in late November, with the other key workers, they withdrew from the Lab in the unforeseen break-up.

The one gallery show that took place after that date (according to *IT* listings) would seem to have been *New London Photographers* in February '69, with Hoppy, surely, among them? His photographs are now recognised as a vital record of the 1960s rock and countercultural scene.

'Who am I, Where am I, What am I doing … here?' images from The Self x 12, *March '68.*

Silkscreen poster designed by Criton Tomazos for his planned exhibition in November '68.

Endnotes

1. BP – Undated memo to Sandy Nairne, then researching his contribution to *Thinking About Exhibitions*, Routledge, 1996, Editors: Reesa Greenberg, Bruce W. Ferguson and Sandy Nairne.

2. BP – Unpublished statement written at the time of leaving Drury Lane in December 1968. *The future / Arts Labs; how what and why – why what and how.* [Drury Lane documents file.]

3. David Jeffrey remembers "some Parisian students turned up with a batch of posters encouraging revolution …They enthusiastically told us that – should we put up the posters – the English working man would visit the Arts Lab, see the posters and be inspired to revolt!" Email 29 October 2018.

4. He formed the jazz fusion band Quintessence which toured with The Who, Led Zeppelin and Pink Floyd, then morphed again in the 90s into the creator of TIP Records, performing and publishing trance music.

5. He also designed album sleeves for The Beach Boys, Soft Machine and book jackets for Arthur C Clark, Mickey Spillane, Len Deighton,

Brian Aldiss, et al. "My paintings [in the 1960s] were pretty weird; no mind expanding drugs used in the process, and I never felt the need for them. My brain comes up with some pretty odd stuff without that complication!" Email 28 August 2017.

6. Schweikert is better known as co-director of the striking film *No Distance* (1970) 'A metaphysical mime play between man and light'.

7. Email 6 January 2019.

8. Email 6 January 2019.

9. 'The People' *IT* n13, 19 May 1967.

10. Email 5 September 2017.

11. TGA 20054/4/2/1/4 Leggett recalls "we took the same performance to Paris (+ some wall hanging pieces) in May 1969 for the *Liberté du Parole* festival at the Vieux Colombier Theatre (of *L'Age d'Or* premiere fame!), but the natives were restless a year after *les événements*, and we were chased off the stage! A truly terrible rock band took over … ." Email 17 January 2018.

12. The title comes from Turgenev's novel of 1852, a series of observations and anecdotes about Russian stratified rural life.

13. Email 3 October 2017.

14. Email 4 October 2017.

15. Yoko Ono had exhibited a live video feed *Sky TV* at the Indica Gallery in '66. Nam June Paik, Wolf Vostell and other video pioneers had yet to show video in Britain.

16. to Michael Maziere studycollection.org.uk

17. "'Discourse' versus 'Medium', Interview with Malcolm Le Grice by François Bovier and Adeena Mey." www.decadrages.ch.

18. Unattributed, Lisson website.

19. John Latham, statement in *State of Mind: John Latham*, Dusseldorf, Stadtische Kunsthalle, 1975. Tate website.

20. The show was however openly attributed to them in both *IT* and the Lab's schedules.

21. Chris Rowley, who sometimes minded the Lab bookshop, remembered working at the Lab "… cutting things in half for an exhibition [Yoko] was doing. We had to cut a whole houseful of stuff in half. Paint it white." (*Days in the Life*, Jonathan Green, Pimlico, 1998). These cut pieces were probably intended for Yoko's solo show *Half-A-Wind* at the Lisson Gallery in October 1967. See Kevin Concannon's exhaustive exploration of this Lab show – 'Lost in the Archive: Yoko Ono and John Lennon's *Four Thoughts*', Kevin Concannon, *Review of Japanese Culture and Society*, v28, University of Hawaii Press, 2016.

22. BP – Email to Anna Braun, 13 April 2017. She continues: "Yoko proposed one other show for Drury Lane. An artist couple, friends of hers, had created a very large four-poster bed in which they slept and from the rails of which they would hang artworks that they'd made. They wanted to erect the bed in the gallery space and live in it as a round-the-clock performance piece. Pam and I … went to see the couple to discuss it further. It turned out that they were in the throes of tragedy; both were heroin addicts – the woman, heavily pregnant, was shooting-up during our visit. … So there was no way in which we could have held that show."

23. Ramos-Poqui was studying at the Slade and RCA at the time. He is now cherished as a Spanish pioneer of Arte Povera and Conceptual Art.

24. Fry, also an inventor, started engineer/inventor James Dyson on his career, saved Bath's Theatre Royal, was chairman of the Arnolfini, Bristol, etc. Unusually, this exhibition was instigated by Jim.

25. Hugh Shaw (from the Arts Council's Art Department) invited Pam and Biddy to participate in its selection and organisation, "but as there was no mention of payment for our work and we were fully involved with other things, we assumed our contribution would be on a voluntary basis, and left most of the work to Hugh, who had a regular salary. When the show was about to be launched Hugh said 'I'm sorry I can only pay you a little, since you haven't done very much!' I would have been more than happy to put in the necessary work if a fee been mentioned at the beginning, as we were living hand to mouth. … In the end my main contribution to the Whitechapel show was a silkscreen poster – a repeating design to be printed on a continuous roll of paper which could be cut according to the space available – but I don't think it was used." BP Email January 2019.

26. See also: J. Henzell, 'Art madness and anti-psychiatry: A memoir', in K Killick & J Schaverien (eds), *Art, Psychotherapy and Psychosis*, Routledge, 1997.

27. Examples of *Swiz* magazines are held at the BAFVSC, CSM. Graham Peet adds: "I think … it was the same 35mm projector that Godard used to show his cut of *One Plus One* under the arches at the South Bank after his famous invitation to the audience to leave the NFT and see *his* version of the film outside". Email 16 September 2019.

28. See Lisa Tickner *Hornsey 1968 – The Arts School Revolution*, Frances Lincoln Ltd, 2008, though she doesn't mention this show. Nor *Art Transplant* at the ICA Gallery: "*Art Transplant* involves a display area, which with graphic, audio visual and imaginative methods will explain [the] Hornsey revolution", *IT* 14 July 1968.

29. "As far as I recall, the event I planned was having two possibilities: (a) … possibly a sound and visual poetry [performance] … or (b) to allow an open ended, more spontaneous and unpremeditated event, letting people who came largely create [it], through negotiating and inter-acting at the space themselves. I remember I circulated a leaflet with a poem-like play on the title '*I never said exactly*'. CT email 12 January 2020.

The Soft Cinema

When programming the Lab's cinema, I faced a problem not shared by Jim, Hugh, or Biddy and Pam. There was no substantial community of active filmmaking artists knocking at the door, demanding that their work be shown. My belief that I could construct an appropriate programme for the Lab was based on very little. I had learned a bit about classic cinema by sitting in on Thorold Dickinson's film studies course at the Slade, which was an extraordinary rich introduction to cinema's past glories.[1] I had developed a sense that artists *could* make radical film works, which was based upon reading about Warhol's approach to filmmaking in New York, and reinforced by occasional encounters with committed artist-filmmakers at Better Books and the UFO club.

At Better Books, I had seen the work of Jeff Keen, Steve Dwoskin and John Latham, all serious artist-filmmakers who would become involved with the London Filmmakers Co-op in its first year, though none of them was prolific at the time.[2] Stacy Waddy (later Marking), another Slade friend, showed her *Pig Poems* (1967), a trio of tiny films based on Spike Hawkins's *Three Pig Poems* (1966), but that ended her experimental filmmaking involvement.[3] I knew Peter Whitehead[4] and Don Levy also from the Slade, but they aspired to big-cinema professionalism that was alien to the 'let a thousand flowers bloom' spirit of the Lab, which I fully embraced; William S Burroughs, then living in London, was active as a filmmaker through his friendship with cinema-manager Anthony Balch, but kept his distance from the Co-op and the Lab; Yoko Ono similarly was present, active, but distant (her *No 4* aka *The Bottoms Film* (1967) featuring the naked rear-ends of many London notables, was shown at Balch's Jacey Tatler Cinema, Charing Cross Road, in August '67).[5]

Otherwise, it was occasional visitors from America who flew the flag for the individual artist filmmaker: Piero Heliczer, Bill Vehr, Andy Meyer, Warren Sonbert and Gerard Malanga, all of whom turned up at Better Books or the UFO club in '66–'67, and allowed us to screen their films. But as the first few months of the Lab's cinema programme makes clear, it was relatively thin pickings. Malcolm's *Castle 1* and Heliczer's *Joan of Arc* (1967, both shown November '67) and a joint show of 8 mm films by Jeff Keen and Michael Klein, (undated, but probably early January '68 were the only new films directly offered to me by their makers.

Design by CoBrA artist Pierre Alechinsky for the Knokke 67/8 festival poster and catalogue cover (courtesy Royal Belgian Film Archive).

But at the very end of 1967 I found myself at the EXPMNTL Festival at the curious Belgian seaside resort of Knokke-le-Zoute, and as a result of this visit, the Arts Lab's cinema programme would change radically, though not immediately.[6] I was there in the company of Jim, John Collins, Simon Hartog, Bob Cobbing and Steve Dwoskin (these last four representing the London Filmmakers Co-op), and filmmakers/performers John Latham, Yoko Ono, Jeffrey Shaw and Don Levy. The

Poster designed by Michael Kline for his joint show with Jeff Keen, January '68?

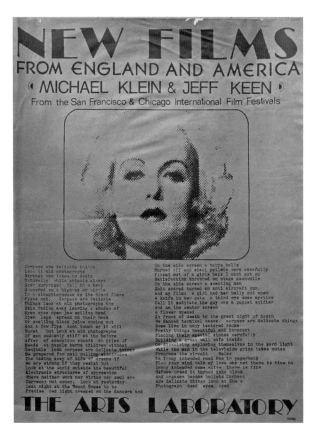

EXPRMNTL Festival was unique in its dedication to the experimental film. It was organised by Jacques Ledoux of the Royal Belgium Film Archive and had been held at the year's-end every 3-4 years since the 1940s. The 1963/4 event had been the occasion of an unsuccessful attempt to ban Jack Smith's pan-sexual Arabian Nights 'orgy' *Flaming Creatures* (1963), which put both the Festival and the film on the cultural map. So the turnout of international artists at the '67–'68 Festival was extraordinary.[7] And suddenly, it was clear that there was a whole international community of artist filmmakers whose work could – and should – be shown in London.

Most immediately, I wrote an extended review/fan letter about the Festival for *IT*, but I had also invited almost everyone I met to show at the Lab. At Knokke, P Adams Sitney revealed that he was travelling in Europe with a New American Cinema programme, a collection of more than 60 films from the New York Filmmakers Co-op chosen by him, Jonas Mekas and Peter Kubelka. And together with Simon Hartog, I undertook to organise a tour

of UK venues for the programme, following its National Film Theatre debut in late April '68. But it would be some time before those I invited at Knokke began to turn up in London and the first few months in '68 were almost as devoid of new works as the last three of '67 had been. So I replayed the successful Anger programme for two weeks, then Clarke's *Portrait of Jason* and added John Cassavetes' *Shadows* (1959) and then in April gave premieres to two new films that one might have expected to open in the West End, Jim McBride's clever pretend-autobiography *David Holzman's Diary* (1967) and Joris Ivens' denunciation of the savagery of American bombing in Vietnam *17th Parallel – Vietnam at War* (*Le 17me parallèle: La guerre du peuple,* 1968). This latter was hardly a crowd-pleaser, but an important work to show at the time, and one which chimed with the outrage being expressed in many of the Lab's theatre productions.

Unique diazo-print poster from hand-drawn design by Jim McBride.

More predictably underground in sprit was Ben Van Meter's *San Francisco Trips Festival – an Opening* (1967) which I borrowed from the art critic Nigel Gosling to show in February. This was a record of what Van Meter described as "… the seminal event of the 60's rock scene … A lot of different folks doing their thing including Ken Kesey and the Merry Pranksters. I filmed it in my then inimitable style [all flash-frames, pixilation and superimpositions] … [It] has been hailed by one academic as 'the most psychedelic film ever made'."[8] It had many imitators in the

1967

Films in competition

Films in competitie

Films projetés en compétition

Selection jury / Selectie jury / Jury de sélection
Dimitri Balachoff, Yannick Bruynoghe, Paul Davay, André Vandenbunder, Roland Verhavert

01 Anima mundi / Erling Johansson / Sverige
02 Bodybuilding / Ernst Schmidt / Österreich
03 Jalousie / Hans Jakob Siber / Suisse
04 Tomorrow's promise / Edward Owens / USA
05 S & W / Wilhelm Hein / Deutschland
06 Laudate / Nicholas Frangakis / USA
07 Life endeath / Robert J. Kaplan / USA
08 Hexagrams / Byron Grush / USA
09 Schwarzhuhnbraunhuhnschwarzhuhnweisshuhnrothuhnweiss oder put-put / Werner Nekes / Deutschland
10 Les caméléons / Patrick Hella / Belgique
11 Eriebnisse der Puppe / Franz Winzentsen / Deutschland
12 Possession du condamné / Albert-André Lheureux / Belgique
13 New tempo «stimulants» / James Goddard / Great Britain
14 Big rich town / Henry Niese / USA
15 Make love not war / Ben Van Meter / USA
16 Joan of Arc / Piero Heliczer / USA-Great-Britain
17 A & Z / Dietrich Schubert / Deutschland
18 Shaman : A tapestry for sorceres / Storm De Hirsch / USA
19 Murahada / Yoichi Takabayashi / Japan
20 Mae East / Cassandra M. Gerstein / USA
21 Week-end / David McNeil / Belgique
22 Line of apogee / Lloyd Michael Williams / USA
23 L'authentique procès de Carl-Emmanuel Jung / Marcel Hanoun / France
24 Der weiße Hopfengarten / Wolfgang Ramsbott / Deutschland
25 Attisonans / Karl-Birger Blomdahl / Sverige
26 Warum hast Du mich wach geküsst ? / Hellmuth Costard / Deutschland
27 Les souffrances d'un œuf meurtri / Roland Lethem / Belgique
28 1967 / Al Rose / USA
29 Push you pull me / Byron Grush / USA
30 Anamorphosis / Guido Haas / Schweiz
31 Selbstschüsse / Lutz Mommartz / Deutschland
32 Soliloquy / Stephen Dwoskin / Great Britain
33 Watts towers / Gerald L. Varney / USA
34 Schnitte / Peter Groba / Deutschland
35 Peacemeal / Albert Allotta / USA
36 Piece mandala / Paul Sharits / USA
37 Besöket / Åke Arenhill / Sverige
38 No compteu ambs el dits (Carmen) / Pedro Portabella / España
39 Entretien / Michel Thirionet / Belgique
40 Chinese checkers / Stephen Dwoskin / USA-Great Britain
41 Opus 3 / Pierre Hébert / Canada
42 Conversation / Clive Tickner / Great Britain
43 Atol / John Stehura / USA
44 Markeneiler / Lutz Mommartz / Deutschland
45 Play 54321 / Andrzej Jurga / Polska
46 Corny / Niels Viggo Bentzon / Denmark
47 Narcoses / Philippe Graff / Belgique
48 Hummingbird / Charles A. Csuri & James P. Shaffer / USA
49 Bolero / Albie Thoms / Australia
50 Naissant / Stephen Dwoskin / USA-Great Britain
51 Poem posters / Charles Henri Ford / USA
52 Eisenbahn / Lutz Mommartz / Deutschland
53 Cibernetik 5.3 / John Stehura / USA
54 Grateful dead / Robert Nelson / USA
55 Pic-nic (Good morning) / Georg Radanowicz / Schweiz
56 Portrait électro-machin-chose / Martial Raysse / France
57 Ray gun virus / Paul Sharits / USA
58 Color me shameless / George Kuchar / USA
59 Jüm-Jüm / Werner Nekes & Dore O / Deutschland
60 Water sark / Joyce Wieland / USA
61 Spiracle / Robert Beavers / USA
62 Turtle soup / Irene Verbitsky / USA
63 Thaler's, Meier's, Sadkowsky's life in the evening / Klaus Schönherr / Schweiz
64 What do you think ? / Yoji Kuri / Japan
65 Trois minutes / Jean-Marie-Lambert / Belgique
66 Wavelength / Michael Snow / USA
67 Auf der Suche nach dem Glück Reinhard Kahn & Michel Leiner / Deutschland
68 Assa 1 / Claude Copin / France
69 Das Seminar / Werner Nekes / Deutschland
70 Wilderness / Abbott Meader / USA
71 The room / Mordi Gerstein / USA
72 The big shave / Martin Scorsese / USA
73 Szachownica / Czeslaw Duraj / Polska
74 Pochod / Ivan Hustava / CSSR
75 Un peu, beaucoup, passionnément / Frédéric Vanbesien / Belgique
76 Jungle madness / Don Duga / USA
77 Fog pumas / Gunvor Nelson & Dorothy Wiley / USA
78 The embryo / Koji Wakamatsu / Japan
79 Ems Nr. 1 / Ralph Lundsten / Sverige
80 The great Blondino / Robert Nelson / USA
81 The Illiac passion / Gregory J. Markopoulos / USA
82 Begin / Jan Kleckens / Belgie
83 Les visages / Andrzej Dyja / France
84 The bed / James Broughton / USA
85 Der Tod des Dr. Antonio durch die Renaissance der geistige Gesellschaft Antonio Lepeniotis / Österreich
86 Self-obliteration / Jud Yalkut / USA
87 Se l'inconscio si riv(bloi(il)a / Alfredo Leonardi / Italia
88 A dam rib bed / Stan Vanderbeek / USA
89 Die Utopen / Vlado Kristl / Deutschland
90 Il mostro verde / Tonio Debernardi & Paolo Menzio / Italia

Films in Competition at Knokke 1967-68.

Left:
'*An* Arabian Nights *orgy*', Jack Smith's
Flaming Creatures *(1963)*.

Right:
'*Convicts in Love*' Jean Genet's Un
Chant d'amour *(1949)*.

following years, and the *genre* soon palled.[9] Also in February, we held the UK premiere of Robert Downey's *Chafed Elbows* (1966), according to US critic Parker Tyler 'a manic comic parody'. It was a film largely shot as still images with live action interludes and much voice-over comic dialogue – a minimal-budget underground success which had run for a month at The Gate cinema in New York.

Other films that made their impact at the Lab in the early months were Jack Smith's *Flaming Creatures* and Jean Genet's extraordinary silent study of frustrated male desire *Un Chant d'amour* (1949–50). The print of *Creatures* had been left in London by Jonas Mekas on his way home from the '63–4 EXPRMNTL Festival to save it from being impounded by customs in New York. It had been offered to me one evening at the UFO Club by its temporary guardian, and I had shown it there, and again (unannounced, but for several screenings apparently) at the Lab in the autumn of '67. It became one of the totemic films of the period. But it only remained in circulation for a few months before Jonas angrily, but not unreasonably, demanded the return of the print.[10] (My attitude to artists' intellectual property was then shockingly casual; discovered cultural gems were to be shared – isn't that what everyone wanted? … I *did* learn greater respect eventually).

Such was the reputation of these films that in January, Jack and I were asked by Kenneth Tynan to show both as an after-dinner entertainment at his house, where his guests included Peter Cook, Harold Pinter, his wife Vivian Merchant, Princess Margaret and Lord Snowdon. Well-fuelled with alcohol, this strange crew survived the exoticism of *Creatures* but balked at *Un Chant d'amour*. Tynan recalls: "Genet's film is about convicts in love … and contains many quite unmissable shots of cocks limp and stiff, cocks being waved, brandished, massaged or just waggled – intercut with lyrical fantasy sequences as the convicts imagine themselves frolicking in the vernal undergrowth. Silence became gelid in the room; no one

was laughing now. Suddenly Peter Cook came to the rescue. *Un Chant d'amour* is a silent film and he supplied a commentary, treating the movie as if it were a long commercial for Cadbury's Milk Flake..".[11] The mood restored, Tynan went on to mock Susan Sontag's defence of *Flaming Creatures* as an example of 'the poetic cinema of shock' and 'both childlike and witty' in her celebrated essay 'Notes on Camp'.[12] (Jack and I were not invited to share our views.)

At the Lab, these films found a more appreciative audience. Paul Buck was not alone in recognising *Creatures* as "a film about pleasure, made for pleasure, a feast for our eyes and imagination …".[13] And as its title suggests, Genet's film too was more an erotic love poem than protest-film, and with Anger's *Fireworks* (1947), it would signal to a rising generation of filmmakers that it was possible to create homoerotic visions and to depict gay love in ways that were wholly affirmative, heralding many artists' films of the 1980s. Equally affirmative and taboo-busting was another film that then came into our repertoire, Carolee Schneemann's *Fuses* (1964–68), which we first showed at a special 'benefit screening' for Carolee in July '68. In *Fuses*, Carolee presents a woman's view of the pleasures of a sexual exchange. She filmed her partner the composer James Tenney and herself as they had sex, and by remotely controlling the camera-actions, she directly challenged what filmmaker and writer Laura Mulvey would later identify as 'the male gaze' implicit in so much filmmaking.[14] Here the sex act is visualised in an essentially expressionist language, Carolee using paint-on-film, rapid editing and collage on the filmstrip to evoke her active and joyful participation.

Carolee Schneemann's Fuses *(1964–).*
Image courtesy CaroleeSchneemann.com.

Kenneth Tynan's letter of thanks.

At the end of April, P Adams Sitney introduced his New American Cinema programmes at the NFT, and then embarked on the month-long tour of a dozen UK venues that Simon Hartog and I had found for him, mostly university film societies. After seeing so much new work at Knokke, Sitney's programmes at the NFT seemed disappointingly retrospective in flavour; absent was anything by Mike Snow who had won the top Knokke prize with his *Wavelength* (1967) or by Paul Sharits, who had shone at Knokke, though the programmes introduced some of the often overlooked, arguably more marginal figures.[15] There was one minor Warhol feature, *Harlot* (1964) but none of his more challenging silent films such as the great film-portraits, the *Screen Tests* (1964–66) or his endurance-testing *Sleep* (1963) and *Empire* (1964). But the programme included major works by Stan Brakhage (absent from Knokke), his astonishing four-hour *Art of Vision*

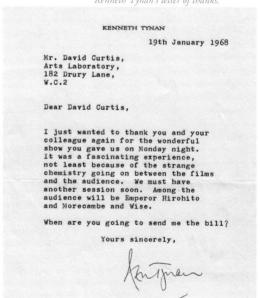

KENNETH TYNAN

19th January 1968

Mr. David Curtis,
Arts Laboratory,
182 Drury Lane,
W.C.2

Dear David Curtis,

I just wanted to thank you and your colleague again for the wonderful show you gave us on Monday night. It was a fascinating experience, not least because of the strange chemistry going on between the films and the audience. We must have another session soon. Among the audience will be Emperor Hirohito and Morecambe and Wise.

When are you going to send me the bill?

Yours sincerely,

The New American Cinema Exposition at the National Film Theatre (NFT programme booklet, April '68).

(1965) and 8 mm *Songs* (1964–69) and Harry Smith's wonderfully detailed hand-painted *Early Abstractions* (1946–57) and *Heaven and Earth Magic* (1957–62). Having all these films briefly in the UK increased the London Filmmakers Co-op's determination to make a collection of American works available more permanently, and this came to pass about six months later when many of the same prints were deposited at the Co-op in a deal negotiated by Jonas Mekas and his intermediary, the Fluxus artist Carla Liss, then living in London.

The tour itself met with a mixed response. Sitney was shocked by the indifference and even hostility of some UK audiences, notably at the University of Essex, where "a claque managed to disturb the entire performance with incessant noise and wisecracks".[16] But the lives of at least two people in that particular student body were positively changed by the encounter. Peter Sainsbury would become one of the founders of The Other Cinema, and then head of the BFI Production Board, so an active supporter of many new forms of cinema. Simon Field would later run the ICA Cinema, and then the Rotterdam Film Festival. More immediately, he joined me in organising the 1970 *International Underground Film Festival* at the National Film Theatre, and together he and Peter co-founded and edited the long-running film magazine *Afterimage* (1970–87).

My interest in the evolution of this still-new art form was now fully awakened, and with all the confidence of the ignorant, I announced: 'intermittently – for several weeks – a history of experimental film' (a term I interpreted very broadly). This started in May and included some eccentric pairings: *Die Nibelungen: Siegfried* (Fritz Lang, 1924) plus *Alice and the 3 Bears* (Disney 1924); *Entr'acte* (Rene Clair 1923) plus *Felix Makes a Movie* (Pat Sullivan 1924). At weekends, after the main programmes, I ran all-night screenings. For example, the early evening's *Battleship Potemkin* (Eisenstein 1925) was followed by 'Late show: It's *Always Fair Weather* [Donen & Kelly], *Last Year in Marienbad* [Resnais], and *Steel Helmet* [Fuller]'. A rich night's worth.[17]

'Open Screenings', which invited people to turn up with films in order to test them upon an audience – works either 'just completed' or 'in progress' – had been an occasional offering at Better Books. John Collins was keen to make them an established part of the London Filmmakers Co-op's identity, and undertook to organise them at the Lab, where they became a regular Tuesday evening fixture. Open Screenings would become a commitment carried on in the Co-op's name in its succession of different

homes for the next 30 years, direct audience feedback being a rare commodity in the world of film. Even in that welcoming context, response was not always forthcoming. After a showing of her own work and that of Charles Levine at an open screening in October '68, Marguerite Paris of New York's Millennium Film Workshop, complained: "It was very frustrating for me as a New Yorker to see that no one asked any questions after seeing the footage I shot ... [She showed her own documentation of a German TV crew filming at Millennium]. It seemed obvious to me that people were curiously wondering what the hell was going on in the film, but were either too shy or too embarrassed to ask. Don't be afraid people! Speak up! Let your heads ring out! Later in the evening I observed ... a somewhat staged dialogue about politics [Leopoldo Mahler's play *Listen Here Now*]. Everyone seemed relaxed and comfortable. But why must it be *staged* for people to relate and reach out to one another?"[18] English reticence often prevails, but the opportunity to try out films before an audience, was, and is, invaluable.

My 'A History of Experiment and Innovation in Film' programmes continued throughout June, with a screening

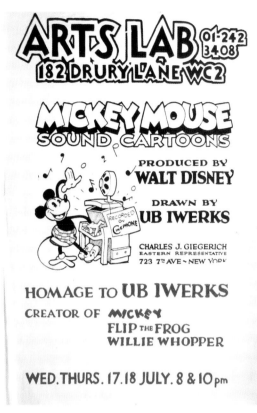

of the few Stan Brakhage films in circulation, and including some of his 8mm *Songs* which I had bought directly from him,[19] Eisenstein's *Strike* (1924), and so on.[20] And then, at last, people I had met at Knokke started to appear. Gregory Markopoulos, who had been given a major retrospective at Knokke, showed his *Twice a Man* (1963) and *Gamellion* (1968) in June, together with *Winged Dialogue* (1967) by his partner Robert Beavers. In contrast to the then current preoccupation of some with filmed psychedelia and structural procedures, the work of both artists was a revelation in its radical attempt to re-purpose montage – the juxtaposition of shots – while at the same time drawing upon classic literature and mythology. Sitney would write compellingly about Markopolos in his study of the American avant-garde *Visionary Film* (1974) but despite this, his work has been rarely screened and is seldom discussed.

At an open screening, the Canadian poet and jazz lyricist Paul Haines showed his *An All Ethnic Electric Programme* (1966), and in early July we showed work by his fellow Canadians Abbott Meader and the scholar/filmmaker Bill Wees.[21] A visitor that month from closer to home was the veteran animator Lotte Reiniger, who was present as we screened some of her detailed, cut-out silhouette films.[22] A post-war refugee, she

animation retrospective at the arts lab on july 8th and for a couple of
days thereafter: films by walter lantz, ub iwerks, pat sullivan, max fl
eischer, chuckjones, oskar fischinger, walter babay disney, and others.
I didn't see all the program, nor did I see the excellently comprehensi
ve Ub Iwerks festival a few days back. Ub Iwerks, folks, is the man behind
Walt Disney's success, being the chief Disney technician for many of th
e earlier Mickey Mouse efforts, until he got sick of Disney's mania for
discipline (see Richard Schickel's The Disney Version) and struck out on
his own to do Flip the Frog and Willie Whopper, both of whom had twice
as much whimsy and taste as Disney ever put into WW or MM. (Disney, dur
ing the making of his incredibly tasteless and overrated abortion Fanta
sia, remarked to Deems Taylor, a rather then-famous American music crit
ic: "Gee, this'll make Beethoven."Taylor nevertheless swallowed this and
did the introduction and continuity for the films that comprise Fantasi
A)Flip started out as a plain old frog, mucking around the silly pads an
d croaking about how great it was to be frog, like the cutesy little an
imals in the Harmon-Ising (get it, get it?) cartoons for MGM would do
in 1936-39. (Flip's lifespan was from 1930 to 1937, when Iwerks scrappe
d him altogether for Willie Whopper, whom he had been drawing for sevra
l years along with Flip. Willie lasted only two or three years.) Eventu
ally, however, Flip graduated to a landlord, a school truant, a cop, a r
estaurant owner, a henpecked husband, a prize fighter, a musician: you n
ame it. In New York, where I live, Flip cartoons, along with Willie, old
Burt Gillette Lolly Loo-Cow and Toonerville Trolley cartoons (Gillette,
a rather uninteresting and unimaginative animator, picked up the right
s to Felix the Cat in 1936 and turned out a series of dull, flat, taste
less cartoons with him. Pat Sullivan hated them, I suppose, as violehtl
y as Fontaine Fox hated the Toonerville adaptations, but Fox's syndicat
e was to blame for that.)and 1917 Paul Terry Terrytoons are run for a
half an hour every morning on local tv, and then the old MGM Harmon-
Ising and Jerry Squirrel , Captain and the Kids and George Pal Puppet
oons are run for another half hour right afterwards. It's a gas to see
Chuck Jones, now one of Warner Brothers' top animation directors, and
Isadore (Friz) Freling working as cel washers for Harmon Ising, and the
n later turning out things like Freddie the Freshman, the Freshest Kid
in Town, all mercilessly resurrected on early morning tv. Anyway, Ub Iw
erks went back to Disney and for many years thereafter did the special
process animation on Disney features, things like rain, flowers in pond
s, pseudosolarisation effects (brilliantly employed in Yellow Submarine
a film whihc the Beatles had about as much to do with as you and I did)
and working out the kinks in Superscope (the Cinemascope forerunner, is
used by Disney just once, in Fantasia, and wasted completely) and Cinem
ascope,like onscreen distortion, softfocus problems. Iwerks recieved
an Oscar for his technical developments in animation about two years ba
ck, especially for his process of transferring the original crayon ani
mation drawing to the plastic cel by Xerography, thus eliminating the
inking stage and giving the lines a great deal more crispness. This
technique is very costly, however, and has been used in only three film
s so far, Sword in the Stone, Jungle Book, and Winnie the Pooh and the
Honey Tree. Anyway, I think that Iwerks contribution to animation is g
reatly underrrated, and I hope many of you caught his show. This essay
has been rather flaccid, and I'm getting rather tired, so I'll leave yo
u with the thought that Oskar Fischinger is a pretty dense fellow, who
follows trends instead of making them, despiye what the Museum of Moder
n (OOPS!) catalog says, and I think that if you haven't seen the mescal
ine animations of Harry Smith you should dig them and try and get a hol
d of them. He's been doing them for thirty years, and they last about t
hree hours altogether and he is to animation what Kubelka is to liveac
tion: absolute and unprovemeable perfection in every frame. Last note,
I hope that a lot of you can come and dig (or not) my films at the Arts
Lab on the 20th of July: I'd like to hear your views on them'."New!

WHEELER DIXON

Early-career film scholarship by Wheeler Woodrow Dixon.

had been living in London and quietly making films for the BBC and others for years, and I kick my younger self for failing to quiz her about her own extraordinary history. *The Adventures of Prince Achmed* (1926) was the world's first feature length animated film and contained astonishing special effects, *magicked* in the pre-computer age entirely optically; in the 1920s she had set up her own studio and had nurtured the talents of Walther Ruttmann and Oskar Fischinger, (most of whose early abstract films I had yet to see).

I also devised a series of programmes looking more broadly at animation. The American film-maker and later noted academic Wheeler Winston Dixon was then in London, and he introduced me to the history of Disney's first animator Ub Iwerks, resulting in *A Homage to the Man Who Invented Mickey Mouse* and another programme of early animation in August, for which Wheeler wrote an intense programme note.[23] In September I balanced this American-centric and largely pre-war offering with a European-biased 'Modern Animation Programme',[24] and promised "Part 3 of this Animation series 'Underground Animation' will arrive when we can get some of Harry Smith's films into this country'!"[25]

July saw two programmes of films by emerging British artists; 'Films by new filmmaker Mike Dunford', then a student at Goldsmiths, and 'Films from St Martins College', the latter including work by Roger Ackling; both Mike and Roger had been encouraged by Malcolm's teaching. There was more student work in 'Films from the RCA' in August (details lost, but possibly including Mauritius footage by David Larcher).[26] Also in July, the Australian filmmakers Corinne and Arthur Cantrill, who were then based in England, showed their 'art' films *Henri Gaudier-Brzeska* and *Red Stone Dancer* (both 1968). Their more experimental landscape pieces were yet to come, but they responded strongly to Will Spoor's mime, and filmed him at work.

The events of May '68 in Paris and American responses to the escalating slaughter in Vietnam were reflected in screenings in July and August. The work of the American activists the Newsreel Collective, shown during the first weeks of July, offered a model to many emerging political

filmmakers in England. The Newsreel Collective was a coalition of groups that came together in early '68 following the 500,000 strong anti-war march on the Pentagon of October '67. Robert Kramer, one of those involved, wrote "[We] want to make films that unnerve, that shake assumptions, that threaten, that do not soft-sell, but hopefully (an impossible ideal) explode like grenades in peoples' faces, or open minds like a good can opener".[27] We also showed at the Lab the portmanteau film *Loin de Vietnam* (1967) assembled by Chris Marker with contributions from Joris Ivens, Claude Lelouch, Alain Resnais, Agnès Varda, Jean-Luc Godard and William Klein, and the anonymous but Godard-inspired (and largely Godard-authored?), silent *Cinetracts* from Paris,[28] the sloganizing equivalents of the Paris posters that had been on view in the gallery earlier in June. In an act of solidarity we showed the *Cinetracts* free, suggesting 'donations please'.

New films and new filmmakers were now presenting themselves in sufficient numbers for me to abandon the 'History' series, and to largely concentrate on one-person and group shows. My two last retrospective programmes were in July, a 'Tribute to Hy Hirsh (five films)' which revealed him to be an unsung master of optical printing and multiple superimposition, and a week later, a Norman McLaren retrospective, McLaren being the one experimental filmmaker then known to the general public. Then there was a flood of solo visitors who came and introduced their films; José Soltero with his camp yet political *Ché is Alive* (1967) starring Taylor Mead, was shown in July and again in September, Wheeler Winston Dixon commenting on its 'offhand violence' ... "Soltero's camerawork is wild and improvisatory, engaging the subject with a ceaseless series of zooms and pans, in the manner of Warhol's *Chelsea Girls*";[29] Sandy Daley's *The Naked Lunch* or *Berkeley Bath Brothel* (1968), a tableau-vivant based on a medieval painting of a bathhouse, with overtones of Californian decadence;[30] Leland Wyler's *Head Rushes* (1968) featuring Warhol 'star' Tom Baker as a Los Angeles *flaneur*; a Stan VanDerBeek Programme; a programme of films by Michel Snow and Joyce Wieland – Snow's *Wavelength* and *New York Eye and Ear Control,* Wieland's *Sailboat* (1933), and *Catfood*; Peter Gidal's first show in England, his *Still Andy, Lovelight, Room,*[31] 'and latest' *Sculptor George Segal*; as well as 'amazing films by Burton Gershfield, Patrick O'Neill and maybe Laurie Lewis'. And more. I'm certain that somewhere in that first year we showed films by Warren Sonbert and Tom Chomont, but when? – the surviving schedules are incomplete.

We certainly gave screen-time to a number of group shows from the many Collectives and Co-ops that were then emerging across Europe and the USA. These included in July 'Films from Aardvark Film Co-op,

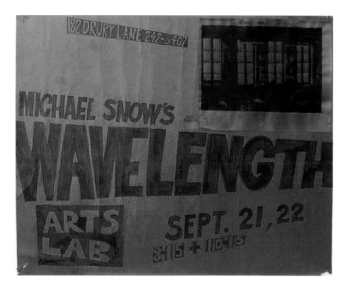

Poster design by Michael Snow.

*Poster designed and silkscreen printed by
Biddy Peppin.*

Chicago' introduced by Bob Greenberg, 'Film from Paris by Jean-Jacques Lebel, Pierre Clémenti & others' in August; 'Films from the Italian Film Co-op' including works by Alfredo Leonardi (who introduced the show), and the two-screen Super8 *Il Mostro Verde* (1966) by Tonino DeBernardi in September, 'Films from Holland' in October including works by Frans Zwartjes, who became one of the best-known of Dutch filmmaking artists, and 'Films from the Belgian Co-op' introduced by co-op organiser Jean-Marie Buchet.[32] There was a programme of 'Films from Italy and Spain' … details of which are missing.

Having lost its foothold at Better Books, the London Filmmakers Co-op maintained a profile at the Lab, if a low one. Its open screenings continued, one in August '68 being dedicated to additions to the Co-op's distribution library, which probably coincided with the publication of its first proper catalogue. But some felt the Co-op's identity was at risk. In late June, Bob Cobbing (or John Collins?) organised a 'FILM EVENT: London Filmmakers Co-op Assembly to discuss the structure and activities of the Co-op now and forever. All living filmmakers invited', and tactically held it at the Antiuniversity space in Rivington St, on neutral territory.[33] Then, or perhaps soon after, Simon Hartog (from the Co-op) and Malcolm (from the Arts Lab) were deputed to propose a structure that might bring together the Co-op's growing distribution activities with the Lab's emphasis on production and exhibition.

In the same spirit, John Collins, ever the peacemaker and go-between, announced that from September, the open screenings at the Lab would become 'EXCHANGES every Tuesday in the cinema' and that at the first of these, 'magazine editors [will] discuss their policies – *OZ* & *Image*', (presumably an opportunity to interrogate their coverage of experimental and underground cinema?).[34] And on 11 September, there was 'London Filmmakers Co-op Show arranged by LFMC' (!), which apparently included work by Dunford and Fred Drummond, the latter another of Malcolm's students at St

Martins. The full integration of making, distribution and exhibition, as visualised by Malcolm and Simon, was only fully implemented with the setting up of the Robert St Lab a year later, where the Co-op gained its own distribution space and workshops alongside the cinema, and continued when the Co-op went solo at the Dairy, Prince of Wales Crescent, in 1971.

By early August 68, the Lab's financial plight was becoming desperate, and to make money we programmed Andy Warhol's *Chelsea Girls* for two weeks, two shows a day, and charged an unheard of (at the Lab) 10 shillings admission. Similarly motivated, we followed in September with a repeat of the Kenneth Anger Programme[35] and another *Chelsea Girls* blitz in October. Derek Hill, who ran the successful New Cinema Club, had secured a one-screen and much shortened version of *Chelsea Girls* and had shown it earlier, but I managed to persuade Warhol's distributor Jimmy Vaughan that there WAS an audience for the full two-screen, three and a quarter-hour version, and he allowed me to show it. And I was right; it was hugely popular.

Poster designed and silkscreen printed by Biddy Peppin.

Chelsea Girls fitted the times perfectly. It had the glamour of all-things New York. It was shambolic, casual, improvised at best. It shared *IT*'s attitude to sex and drugs: that anything goes and above all everything should be shown and talked about. It was psychedelic in parts. In the Lab schedules we quoted from Jack Kroll's enthusiastic *Newsweek* review: "The fact is that in today's splintered world, Warhol's split screen people are just as meaningful as Jack Gelber's garrulous junkies, Edward Albee's spiteful comedians, John Updike's poetic suburbanites. So there they are, two helpings at a time – in colour and black-and-white – the fat lesbian pill popper who lives on the telephone like a junkie Molly Goldberg; the tomato-faced W.C. Fields-like mother ranting against her over-cool son while his passive chick sits frozen with intimidation; that same chick in another room, herself now the sadist to her passive chicks; a vacantly beautiful blonde endlessly trimming her bangs like the Lady of Shallot waiting for a lanceless Lancelot; a blonde-helmeted boy, an Achilles of Narcissism, doing an onanistic monologue-and-strip in a coloured stroboscopic limbo which makes him look like Man regressing to a primal homunculus." (He's describing Brigid Polk (now Berlin), Marie Menken (a needlessly cruel description), Gerard Malanga, 'Hanoi Hannah' (Mary Woronov), Nico and Eric Emerson, the latter filmed mid LSD-trip).[36]

71

The Film Co-op's potential sphere of influence – as mapped by Malcolm Le Grice following discussion with Simon Hartog.

Poster designed and silkscreen printed by Biddy Peppin.

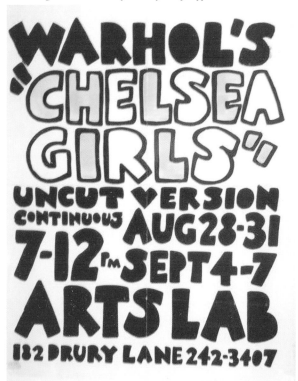

But the Warhol experience was tough on our projectionists.[37] Until then, being a projectionist at the Lab entailed getting to know intimately a huge variety of interesting films. These marathons were more of an endurance test, so the shows by individual artists and group presentations which interrupted them were a welcome relief. That said, we showed Malcolm Le Grice's programme four times in November, such was my certainty of the importance of his work.[38]

In October, Birgit Hein wrote to Steve Dwoskin inviting him on behalf of the London Co-op to a meeting to be held in Munich in November, as a follow up to Knokke, and with the founding of a European Filmmakers Co-op on the agenda. Steve asked me to accompany him and I wrote to Birgit suggesting I brought "some films by Malcolm Le Grice, who is one of our best filmmakers".[39] At the meeting we agreed that *all* Co-ops in Europe should publish complete listings of their colleagues' collections in their own distribution catalogues. Films were shown, and there were further exchanges of addresses and phone numbers; there was a sense of a momentum gathering across Europe. In December, Birgit wrote to me "this morning arrived the list from Carla Liss with the films you got from Mekas. Congratulations!!"[40] (The New American Cinema collection had now been promised to the London Filmmakers Co-op and would arrive in Summer '69). She went on to report on her progress in compiling Germany's version of the international distribution catalogue, which the German magazine *Film* would publish. But the European co-op wasn't to be. Her catalogue efforts were not reciprocated elsewhere, and worse, she can hardly have really welcomed Carla's news that the London Co-op had gazumped its European partners in the bid to secure these American films. A double bill in late November of Downey's *Chafed Elbows* and *Sins of the Fleshapoids* (Mike Kuchar, 1965) followed by a late show of *Hells Angels* (Howard Hawks, 1930), was the last set of screenings at Drury Lane programmed by me.

After the split, *IT* announced a new 'free flow' use of the building, 'one ticket admits to all', and from 11 December 'every night indefinitely' *Don't Look Back* (1967) D A Pennebaker's record of Bob Dylan's 1965 concert tour in England,[41] which carried on as the main attraction through January and February, till its role was filled in March by *The Magical Mystery Tour* (BBC, 1967), a print donated to the Lab in a gesture of support by the Beatles. This pattern was interrupted in early January by a one-off screening of *Baldwin's Nigger* (1969) by Horace Ové (oddly paired with *Corps Profond* (Etienne Lalou/Igor Barrere, 1960). By

At the European Filmmakers Co-op meeting in Munich, October '68; Birgit Hein, Steve Dwoskin, Robert Beavers and the author (photo courtesy Birgit Hein).

then, Jim had invited Sandy Daley to look after the cinema programme and in between the repeating Dylan and Beatles features she added a screening of Yoko's *No 4*,[42] a repeat of *Chelsea Girls*[43] and Scottie's *Longest Most Meaningless Movie in the World*, this latter 'now 8 hours ...' and a scattering of Lab favourites such as *Cabinet of Dr Caligari* (14 February); *Battle Ship Potemkin* (28 February); *The Saragossa Manuscript* (Wojciech Has, 1965)[44] (10 March) and 'The Films of Jean Vigo' (22 March). She also offered occasional mixed history programmes such as one that that paired Clair's *Entr'acte* with films by Robert Breer and Ray and Charles Eames in February and 'Early films including Lotte Reiniger' in March. Films new to the repertory included *Lee Harvey Oswald* ('a BBC CIA

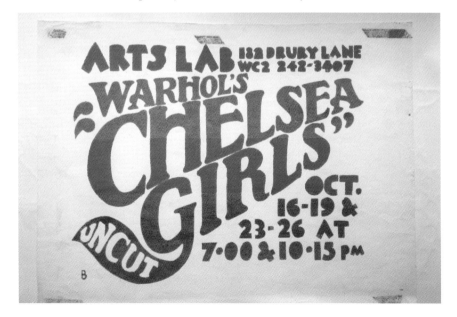

Poster designed and silkscreen printed by Biddy Peppin.

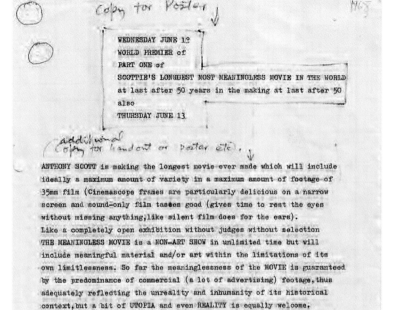

Draft text by Scottie for an unrealised poster/flier. Shown first in June, Movie had many subsequent performances at both Labs, growing in length with each appearance.

documentary') in February and a China season in March, beginning with *The Opium War* (details lost) followed by *The Magic Lotus Lantern* (1959), before in April returning to old staples such as Welles's *The Magnificent Ambersons* (1942), Edward Dmytryk's *Farewell My Lovely* (1944) and in May, *Les Enfants Terrible* (Cocteau / Jean-Pierre Melville 1950), *The Round-up* (Miklós Jancsó, 1966) and 'Trivia, trailers, Films Flash Gordon etc.'. The last of Sandy's programming seems to have occurred in May and June when films of the Living Theatre's *Paradise Now* (possibly an early draft of Sheldon Rochlin's film of 1970?) and *Théâtre-Libre* were on show 'from time to time'.

At the end of May '69, Hoppy held an 'all night demonstration of video shot on Sony Portapak' at the Lab as part of the Camden Fringe Festival, his press release enthusing: "The equipment supplied by TVX is made by Sony … and is the only truly portable TV equipment in the world. It weighs only few pounds and runs off its own internal batteries. It's so easy to operate that much of our material has been shot by interested on-lookers after only a few seconds of instruction. … It was featured on BBC-TV's *Tomorrow's World* programme last week. … This material would not normally be seen on TV due to its 'experimental' and 'avant-garde' quality. … Included are electronic experiments and very frank interviews with well-known people."[45] Hoppy's video was certainly 'avant-garde' in the sense that his advocacy of the medium was pioneering and inspiring. And Jack's collection of video records of talks and events, such as *Bobby Seale Black Panther Officer at Columbia University* on offer in June presumably filled in at least some of the yawning gaps in the cinema's schedule. The soft-floor cinema's reputation as a flop-house and sometimes orgy venue (the former fully justified, the latter perhaps less so) dates from this period.[46]

Endnotes

1. Lutz Becker and Ray Durgnat were Slade students then, and led many memorable post-film discussions.

2. The performance artist Bruce Lacey and film-installation-maker Jeffrey Shaw were others whose work I probably saw at Better Books.

3. Stacy attended the Knokke festival and reviewed it for *New Worlds* magazine. She was later active with Maurice Hatton and others in attempts to reform the BFI.

4. Maker of *Wholly Communion* (1965) his record of the Albert Hall poet's gathering and *Tonight Lets All make Love in London* (1967) a portrait of 'Swinging London'.

5. *No 4* was shown together with a filmed record of her *Wrapping Event* (one of the Trafalgar Sq. lions, wrapped, Christo-style). The cinema is still very recognisable, though now a pub, The Montagu Pyke. *No 4* was shown at the Lab in 1969.

6. The EXPRMNTL Festival was held in the seafront Casino, with its decorations by Rene Magritte. Yoko Ono performed a bag piece, and showed *No 4* out of competition. Jeffrey Shaw was then active in London, later one of the founders of ZKM, Karlsruhe. Steve Dwoskin had films in competition and won the Solvay Prize; John Latham projected films into an inflatable by Shaw; Don Levy showed his *Herostratus* (1967) funded amidst some controversy by the BFI; John Gillett from the BFI and Mike Kustow from the ICA (where Levy's film was premiered) also attended.

7. Birgit and Wilhelm Hein were there from Germany with their film *Rohfilm* (1967) and I was immediately struck by its close affinity with Malcolm's *Castle 1*. Also at Knokke were Lutz Mommartz, Werner Nekes and Dore O (Germany); Alfredo Leonardi, Gianfranco Baruchello and Tonino DeBernardi (Italy); Pierre Clémenti and Etienne O'Leary (France); Peter Kubelka and VALIE EXPORT (Austria), Takahiko Iimura (Japan); Albie Thoms and Arthur and Corinne Cantrill (Australia); Robert Breer, Paul Sharits, Michael Snow, Joyce Wieland, Stan VanDerBeek, Shirley Clarke and Jonas Mekas, and the scholar/curators P Adams Sitney and William Moritz (all USA/Canada); the USA émigrés Gregory Markopoulos and Robert Beavers, and many more.

8. http://pie-in-the-sky.org/2015/05/22/ben-van-meter-sf-trips-festival-an-opening/

9. I myself contributed a painted and bleached psychedelic film based on footage shot by Tutte Lemkow at the *14 Hour Technicolor Dream;* Anthony Stern's *San Francisco* (1968), made for the BFI, another example.

10. 'Report from Swinging London' by Miles in *Village Voice* 2 January 1968, mentioning screenings of the film at the Arts Lab, with Jonas's circling of '*Flaming Creatures*' and note "if true, MUST BE ACCOUNTED to Jack – Jonas." I sent Jack a long apology. [Drury Lane letters file]

11. *The Diaries of Kenneth Tynan* John Lahr (ed.), Bloomsbury 2001. A letter from Jim to John Lennon [15 May 1968, Napier] records that we arranged for him to see *Creatures* at the Lab, just before Sitney reclaimed the print.

12. In her *Against Interpretation,* Farrar, Straus and Giroux (1964).

13. Buck remembers: "I saw [*Creatures*] at the Lab a number of times. The images that lingered were the cock creeping over the shoulder of Joel Markman, the rape scene which defied scandal through its posturing and comic fakeness, the wobbling breasts, and the prolonged lipstick application scene. Only at later viewings did I notice the cock-fondling; how desire (not from a homo-erotic angle) was stamped upfront … It broke so many notions surrounding filmmaking, not just in the content, but in its approach and techniques … That Jagger, Pallenberg and Donald Cammell, if not Nic Roeg, saw *Flaming Creatures* is obvious from the lipstick application scene in *Performance* (1970)". Email 2 October 2019.

14. In some of her writings, Schneemann attributes 'the gaze' to that of her cat, Kitch.

15. Such as Larry Jordan, Willard Mass, Paula Chapelle, Robert Gessner; Gerome Hill, Carl Linder, Thom Anderson, Gary Schneider, Storm De Hirsh, Red Grooms and Gordon Ball.

16. 'The New American Cinema exposition' P Adams Sitney, *Film Culture* n46. 'Autumn 1967', in fact October 1968.

17. Others in May–June: *Edgar Alan Poe* (D W Griffiths 1909) plus *The Cabinet of Dr Caligari* (Weine, 1920); *Blackmail* (Alfred Hitchcock 1929) plus *Romance Sentimental* (Eisenstein and Alexandrov, 1929) both sound-experiments of a sort.

18. Undated letter to the author, clearly intended for publication or display … [Drury Lane letters file].

19. Brakhage was then exploring the sale of 8mm prints as a way of generating income.

20. Such as – a programme of films by Maya Deren and Germaine Dulac, *Le Sang des Betes* (Georges Franju 1949), *The Fall of the House of Usher* (Jean Epstein 1928), Leni Riefenstahl's 1936 *Olympiad* reels, Dziga Vertov's eye-opening *The Man With the Movie Camera* (1929), Fritz Lang's *Metropolis* (1927) and more.

21. *Winter Epitaph for Michael Furey* (Wees, 1967), *Shiva Ree* (Meader, 1968) and *Celebration no1* (Meader, 1967). Wees is noted for his books *Vorticism and the English Avant-Garde* (1972); *Light Moving In Time* (1992*), Recycled Images: The Art and Politics of Found Footage Films* (1993).

22. *The Grasshopper and the Ant, Papageno, The Gallant Little Taylor*, and an extract from *The Adventures of Prince Achmed (Die Abenteuer des Prinzen Achmed*, 1926).

23. 'American and European Animation: Disney, Fischinger et al.'. We showed Wheeler's own *Numbers Racket, Candix Plane, Sacrament 1, Dave's Fantastic 50s Rock Band,* et al. in July and again in November. Earlier, Wheeler assisted Scottie project his *Longest Most Meaningless Movie* … Wheeler remembers: "I met Jonathan Miller in 1967 when he came to the United States to screen his BBCTV *Alice in Wonderland*

(1966) and we struck up a friendship. … When I arrived in London the following summer … I wound up crashing on the couch in his living room for a month while checking out the burgeoning arts scene in London. Jonathan … immediately suggested that I visit the Arts Lab, where I was warmly welcomed and informally put to work doing program notes, assisting with screenings, projecting in the downstairs 'soft cinema' … . At its best, the Lab offered a utopian vision of a community of artists working together to create a free and open space for experimentation and the public presentation of cutting edge work – and it certainly had an enormous impact on my later career as a filmmaker and writer." Email June 2019.

24. 'Borowczyk, Cannon, Dunning, Eames, Freleng, Hubley, Kolar, Kristl, Kuri, Laloux, Lenic, Mimica, Murakami, Vukotic etc.,' John Collins as so often my source of advice.

25. It would be a long wait for Harry Smith; the New American Cinema collection brought from New York by Carla Liss failed to include his work and prints only arrived when I bought them for the Arts Council's *Film Tour* in the late 1970s.

26. Larcher made his film *K O* while at the RCA in 1965.

27. We showed *Newsreels* No 1-5 (3–4 July) *Newsreels* No 6–10 (5–6 July). Kramer quote *Film Quarterly*, winter 1968.

28. Either Simon Hartog or Jean-Jacques Lebel was the conduit for these films.

29. Dixon: *The Exploding Eye: A Re-Visionary History of 1960s American Experimental Cinema* (1997). Re-titled *Dialogue with Che*, Soltero's film was shown at the Cannes and Berlin Festivals in 1969.

30. "We actually built the bath in the medieval perspective of the 15^th c picture. It was shot in Berkeley in Summer of '66. I took the picture around on Telegraph Avenue and asked everyone if they would like to be in the movie. I wasn't expecting it but they just about all said yes. That was the summer of the nude beach parties. Why they are still is because they're trying to pose like the painting; the parts where they break up, those happened spontaneously". SD Contemporary note. Later, in New York, Sandy lent Robert Mapplethorpe his first camera and made the portrait of him *Robert Having His Nipple Pierced* (1970) premiered at our 1970 NFT Underground Festival, (a film described by Patti Smith as 'Robert's *Chant d'amour'. Just Kids*, Bloomsbury 2010).

31. Did Gidal's love of repetition start here? He recalls when preparing for that screening "I said I only have two 5 min prints [of *Room*], no equipment to separate them … . you said 'why not showem both?'" Email 23 May 2020.

32. Including Buchet's *Insane*, Robbe De Hert's *Histoire d'un déménagement* (1966), and Roland Lethem's *La Ballade des amants maudits (*1966) and probably *Les Souffrances d'un oeuf meurtri* (1967), this latter a 'love-poem' in the spirit of Georges Bataille.

33. *IT* on-line archive … For illuminating but unsurprisingly conflicting accounts of these Co-op/Arts Lab tensions, see Mark Webber's *Shoot Shoot Shoot*, Lux Publishing 2016.

34. But there is no further reference to Exchanges in the schedules.

35. *Fireworks, Eaux d'artifice, Scorpio Rising, The Inauguration of the Pleasure Dome.*

36. *Newsweek* 14 November 1966.

37. Our projectionists then included Al Deval, Zoran Matic, Alan Shepherd, Dave Harrington, David Kilburn, Mike Leggett and me.

38. 1–2, 10–11 November 1968, included were *Castle 1, Castle 2, Little Dog for Roger, Blind White Duration, Talla, Yes No Maybe Maybe Not*, all 1967–1968.

39. Letter 30 October 1968. It seems I took Malcolm's *Talla* (1967–1968).

40. Letter 19 December 1968.

41. The film was secured by the teenage theatre-hand and sometime projectionist Matthew Knox, Pennebaker's nephew.

42. For Ulla Driehaus, (now Ulla de Mora) one of Sandy's projectionists, screening Ono's *No 4* was a highlight: "I got to shake [Yoko's] hand and that of John Lennon, one of my biggest heroes". Email 23 August 2018.

43. Sandy probably knew most of the cast of *Chelsea Girls* personally, since when in New York she lived in the Chelsea Hotel where it was filmed. Of her time at the Lab she recalled "I have such fond memories … such as making 8 mm movies with Syd Barrett or showing Godard's *One Plus One* twenty-four hours a day until the print wore out". Letter 1 February 2020. When she showed the Godard film is undocumented.

44. With its Russian-doll structure of one story within another, this was already a much-repeated late night Lab favourite.

45. Press release [Drury Lane documents file].

46. See for example *Days in the Life*, Jonathan Green, Pimlico 1998.

Challenges

On 15 November 1968 a notice was posted in the Arts Lab signed by Jack Moore: "The Human Family will stay [in residence at the Lab] at least until the day after Christmas. During this period, Jack will make the schedule and policy decisions. Anything projected for this period should be mentioned now as time and space will be minimally available throughout the entire building, which will probably be open around the clock. The overall policy envisioned in the last meeting is hopelessly horse-before-the-cart and we have vetoed all decisions. We feel that the financial problem is more a question of wise spending and fund-raising than one of increased centralised control."

This declaration was Jack and Jim's response to Lab-workers' meetings held in October and November at which a number of changes had been proposed, notably including budgetary planning and oversight, prompted by the deepening financial crisis and a growing sense that the Lab's social function, that now seemed to include serving as an overnight refuge, was endangering its artistic purpose. Rent and rates hadn't been paid; equipment was disappearing; the issue of fire exits hadn't been addressed and the question of who would be responsible for policy in the theatre when Jack returned was unresolved. Jack's assumption that he would take sole control of the theatre particularly alarmed David Jeffrey, Martin Shann and Will Spoor who had been responsible for its smooth running it in his absence.

In the notes of this meeting, headed "Arts Lab – things that will have to happen to make the place possible to work in creatively rather than as drudges", there were proposals that "all scheduling to be carefully coordinated; [some] productions prioritised, others given a minimal amount of time unless they showed promise", in other words, 'quality' mattered.[1] There were suggestions about the allocation of rehearsal time and technical resources; essentially, if they involved Lab staff, they should be paid-for; urgent maintenance and building a fire escape "should be our only expenditure now". The back room should become a laboratory for the theatre's lighting and sound research "so we may have to sacrifice the hostel angle." And more "We should concentrate office functions on desk area and keep all staff and information there. All technical and sound equipment should be kept in the kitchen area (with new lock and fire-proof

```
Arts Laboratory, 182, Drury Lane W.C.2.

THE FOLLOWING ARTS LAB CO-FOUNDERS AND STAFF HAVE BROKEN ALL CONNECTION
WITH JIM HAYNES' ADMINISTRATION OF THE ARTS LAB.

David Curtis          Cinema Director
David Jeffrey         Technical Director
Philippa Jeffrey      Administrative Co-ordinator
Biddy Peppin          Gallery Director and publicity
Pamela Zoline         Gallery Director
Martin Shann          Master of Works
Will Spoor            Theatre Director
John Collins          Accountant
David Kilburn         Cinema
Ellen Uitzinger       Administration
Rosemary Johnson      Administration

On November 15th a notice was posted in the Lab, signed by Jack Moore
(who has been on tour in Europe for the past 6 months), vetoing all
proposals for decentralising Lab administration, and announcing that
from December 10th Jack will make all "schedule and policy" decisions
and that the building will be only "minimally available" to groups
other than the Human Family.

We believe that people working in all media must have freedom of
access to the Lab's facilities, and that this cannot be guaranteed
under any dictatorship however benevolent.

                                            November 18th '68
```

The mutineer's point of no return, November '68.

door)"; Philippa should be sole holder of the Admin chequebook, David Jeffrey the Theatre one, and "a separate account be opened for Jack when he returns … He should *not* be able to cash cheques at the till"! Tensions had been developing for some time.

Jack's notice, with its dismissive tone, and Jim's implicit acquiescence, prompted the posting of another (on the 18th), announcing the withdrawal of the majority of the staff, concluding (pompously): "We believe that people working in all media must have freedom to access the Lab's facilities, and that this cannot be guaranteed under any dictatorship, however benevolent".[2]

With fortuitous timing, an article by James Allen 'The Arts Lab Explosion' appeared in *New Society* on the 21st of the same month, commenting on the rapid growth of Art Labs across the UK, and rehearsing some of their shared problems. "The provincial mushrooming of arts labs has taken everyone by surprise … There are now five full-time provincial arts labs with permanent buildings (Brighton, Manchester, Newcastle, Halifax, Cambridge); five more which should shortly acquire buildings (St Ives, Edinburgh, Birmingham, Oxford, Coventry) and at least a dozen towns … which have arts lab activities going on, but no permanent premises yet. … The economics of small theatres are such that an arts lab (maximum audience never more than 100 at Drury Lane usually less elsewhere), will automatically show a loss however successful the production. … At Drury Lane, producers normally do not receive payment. Actors and actresses there get only a percentage of the takings; the fifteen full time permanent [Lab] staff share a maximum of £150, split between them. … Sometimes the problem is overcome by a combination of Arts Council subsidy and 'risk-and-safe' mix policies. Strangely enough, while the London Arts Lab has been turned down three times by the Arts Council (one at least after express recommendation by the Drama subcommittee) the relatively unproven Brighton Combination has just been awarded a substantial sum, even though it had not applied."

The Drury Lane Arts Lab's relationship with the Arts Council was indeed problematic. The Council's Chairman Lord Goodman had previously been supportive of Jim but now disapproved of his involvement with *IT*,[3] and there was a further complication that nineteen-year-old Nigel

Samuel – on the Arts Lab's letterhead as one of the company directors – had come into a fortune following his father's suicide, and this vast inheritance was administered by Goodman.[4] Was Jim taking advantage of Nigel? In May '68, in a letter to Goodman, Jim had tried to address these issues: "I'm sorry to have caused you concern, yet I would like you to know that I appreciate all that you have done for me and for the arts in this country. I have always looked upon you as a friend. Recently many people have said you were against any Arts Council financial assistance to the Arts Laboratory. After our recent breakfast, I departed with the distinct impression that you intended to remain neutral as far as your position on the Arts Council; and that if the Drama Panel made a recommendation, you did not plan to block it. Did I misunderstand you?" He insists that Nigel's role is nominal, just one of four directors, his liability limited to that of initial guarantor for the lease and overdraft, and suggests: "if Nigel wants to withdraw he is free to do so", then declares: "There is no legal link with *IT*… . Drugs. I feel as strongly as you do. … The arts can fill the void in lot of young people's lives."[5]

It had no effect; indeed Jim's decision to include a copy of *IT* to illustrate the newspaper's inoffensive nature was probably a mistake. The popular press was already obsessed with 'Summer of Love' stories of drugs and promiscuity in which *IT*, the Arts Lab and other underground venues regularly featured. Hoppy had been imprisoned in June '67 for cannabis possession; Mick Jagger and the gallerist Robert Fraser were arrested for possession in the same month; the establishment had youth culture and the underground firmly in its sights. More than once, in its first year, the Lab had been raided by the police, but fruitlessly. On one occasion the Drugs Squad even naively planted cannabis in the corridor outside Jim's room where it was discovered and disposed of before they arrived. They claimed to be looking for 'stolen theatre costumes' and went straight to where the drugs had been concealed, and were visibly disappointed by their absence. (Jim didn't smoke, drink alcohol or have any need for drugs.)[6]

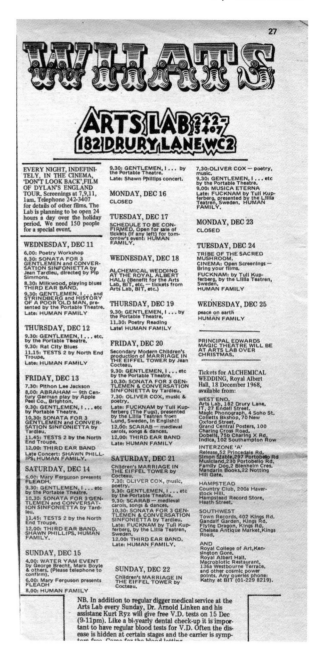

The Lab's schedule begins to reflect changes after the split. From 'Happenings' page IT *n 46, December '68.*

CIRCUIT 2/6

···· ARTISTIC LIFE IN THIS COUNTRY MUST NOT BE DOMINATED BY A SMALL, NON ELECTED, SELF APPOINTED CAUCUS IN ST JAMES SQUARE — LORD GOODMAN

··· YOUNG PEOPLE LACK GUIDANCE, LACK CERTAIN TIES LACK VALUES ···· THEY NEED SOMETHING TO TURN TO ···ONCE YOUNG PEOPLE ARE CAPTURED FOR THE ARTS THEY ARE REDEEMED FROM MANY OF THE DANGERS THAT CONFRONT THEM AT THE MOMENT ·····

The Arts Council Chairman Lord Goodman's pervasive influence reflected on the cover of the literary magazine Circuit, *the voice of FACOP in Summer '69 (image courtesy David Bieda).*

While Goodman was vetoing any direct support of the Lab, curiously, during the same period, the Drama Panel was able to make individual awards to emerging playwrights and fringe companies including some very closely associated with the Lab such as Pip Simmons, Hare and Bicât and Lee Harris. Nor had the Arts Council any difficulty in supporting other contemporary multi-art-form arts venues. In Edinburgh, The Traverse was in yearly receipt of £13,000 from the Scottish Arts Council, and in London the ICA was supported by the Arts Council in its move from Dover Street to new premises in the Mall, and also received revenue funding.

The question of subsidy for filmmaking and film screenings was different. I soon discovered that the Arts Council had no interest in film other than as promotion for other art-forms, (to this end it had commissioned a number of documentaries about artists, produced and distributed for the Arts Council by the BFI). The BFI had an Experimental Film Fund which financed calling-card short films by emerging talent heading for the film Industry.[7] Neither had funding available to support film exhibition. Furthermore, neither the Arts Council nor the BFI had any conception that artists might want to make films, as they made paintings and wrote poems, and that at least *some* aspects of this activity might be worthy of support. Malcolm and I set out to educate them.

In the autumn of '68, I proposed a distribution scheme for experimental film to Hugh Evans, the Arts Council's officer then responsible for its arts documentary-making, and wrote an unsolicited paper *Subsidies to Independent Filmmakers: the present situation and how it might be improved,*[8] which I sent to both the Arts Council and the BFI, suggesting a way forward, but nothing resulted. (It would be 1973 before an Artist's Film Subcommittee was set up at the Arts Council.)[9] I corresponded with William Coldstream who was Chairman of the BFI and a Council member at the Arts Council, so was in a position to be useful; Malcolm and I both knew him from the Slade where he was Professor (Head of School). He, too, was sympathetic, and indeed came to a screening at the Lab at our invitation in October '68;[10] he invited us to meetings, but again it would be years before there was any real change in attitude at the BFI.

When the BFI *did* change in the mid-70s, it was as a result of Malcolm's patient cultivation of Bruce Beresford, then head of the Experimental Film Fund, and Bruce's more sympathetic successor Mamoun Hassan, who took over in 1971.

Our frustrations were shared by the many people then setting up regional Arts Labs and becoming involved in new art-forms. In late September or early October '68, Philippa Jeffrey and Nicholas Albery organised an Arts Labs Conference at Drury Lane to discuss common problems and agree a united approach.[11] Towards the end of that year, a lobbying organisation – Friends of the Arts Council Operative (FACOP) – was established, with key players including David Bieda and David Robins of *Circuit* magazine, Su Braden of Pavilions in the Parks and artists Jos and Joe Tilson,[12] and more loosely associated Peter Sedgeley and Bridget Riley of Space Studios and Artists Information Registry (AIR), Barbara Steveni and John Latham of the Artists Placement Group (APG), Bill and Wendy Harpe from Liverpool's The Blackie, and many of us from different Labs.[13] FACOP directly lobbied a panel that had been set up by the Arts Council to investigate the case for establishing a New Activities Committee, and counter-proposed the setting up of a 'democratically elected artists' panel' to address living artists' needs. In June '69, FACOP organised an Artists Conference at St Katherine's Docks in London attended by 350 artists "to discuss the role of the artist in society, the problems of patronage, the need to spend money on living artists rather than dead art, the situation of the Arts Labs, the need for new and better buildings for the arts". Malcolm contributed to *Circuit's* series of reports on the Conference, endorsing FACOP's proposal of an 'artists' panel', and Roland Miller of the People Show contributed a paper proposing ways in which the Arts Council might "meet the difficulty of subsidising theatre groups that are both homeless and outside the normal run of commercial dramatic work".[14] Suggestions poured out of us.

In response, later that same June, the Arts Council invited a number of us onto its newly formed New Activities Committee.[15] We were first summoned to a 'get to know your chairman' meeting at Michael Astor's home in Swan Walk, Chelsea, where we were served breakfast by his butler; a generous gesture, but possibly as misconceived as Jim's enclosure of *IT* in his letter to Goodman, for the gap between us and them can rarely have felt greater. The Committee's aims were set out in a letter from Astor to Malcolm: "(1) To spend its somewhat inadequate capital wisely and see that certain existing organisations (such as Brighton Combination) which have started well, do not die for lack of funds [which Brighton, Drury Lane and Robert St, all duly did]. (2) Prove convincingly

FACOP campaigning poster, designer/printer uncredited.

'J Henry Moore's finest moment'. Jack designed this ad which formed the rear page of IT *n 46, December '68. Reproduced from Johannes Eichmann's* Anatomiae pars prior *(1537), an early account brain dissection, the face and gesture might be Jack's own.*

the need for a good deal more money ... (This is why the Committee must have strong representatives at Council level) (3) Establish in the course of its first six months an effective modus operandi for the future. No doubt there will be other organisations such as FACOP or the artists' council which will pursue their own course ...".[16] At the Committee's first formal meeting there were applications on the table totalling £214,000 but just £15,000 available. This miss-match was so absurd that we decided not to fund any individual projects, but to spend the £15,000 on a series of regional fact-finding and awareness-raising gatherings or festivals, but of no immediate help to anyone. There would be no response to our pressing needs.[17] Jim had often wryly pointed to the fact that according to the Covent Garden Opera House's own accounts, its kitchens alone received £35,000 in annual subsidy from the Arts Council; in the same spirit, FACOP produced a fine May '68 style silk-screened poster of a pair of scales with 'Covent Garden £1.5 million' on one side of the balance, '150 Arts Labs at £10,000' on the other.

A year earlier, an injection of £10,000 might indeed have saved the Drury Lane Lab, though one wonders whether Jim would have simply passed it on to Jack and the Human Family, for whom he maintained such an unwavering affection. A week before we staged our August *Chelsea Girls* marathon in an attempt to rescue the Lab's finances, Jim had written to Victor Herbert (the Living Theatre's sponsor): "Thank you for your letter and offer of support for the Human Family. So far I have raised about £160 which I have passed to Jack. There is talk of a large scale Albert Hall pop concert to help the Human Family and the Laboratory" (*The Alchemical Wedding*). He mentions the Drama Panel's three recommendations and Goodman's veto "because of my relations with him, because of *International Times*, because of Nigel Samuel, etc. etc.", then continues "Nigel is no longer associated with us, and, departing, he was at least good enough to clear our overdraft of £2,200. ... Will you or do you know anyone who might be prepared to act as guarantor? we have had talks with the Beatles' solicitor and with John Lennon and they promised me verbally and in writing [that] as soon as their Foundation has been formed the Arts Laboratory will be one of the first recipients of a grant. They expect the Foundation to be formed in the New Year."[18] Victor declined, and the Beatles Foundation support wasn't forthcoming either; by the New Year a more business-like regime had taken over at Apple.

ARTS LABORATORY,
182 Drury Lane,
Covent Garden,
London, W.C.2.
28th October, 1969

Dear Friends,

Pleasr accept this duplicated newsletter from me with some news
which should interest you. The Arts Laboratory located on Drury
Lane for the past two and a half years is closed. The Arts Lab
was many things to many people: a vision frustrated by an indifferent,
fearful, ans secure society; an experiment with such intangibles as
people, ideas, feelings, and communications; a restaurant; a cinema;
a theatre (Moving Being, Freehold, People Show, Human Family, etc);
underground television (Rolling Stones at Hyde Park, Isle of Wight,
Dick Gregory All-Night Event); a gallery (past exhibitions include
Yoko Ono & Lennon, Takis, et al); free notice boards (buy/sell, rides
to Paris); a tea room; astrological readings; an information bank
(tape,video,&live-Dick Gregory, Lennie Bruce,Michael X, Michael
McClure,...); happenings (verbal and otherwise); music (live and tape
including The Fugs, Donovam, Leonard Cohen, Third Ear Band, Shawn
Phillips, Kylastron,etc.); books,magazines, and newspapers (Time
Out, IT, SUCK,OZ,Rolling Stone);information.

People flowed through--young,old,fashionable,unfashionable,beautiful,
bored,ugly,sad,agressive,friendly--five bob if you can afford it,
less if you can't. A few people in a position to help financially
took but never gave. They asked, "What's the product? What's its
name?" The real answer was Humanity: you can't weigh it, you can't
market it, you can't label it, and you can't destroy it. You can
touch it and it will respond, you can free it and it will fly, you
can create it and it will grow, if you kill it- it's murder. The
kids here don't believe it's the end and they're right for it will
reappear in another form. "We are the seeds of the tenacious plant,
and it is in our ripeness and our fullness of heart that we are given
to the wind and are scattered."

Some facts: The Arts Council gives £13,500 per annum to the Traverse
Theatre in Edinburgh which I founded and directed and which is only
one third the size and scope of the Lab. The kitchens of the Royal
Opera House are given some £37,000 per annum by the Arts Council.
The Arts Lab received no support from the Arts Council. I have been
xasked to join the Arts Council. I am £8,000. in debt.

The future: My future plans and the future plans for the Lab are
clouded. I might move to Paris or to Amsterdam or to both cities.
I have been invited to lecture at the new University of Paris at
Vincennes. The Lab has been invited to present a season of London
theatre, film, music, experimental television, etc at La Lucernaire,
a theatre in Paris, in December.

The loss does not diminish the scope of the experience, I have
learned. The fullness and unpredictability of the future out-
distances the past. Perspective brings understanding-a property
of future and past. The future has a delightful habit of turning
into the present.

Blessings and regards,

Jim Haynes

Future address:
Post Office Box 2080.

Jim's bittersweet farewell to London.

83

In his *Guardian* obituary 'Lights out for the Arts Lab' Nicholas de Jongh recalled that "in March ['69] the Chairman of Hampstead Magistrates granted a distress warrant to Camden Borough Council for the Arts Lab's non-payment of rates. An anonymous gift of several thousand pounds given to Haynes averted disaster. But it was not sufficient."[19] This latter gift of £5,000 was almost certainly given by Sylvina Boissonnas, the young Parisian heiress who was also at the time supporting individual members of the Exploding Galaxy and the extraordinary Zanzibar group of film-makers in France.[20] *The Alchemical Wedding* at the Albert Hall (18 December 1968) needless to say failed to make serious money, though Jack sold some video footage to Dutch TV; Jack's first collection of video equipment, donated by Lennon, had been lost during the Family's travels; new equipment was bought with which to record the *Wedding* and the receipts covered its purchase, hire of the Hall and fees to performers, but little more.[21] Without Arts Council support, the Lab's financial ills were incurable.

Though not a financial success, for Lee Harris, the *Alchemical Wedding* was none the less memorable: "The hour had come, the crowd buzzed with excitement, but nothing happened. The audience started to fidget in their seats, there was an air of anxiety about. Then I noticed the small bedraggled figure of Jack Moore walking slowly through the crowded well of the hall, his finger to his lips beckoning silence. By the time he had reached the front of the stage there was a silence only broken by the odd nervous guffaw or raucous catcall from the back. The silence became long and deep and seemed to engulf us. Then, almost out of nowhere, someone banged a drum, there was an ecstatic cry of joy, the Krishna devotees began to chant and I found myself swept off my feet by the momentum. The space in front of the stage filled with swaying, swirling bodies high on the energy created out of the silence. It was J. Henry Moore's finest moment. This was the culmination of what The Human Family was about. Theatre in its highest form was an act of communal magic that could transcend earthbound reality. Musicians played, poets ranted, and John and Yoko crept into their white sheet-like bag on the stage and stayed there out of sight for what seemed like ages. I watched a baby crawl slowly by. And that was the 'bag happening'. All mayhem broke out when a young female member of the audience stripped off her clothes and danced in naked delight. When the police were called and attendants tried to remove her, groups of people started stripping off their clothes in solidarity. There was a retreat and a truce was worked out, and no-one was arrested."[22]

Following the *Wedding*, and especially in the Lab's last nine months, the number of penniless teenagers coming from afar and expecting to sleep

at the Lab grew to a flood (Jim blaming the many TV programmes that had featured the Lab and directly associated it with the Beatles, thanks not least to John and Yoko's exhibition). Early in '69, he took over the boarded-up and abandoned Bell Hotel near the Lab to accommodate them, and tried to persuade the GLC to accept rent to make this occupation legal. Before long, the police arrived and made the place inhabitable.[23]

Jim obliquely anticipates this shift of focus for the Lab in an appeal to Lord Goodman, written just days after the departure of the majority of his original Lab team. "I would like to solicit Arts Council patronage on behalf of the Arts Laboratory and for all the artists who work with us … One aspect of the Laboratory's work which we never envisioned, and which doesn't directly concern the Arts Council, but which nevertheless I feel we should draw to your attention is the amount of time and energy we spend directly helping people of all ages (but mainly young) from all over the world. These people seek our space and time and energy to solve innumerable problems. Sometimes they want to meet fellow poets, painters, musicians and we attempt to bring about introductions. Sometimes they want to know inexpensive places to sleep, restaurants etc., and we have become an important information centre … ."[24]

This new people-centred Lab had its fans. Lee Harris, who came from repressive South Africa and had briefly been part of the Human Family, saw its positive side: "The lab had drifted towards being a people theatre, where we were all performing artists just by virtue of being there. The nice thing about the place was that all sorts of interesting people would pop in. Through Jim's largesse I worked as a make-up artist for Frank Zappa; went down to Stonehenge on a red double-decker bus with The Fugs and sat on the floor cross-legged rapping with Mama Cass."[25]

And Lee again … "To cap it all, one evening in early December, a group of heavy dudes, looking like wild-west frontiersmen, walked into the Lab. It was Ken Kesey and the Pleasure Crew, some Dead-heads and two bikers from the Hells Angel chapter in San Francisco. I spent the night sitting and rapping with them, and in the morning I rode pillion on one of their bikes to the Beatles' plush Apple offices in Saville Row. The group occupied an office suite, and we had a great party where all sorts of people popped in during the day. Time seemed to have slipped by, for it was late in the evening when a figure loomed at the office door. There was a silence as he calmly said, 'It is nice of you to invite me to your home,' reversing the situation. 'Are you asking us to split?', asked one of the Pleasure Crew. 'Ying yang, yes, no', answered George Harrison enigmatically."[26] (Though amicably resolved, this 'occupation' can hardly have helped Jim's pleas to Apple and the Beatles' foundation.)

Perhaps Jim already saw that the end was in sight. As early as January '69, just six weeks after we had left the Lab and still nine months before it closed, he wrote Biddy and me a sweet letter "I hope all is going well with you … I am on a long overdue holiday in Paris, Barcelona, Geneva, Hamburg, Stockholm, Copenhagen, Oslo, Amsterdam, Munchen, Milan, [Florence?], Rome, and shall return to London at the end of February."[27] Was this an admission that he was abandoning the Lab to Jack (and Ken Kesey's Angels, who had taken up residence) and was distancing himself from the consequences? As he travelled through Europe, he was probably already prospecting for a new life elsewhere for it seems that by September he had secured promise of a post at the new University of Paris 8, Vincennes, and indeed he started teaching there later in the year.[28] He was also now one of the founding editors of the sex-liberation newspaper *Suck,* based – for censorship reasons – not in London but Amsterdam.

Yet, that same September, he was also still fighting on behalf of the Lab, writing in Nicholas Albery's *Arts Labs Newsletter*: "In many ways we are in our worst and best positions ever. Bad news first: Money – like everyone else, we are broke. Landlord wants his rent and states he plans to start legal procedures to collect. Also the Fire Department are making life difficult again. Good news. Good group of people creating good vibrations. Much work being done. Building a mixed-media video-theatre in the front room. Front door will be back door and entrance will be from back alley. We are still working on a Video Network throughout Europe and hope to be getting some obsolete 405 TV equipment for free. Food at the Lab better than ever. We hope to open a new building sometime soon. News on this later. We also hope to open an Information Bank. Our company, Human Family, soon to rise again."[29] Just weeks later, the doors shut on the Drury Lane Arts Lab for the last time.

Drury Lane abandoned (photo David Kilburn).

Endnotes

1. Notes [Drury Lane documents file]

2. It was signed: David Curtis, Cinema Director; David Jeffrey, Technical Director; Philippa Jeffrey, Administrative Coordinator; Biddy Peppin, Gallery Director and Publicity; Pam Zoline, Gallery Director; Martin Shann, Master of Works; Will Spoor, Theatre Director; John Collins, Accountant; Ellen Uitzinger, Administration; Rosemary Johnson, Administration.

3. As early as January 1967, Goodman had vetoed Miles's appointment to the Arts Council Literature Panel, because of Miles's involvement with *IT* and by association 'drugs'. On that occasion, Panel member Brigid Brophy led a protest – asking whether Samuel Taylor Coleridge would similarly have been asked to resign – but unsuccessfully. See Peter Fryer 'A Map of the Underground', *Encounter*, October 1967, v29, n4.

4. His late father, Howard Samuel, had been a property magnate, and major Labour Party donor.

5. 9 May 1968 *Thanks for Coming Encore*.

6. Hard drugs were indeed a problem then. Philippa, Biddy and I remember regularly inspecting the Lab's toilets to remove abandoned needles. Philippa remembers trying to 'freeze out' a dealer who came regularly and openly encouraged his young customers to move onto harder drugs. On another occasion … "a teenager who I had got to know appeared to be disturbed … he was holding up the queue … he was trembling uncontrollably and begged me for money. He said he was going into cold turkey and needed a fix. … So rather than having him disintegrate right by the desk, I gave him the money from my wallet. He disappeared but reappeared shortly afterwards, cock-a-hoop and showing off." Email 2 May 2019.

7. Levy's *Herostratus*, shown at Knokke, had been an exception in both its feature-film length and its experimental ambition and had nearly bankrupted the BFI's Experimental Film Fund.

8. Kindly proof-read, typeset and printed by David Kilburn at LPE where he worked; he also published *Green Island*, an occasional magazine of writings and images, and helped with the cinema at both Drury Lane and Robert St.

9. I also sent a letter 'on the cinema's objectives and how it is organised and scheduled' to the great and the good (Joe Tilson, David Sylvester, John Pope Hennessy, Gabriel White and Prof William Coldstream), enclosing this paper [undated, early October 1968; Drury Lane letters file].

10. We showed him Snow's *Wavelength*, Coldstream's letter of thanks reminds me.

11. The Conference was attended by James Allen, and was the source of much of his article. There was a second, National Arts Lab Conference, organised by Philippa Jeffrey with support from the Arts Council and held at the Cambridge Arts Lab in January 1969. A number of us from the still homeless New Arts Lab participated. Nicholas Albery established an *Arts Labs Newsletter* in October 1969, 'produced by BIT Information Service, 141 Westbourne Park Road'.

12. Artist Bernard Cohen remembers a FACOP meeting at the Tilson's flat at which radicals proposed bombing the Arts Council's 105 Piccadilly base. (A desperate joke, surely, but apparently taken seriously by Cohen.) BL 'Artists Lives', *Bernard Cohen* part 19.

13. Pavilions in the Parks 1967–71 hosted arts events in temporary structures in order to reach new audiences, see *Su Braden Artists and People*, 1978; Space Studios founded 1968, still addresses the need for artists' working spaces; APG 1966–2005, sought to place artists in industry for their mutual benefit.

14. 'I Think, Artists Conference Report', *Circuit* 10/11, 1969.

15. Its initial membership included Hugh Davies, Bill Harpe, Jenny Harris (Brighton Combination, later Albany Empire), John Lifton (Computer Arts Society/ New Arts Lab), Jos Tilson (then compiling *Catalyst* her information-sharing bulletin for people/groups involved in the arts), and me, plus the Arts Council officer Ian Bruce, the grandees Griselda Grimond (daughter of Liberal Party leader Jo), Peter Jay (broadcaster & son-in-law of PM Jim Callaghan), Edward Boyle (MP), Frank Kermode (UCL / broadcaster), Lord Harewood and Peter Hall (these last two attending no meetings). Later, apparently at my request, Jim was added to the Committee, but attended no meetings.

16. 11 June 1969 [FACOP NAC file].

17. Peter Stark reminds me that he was a beneficiary of this funding, receiving £1,500 towards "researching New Activities in the Arts throughout the Midlands, writing a report of them and organising a festival *Gathering Number One* … this funding – and recognition – at precisely this point in time was crucial to the continued existence of the Arts Lab in Birmingham." Email 21 January 2018.

18. 21 August 1968 *Thanks for Coming / encore*; TVX's letterhead in spring 69 indicates that Nigel was still associated with Hoppy.

19. *Guardian*, ibid.

20. *Le Révélateur* (Philippe Garrel); *Ici et maintenant* (Serge Bard); *Deux fois* (Jackie Raynal) all 1968; *Acéphale* (Patrick Deval) starring many Exploding Galaxy members, 1969. And more.

21. John Collins, who booked The Albert Hall for the *Wedding*, recalls that the new video equipment largely malfunctioned; Email November 2017, yet *IT* reported "The lab made a Video Television Recording of the whole of the *Alchemical Wedding* – which will be shown on and off during the next two weeks".

22. Lee Harris 'Works', September 1999, www.leeharris.co.uk.

23. *IT* 52, 14 March 1969 Charles Marowitz saw this takeover as being at the forefront of the squatters' movement. 'Dateline London by Charles Marowitz', 'Sorry Jim', *Village Voice*, 11 December 1969.

24. 26 November 1968, [Drury Lane letters file] He wrote on letterhead still listing all the original staff, and needless to say, didn't mention our departure. His enclosure with this letter was a copy of James Allen's *New Society* article 'The Arts Lab Explosion'.

25. Lee Harris 'Works' website, ibid.

26. Lee Harris 'Works' website, ibid. Derek Taylor suggests that George Harrison had himself invited the Hells Angels to visit, when he met them earlier in America. Jonathan Green, *Days in the Life*, Pimlico, 1998.

27. Letter in Drury Lane letters file.

28. In 'Life – Jim Haynes' on the Haynes website (www.jim-haynes.com), he reports that he taught at a Summer school in Granna, South Sweden that year. At Vincennes, he taught 'Sexual Politics and Media studies'. *Suck* was co-edited with Bill Levy (former *IT* editor), Germaine Greer and Heathcote Williams.

29. 'The Arts Lab Movement' (Bit Report), *IT*, 66, 10 October 1969.

PART 2

The New Arts Lab at Robert St. (IRAT)

Setting-Up

Those of us who marched out of Drury Lane at the end of November '68 immediately began to look for a building in which to set up a new Arts Lab – one run on more democratic lines and with a greater emphasis on research and experiment. Biddy, Pam, David and Philippa Jeffrey, Will Spoor, Martin Shann, Hugh Davies, David Kilburn and I were now joined by John Collins (who had plans for a printing-press/workshop), Rosemary Johnson (keen to run a bookstall and Library), Malcolm (now wearing the hat of the Film-Co-op's workshop), John and Dianne Lifton (friends from student days who worked with computers and performance), Hoppy (with his planned TV lab – TVX), Carla Liss (now responsible for the London Film Co-op's distribution library), and Fred Drummond, who became involved in both the film workshop and the cinema. Lance Blackstone was the Lab's ever-supportive accountant.

In late March or early April '69, we issued a 20 page prospectus, *The New Arts Laboratory Project*, detailing our aspirations, the people involved, our space needs and the likely costs, all beautifully printed (clandestinely, I imagine), by David Kilburn at the London Press Exchange (LPE) where he worked as a marketing consultant. Buildings we investigated as possible sites for the Lab included the former Marshalsea Prison in Southwark

A Lab workers' meeting before IRAT/Robert St formally opened: L–R Alan Shepherd (filmmaker projectionist), Biddy Peppin, DC, Pamela Zoline, Judith Clute, Dianne Lifton, Michel La Rue (architect), John Lifton, Martin Shann, Hoppy and David Jeffrey (photographs by David Kilburn).

CYBERNETICS AND SOCIETY

Living with Technological Change

ANTHONY WEDGWOOD BENN *

Equally significant may be the development of a degree of personalised selection even from the mass media. Work is going ahead on various relatively cheap and effective TV recording systems that would allow us to record those TV programmes we want, when they are transmitted, and show them when, and however often, we want to watch them. When this equipment becomes widely used the present highly centralised programme planning of the BBC and the ITA, whose details we read in *Radio Times* and *TV Times*, will be capable of being broken down to allow us individual consumer choice. Indeed, it is possible that the transmitters could broadcast programmes during the night which we would select and see, according to our own preferences, next day or later, or again and again. The educational possibilities that may well be opened up as a result could be the answer to the problem of providing programmes to meet minority interests and put the mass media into quite a different relationship with the viewers. It is against this technical background that we shall have to consider the future of the broadcasting organisations when the BBC Charter and the Television Act come up for renewal in the mid-1970s. The choices open to us may be rather wider than we imagined in 1964, and we shall never make the best choice unless we really understand what the new technology is going to be capable of doing. This may well prove to be one of the most important and immediate examples of the need to bring together the technological and political factors.

COMPUTER ARTS SOCIETY
BRITISH COMPUTER SOCIETY SPECIALIST GROUP

EVENT ONE EVENT ONE EVENT ONE EVENT ONE EVENT ONE EVENT ONE EVENT ONE

ROYAL COLLEGE OF ART SOUTH KENSINGTON LONDON SW7 NEXT THE ALBERT HALL

SATURDAY AND SUNDAY 29TH AND 30TH MARCH 1969 FROM 11 AM EACH DAY

SATURDAY

12 PETER ZINOVIEFF INTRODUCES SOME COMPUTER MUSIC AND SOME OTHER THINGS
1 JOHN TILBURY PLAYS COMPUTER MUSIC BY HERBERT BRUN AND OTHERS
2 TYPODRAMA BY MALCOLM LEGRICE AND ALAN SUTCLIFFE
3 A COMPUTER COMPOSED STAGE FIGHT BY WILLIAM HOBBS AND JOHN LANSDOWN
4 A BALLET IN PROGRESS BY DAVID DREW AND JOHN LANSDOWN
5 CHRISTOPHER EVANS LEADS A DISCUSSION ON BRAINS AND COMPUTERS
6 TYPODRAMA BY MALCOLM LEGRICE AND ALAN SUTCLIFFE
7 JONATHAN BENTHALL LEADS A DISCUSSION ON ART AND TECHNOLOGY
8 TRILOGY - A MIME IN PROGRESS BY JOHN LIFTON AND GEORGE MALLEN

SUNDAY

12 TRILOGY - DEMONSTRATION OF MIME IN PROGRESS BY JOHN LIFTON AND GEORGE MALLEN
1 DEMONSTRATIONS OF COMPUTER CHOREOGRAPHY BY JOHN LANSDOWN
2 READINGS OF COMPUTER POETRY BY ROBIN SHIRLEY AND SPIKE HAWKINS AND OTHERS
3 JOHN TILBURY PLAYS COMPUTER MUSIC BY HERBERT BRUN AND OTHERS
4 EDWARD LUCIE-SMITH LEADS A DISCUSSION ON THE ARTIST IN A TECHNOLOGICAL SOCIETY
5 TYPODRAMA BY MALCOLM LEGRICE AND ALAN SUTCLIFFE
6 PETER ZINOVIEFF INTRODUCES SOME COMPUTER MUSIC AND A SURPRISE
7 GORDON PASK LEADS A DISCUSSION ON COMPUTERS AND PLEASURE
8 JOHN TILBURY PLAYS COMPUTER MUSIC BY HERBERT BRUN AND OTHERS

(where Dickens's family has been imprisoned in the 1820s, and little changed since), an empty Gothic school at the top of Endell St., Covent Garden, and another school in Ladbroke Grove, the latter found by Caroline Coon of the hippies' legal advice provider Release. But in May we settled on an empty factory at No1 Robert Street, just off Hampstead Road, north of Euston Road, which was offered to us at a peppercorn rent and the promise of rates relief by Camden Council, (thanks to Conservative Councillor Christine Stewart-Munro and her Labour fellow Councillor Roy Shaw). It had one drawback – it could only be ours for two years as it was scheduled for demolition and redevelopment in 1971.[1] Space Studios agreed to take on the lease until we were able to form our own non-profit company, which IRAT eventually became.

The New Arts Lab's imposing additional name – The Institute for Research in Art and Technology (IRAT) – was devised sometime between May and July, and probably most closely reflected the interests of John Lifton, Malcolm and Hoppy, all in different ways keen to explore, and to widen access to, technologies now potentially available to artists – computers, film and video. 'New technologies' were in the air. John had shown work at Jasia Reichardt's landmark exhibition *Cybernetic Serendipity* at the ICA in August '68;[2] both he and Malcolm were members of the newly-formed Computer Arts Society (CAS) and exhibited interactive works at the Society's inaugural exhibition *Event One* at the Royal College of Art in March '69;[3] John, Dianne and John Lansdown (CAS founder) would demonstrate computer-aided dance at another CAS event at the ICA in June '69.[4] Hoppy had shown examples of 'Local Television' – the novelty of do-it-yourself-TV – as part of the Camden Fringe Festival in May at both the Camden Arts Centre and the Drury Lane Arts Lab; he was in touch with Tony Benn, then Minister of Technology, and Benn was a known enthusiast for such grass-roots engagement.

And here, surely, was another potential source of financial support for the new Lab – though in the event none materialised.[5]

The split from Drury Lane had generated some press interest and we were able to capitalise on this.[6] As early as February, *The Times* reported on our plans: "[The team] would like to see under one roof an experimental theatre, a videotape laboratory, a film workshop, and art gallery and printing and lithographic facilities [to be] visited by individuals or groups who would otherwise only be spectators to artistic creativity. Here they would be encouraged to explore their own creative abilities. ... [This would be] a step towards the democratisation of art. ... One feature, a 'cybernetic theatre' would attempt to bring about a close integration between live performance and technical equipment. Traditional 'live elements' of drama such as speech, mime, music and dance would be monitored by technical equipment which would alter the environment, such as lighting and shape of the performance in accord with the information it picks up."[7]

The plans for Robert Street's theatre brought together John and Dianne's interest in computer-aided performance, David Jeffrey's desire for enhanced technical resources, a base for the People Show and Will Spoor's keenness to establish a 'coenaesthetic workshop' in which to "develop mime away from its traditional forms, and to explore the undifferentiated sensations that create an awareness of the human body – its movements, its tensions and its potential, leading to a new form of dramatic body movement."[8] In an *Information Bulletin* issued in July that described the different areas of the new building (again printed by Kilburn, and the first to be headed 'IRAT'), they wrote "The theatre will be completely unstructured but will be equipped with small flexible units of seating and platform which can be arranged in any desired way. A light spaceframe structure will be built across the ceiling to accommodate light or sound equipment and scenery. We hope to build a small fully equipped control room on wheels that can be positioned anywhere in the theatre or even taken to other parts of the building for special performances. Although the theatre will be orientated towards trans-media and technically experimental productions, it will also be able to put on completely conventional drama."

Elsewhere in the *Bulletin*, Lifton and Jeffrey expanded on the role of the 'Electronics / Cybernetics' workshop, announcing the close involvement of the Computer Arts Society, which "intends to run a timeshared computer terminal within the workshop", and promising an ambitious programme of audio-recording and publishing. Roland Miller of the People

Splinter

New Arts Laboratory: Breakaway group from the original Drury Lane Arts Lab, led by its co-founder, David Curtis, has persuaded Camden Council to lease it a former chemical factory, due for demolition next year, at a nominal rent. The group has a spacious 11,000 square feet which it plans to turn into workshops, performing and exhibition areas. These will give technical facilities and working space for anyone who wants to experiment in any of the arts—appropriately supervised.

The lab plans to explore the boundary between art and technology. John Hopkins—founder of the 'International Times' and the UFO* club—will be trying to make do-it-yourself television viable, with locally recorded programmes to be played back on your own set.

The new lab will also house the London Film-Makers Co-Op which aims at low-cost film making for all. It has already built its own developing and printing machines and hopes to add editing facilities soon. A cinema, too, will introduce Londoners to the as yet unfamiliar European underground.

Financial stability and low rent obviate a purely mercenary outlook—experimentation will have priority. After an initial £750 needed to put the building in order has been raised, any income will go on equipment and facilities. Practical help is as vital as cash. Passers-by are welcome to drop in and help with building and painting.

The cinema is already operative—ring for details—the whole lab next month. (London New Arts Laboratory, 1 Robert Street, NW1, 387 8980).

* *Unidentified Flying Objects.*

LAST CHANCE. The Anglo-American Pop Art exhibition at the Hayward Gallery closes on 3 September. Monday-Saturday 10-6, Tuesday and Thursday until 8; Sundays 12-6.

The inspiring prints and drawings by George Stubbs close at the Victoria and Albert Museum next Sunday. Monday-Saturday 10-5.30, Sundays 2.30-5.30.

The Observer, *31 August 1969.*

Facing page, upper: *This reprint of an article by Tony Benn was circulated with the IRAT prospectus in Spring '69.*

Facing page, lower: *John Lifton and Malcolm Le Grice were both members of the Computer Arts Society and took part in its inaugural exhibition at the RCA in March '69'.*

INSTITUTE FOR RESEARCH
IN ART & TECHNOLOGY
LONDON NEW ARTS LABORATORY
1 ROBERT STREET , LONDON , NW1.387 8980

INFORMATION BULLETIN 2
JULY 1969

An update of departmental plans, issued
in July '69.

Show described their contribution oddly surreally: "The images [dramas?] themselves are formed from spectators' and artists' shared experiences before and during the show; 'form' is the intersection of boundaries between you and me, this room and her mother, yesterday and his supper, dead flesh and fireworks." The section on Theatre concluded more soberly: "The experience gained from the theatre's experimental use will provide a training ground for the theatre of the future unlike any obtainable elsewhere. We intend that [in addition to] the connection with the CO-ORD circuit of British experimental work that is being established [probably a reference to Miller's paper to the Arts Council], we will be able to present some of the interesting avant-garde theatre that is going-on on the continent."

In the same *Bulletin*, Malcolm wrote of his plans for the film workshop, itself equally ground-breaking in terms of access and creative potential: "For some time it has been the intention of the [London Filmmakers] Co-op to make film production facilities available at very low cost to its members. Experiments with primitive and home-made equipment [some experimentally installed for a time at Drury Lane] have produced good enough results to show the feasibility of the enterprise, and more permanent and serviceable equipment is now needed. The reasons for this kind of development are both financial and creative. The financial advantages are obvious in terms of laboratory costs, but the most essential advantage is the creative use of the various printing and processing techniques which are impossible to explore without enormous resources in the commercial laboratories." Essential to his wish-list of equipment were professional printing and processing machines each costing between three and seven hundred pounds – enormous sums.

Hoppy's video workshop was another novelty promised by the new Lab. In the *Bulletin,* his declared priorities reflected the very real – but today scarcely conceivable – limitations of video in its infancy: "solving the problem of editing recorded ½-inch tapes …; designing a really cheap converter so that existing video can be plugged into a domestic TV set …; co-ordinating information on existing closed circuit TV systems in universities [the only non-broadcast TV equipment then accessible] …; setting up a prototype system of [local TV]; the building up of a pool of equipment.."[9] His wish-list of equipment again came to over £3,000. The section on cinema promised "screenings arranged by the Lab itself, by the London Filmmakers Co-op and by other non-profit independent groups" and was signed by Carla and me; the 'exhibition area' promised that "whatever is shown would be experimental in its field (whether 'art' or non-'art')" and was signed by Pam and Biddy;[10] 'music' "aimed to provide an opportunity for young composers working in every idiom to

try things out, free from commercial pressures";[11] there would be printing and metal and plastics workshops, the latter run by Bernard Rhodes. Curiously not mentioned in the *Bulletin*, through already planned, were a photography darkroom run by Ian Robertson and Graham Peet and a screen printing workshop run Ian Robertson and Judith Clute.[12]

The *Bulletin* described a grand vision; the realities were harsher. We struggled to convert the raw building throughout June, July, August and into September, with no budget and wholly dependent on volunteers.[13] We removed a goods-lift between floors that obstructed the future gallery and theatre

No. 1 Robert Street before conversion (photo David Kilburn).

spaces, leaving gaping holes to be filled; there was a projection box to be built for the cinema; pipes lagged with asbestos had to be removed and holes had to be cut in concrete walls to allow for new doors where needed. No-one was paid. Malcolm, John Lifton, David Kilburn and John Collins had existing part-time or full-time employment elsewhere, which sustained their participation to an extent, but curtailed their available hours.[14] Biddy took on part-time lecturing and graphic work. David and Philippa Jeffrey, Martin Shann and I had been working full time at Drury Lane (earning £10 a week when the Lab could afford it) and had been income-less since December, so we too had to find other jobs and accept the distractions. David found work with a small electronics company, Audio Ltd; Martin worked with Mark Boyle on his ICA exhibition *Journey to the Surface of the Earth* (1969), I fruitlessly tried to recover my former job of part-time tutor in painting at Birmingham College of Art before Derek Hill came to my rescue and offered me freelance work organising his New Cinema Club's press shows and selling advertising in the club's programme brochure.[15] I also signed a contract with Studio Vista to write *Experimental Cinema*, which secured me an advance of £300, a sum that seemed huge at the time, but came with its own time demands.[16]

Camden's decision to offer us the Robert Street site coincided with the setting-up of the Arts Council's New Activities Committee, which added to our distractions. John Lifton, Hugh Davies and I had all been co-opted as members and were involved in its many meetings throughout the summer (as we worked on converting the building) and through the autumn. Our collective decision to spend the Committee's tiny allocation of £15,000 on regional gatherings and festivals, rather than giving direct support to a lucky few, meant we knew from the start that the Arts Council was unlikely to find any means of properly supporting the Robert

Poster for John Lifton's Interface III *installation at the ICA, produced by Graham Peet at the Lab's photo/print workshop. Courtesy Graham Peet.*

Street project. As Nicholas Albery predicted in his report on the discussion of Arts Labs funding at the Artists' Conference, "it would require long-term infiltration and revolution with[in] the Arts Council before it coughs up anything more than financial peanuts".[17] By the end of the year, both John and I had left the Committee, overwhelmed by other commitments.

But membership of the Committee was initially useful at least to the extent in that that the Arts Council's Secretary General Hugh Willatt now knew who we were, and was prepared to write to the Camden Town Clerk supporting our application for the building's use, apparently with Goodman's blessing. Conveying this news, Willatt wrote to me: "This letter was written on the assumption that if the New Arts Lab project were to obtain use of these premises, they would make them available to a number of groups giving performances".[18] This condition would positively lead to a grant from the Drama Panel of £3,000 towards theatre equipment, the Lab's only serious support, but also morphed into an assumption that the Lab would manage a regional touring circuit for experimental theatre groups.[19]

Our new relationship with Camden Council brought yet further distractions. Christine Stewart-Munro was planning its First Camden Fringe Festival to occur in May and was desperate for attractions, and we felt obliged to assist. Hoppy offered his 'all night demonstration of video shot on Sony Portapak', Pam and Biddy hired a bus to be driven round the borough on two weekends, taking out the downstairs seats to show paintings, and offering films upstairs.[20] Pam was also involved in setting up "a suburban front room on the pavement in Tottenham Court Road as a set for impromptu performances by a drama group" (Tom Osborn's Group Events).[21]

Meanwhile, Will Spoor and the People Show managed to secure gigs at Oval House, Marowitz's The Open Space theatre and (bizarrely) Ronnie Scott's;[22] places where proper fees were offered; Carla Liss organised some Film Co-op shows at the Electric Cinema in Ladbroke Grove and at the Edinburgh Film Festival, the latter featuring the newly-arrived New American Cinema collection and works by the swelling number of British filmmaking artists.[23]

But even before the Lab opened, the lack of any budget for the project began to take its toll. David Jeffrey drifted away; "my involvement with

Audio Ltd and learning electronics ended up consuming all my time".[24] Martin Shann briefly took his place but was offered teaching in Birmingham so soon moved out, George Craigie becoming his replacement and in turn, the new building's resident caretaker/fixer/calm presence.[25] Will Spoor and Ellen Uitzinger returned to Holland in pursuit of paid work even before the building opened. All of us who remained continued to work unpaid throughout the Lab's life; only George, the projectionists, technicians and reception staff received any wage.

As our planned October opening loomed, the building's transformation was far from complete (indeed, in places it was never finished), but the *Hampstead and Highgate Express* helpfully previewed our offerings, particularly responding to our promised novelties: "The Lab has been formed by a group of talented experimentalists who have taken over a disused factory on Robert Street [and] are working day and night to turn it into an elaborately equipped workshop for the creation and application of new media. Besides wanting money – more than £15,000 for the first year – they are appealing for unwanted tellies to help an already advanced research programme which could mean that in a few years people will be tuning in to neighbourhood TV stations or buying their own quality programmes on videotape cassettes ... John Hopkins whose work with video-tape during the Camden Festival showed that neighbourhood TV is possible, will be among the innovators at the lab. ... The Lab's electronics and cybernetics workshop will work in close collaboration with the Computer Arts Society which intends to run a time-shared computer terminal within the workshops." ... John and Dianne Lifton "originators of the first computer-written mime scrips, [have] plans to combine electronics with human movement to create a new kind of theatre. ... 'The interesting things occur where divisions are broken down', says Dianne."[26] (The breaking down of divisions between the arts had been a uniting ambition of the enterprise from its inception.)

Exploring the building – l/h DC, Hoppy and Biddy on the roof; r/h Dianne in a hard hat with ?, David Jeffrey and a newly erected stud wall, Biddy, Dianne & John Lifton (photos David Kilburn).

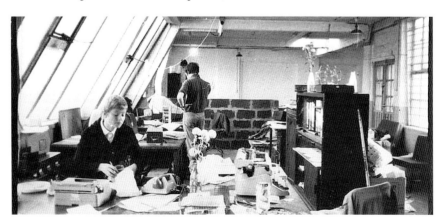

The Office – Rosemary Johnson and John Lifton (photo David Kilburn).

Endnotes

1. Rent of £100 pa; rates £100 pa. ('Press Release', July?1969) David Kilburn provided the link to Camden. "One of my older colleagues [at LPE] was a Camden councillor, Roy Shaw. Over the course of many conversations, I told him about the [Drury Lane] Arts Lab and what went on there ... Eventually, I found myself talking to him about how the Lab was in imminent danger of collapse since it was not able to pay the rent or other operating expenses. ... Roy volunteered that Camden Council might be able to help ... since the Council owned a substantial amount of empty and unused property." Email 24 February 2018.

2. John's contribution was 'a computer controlled projection system in a geodesic dome'.

3. Here, his *Interface 3* "used movements seen by a compound eye – made of an array of photocells – to produce electronic music ... Attendees could move or dance in front of it to create their own music. With Dianne, it was also featured in performances using computer-generated scripts" [JL statement, *An Arts Lab Continuum*, 2018]. Malcolm collaborated with CAS's Alan Sutcliffe on a performance work entitled *Typodrama*.

4. 1 June 1969 [flier Robert St file].

5. Benn was Minister till the Labour Government fell in Summer 1970. Issued with the prospectus was a printed extract from his article 'Cybernetics and Society – Living with Technological Change', *New Statesman*, 13 December 1968, in which he welcomed the prospect of 'cheap and effective TV recording systems (a socialist dream of a different future for TV).

6. I.e., 'Arts Lab Split', *IT*,45, 29 November 1968 ; 'Schism at the Arts Laboratory', Michael Dempsey, *Art & Artists*, January 1969, 'London New Arts Lab', *Time Out*, 2–16 August, 1969; 'Splinter', *Observer*, 31 August 1969; 'A Home for the Arts Lab Offshoot – Londoners Diary' *Evening Standard*, 13 August 1969.

7. 'New arts workshop planned', *The Times*, 3 February 1969

8. 'Theatre' *Information Bulletin 2*, IRAT, July 1969.

9. 'Video' *Information Bulletin 2*, ibid.

10. Later schedules list Judith Clute and Godfrey Rubens alongside Pam as exhibition organisers.

11. Curiously, not signed by Hugh Davies, though he is listed as 'arranging several live concerts'.

12. Graham Peet remembers: "at IRAT I helped set up a darkroom in the old boiler room, rather a thankless task considering how dusty a room it was. I remember being given £5 – an actual old fashioned huge £5 note – by J G Ballard towards the work – he had been installing the *Crashed Cars* exhibition. I also did silk screen printing there. I printed a rather fine poster for John Lifton's ICA show *Interface 3A* on mirror plastic". Email 15 September 2019. Annabel Nicolson remembers "enjoying having easy access to these facilities". Letter 8 January 2018.

13. My brother Duncan Curtis, was one (he later joined Liverpool's sibling to the Lab, The Blackie); Fred Drummond, just graduating at St Martins, another.

14. A schedule of events published in February 1970 urges those wishing to contact staff to do so 'in the afternoon', or in Malcolm's case 'in evening only'.

15. After the Lab opened, I also curated some NCC programmes such as *An American Eye-Opener* and *European Underground*.

16. It was one of a series; others contracted at the same time were: *Experimental Music*, (Michael Nyman), *Experimental Theatre* (James Roose-Evans) and *Experimental Painting* (Stephen Bann).

17. 'Arts Labs Seminar' – 'I THINK ... Artists Conference Report' *CIRCUIT* 10/11, undated, mid July 1969. At this Arts Labs discussion, Jim Haynes apparently suggested 'a wild scheme' in which "the Drury Lane Lab would help finance other labs ... by sending out its resident pop group (Whispering Concrete) and its own film which the Beatles have given it [*The Magical Mystery Tour*] for benefit performances ... to help other Labs raise enough money to buy £600 Video Units and thus set up a 'Video Tape Network'. (One Lab shoots something good, makes 20 copies, and the day that it can sell 30 mins to TV, it has paid for its equipment.)"

18. Letter 20 May 1969 [Robert St file].

19. 'New Labs for Old' [aka 'Out of the Ashes'] article in *Light* issue 1, 1970, uncredited.

20. Biddy says this proved a half-baked effort, and remembers with embarrassment seeing Margaret Drabble seated in the bus, looking disconsolately at its modest offerings.

21. *The First Camden Fringe Festival* – press information 21 April 1969.

22. Performances by 12 companies over five Sundays at Ronnie Scott's were funded by the Arts Council Drama Department's 'experimental theatre allocation'. (Report to the 1st Meeting of New Activities Committee 22 July 1969.)

23. The EFF programme included *A Swiz Event* (Scottie), and films by Malcolm, Steve Dwoskin, David Larcher (*Mare's Tail* premiere), Fred Drummond, Simon Hartog, John Latham, Peter Whitehead and Gordon Payne.

24. DJ Email 25 October 2018.

25. George Craigie (Patterson), had been an apprentice electrician with SSEB in Edinburgh before coming South with some art school friends where by chance he gravitated to the Arts Lab, just when his skills were needed. A quiet man of seemingly infinite skill and patience, when the Lab closed he moved with others to Prince of Wales Crescent, then travelled twice round the world with a rock group.

26. 'Billboard', *Hampstead and Highgate Express*, 25 July 1969.

The Building

The New Arts Lab, Robert Street opened on 4 October 1969 with a huge party. The North London press announced "Over 1000 energetic people were at the New Arts Laboratory's opening last week, so it would be wrong to say the machines were taking over. But they

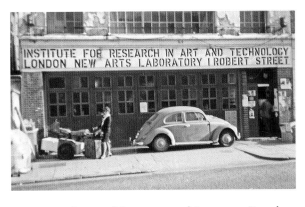

were definitely making a strong bid in the lab's converted factory. ... A 'poetry machine' in the centre of the gallery area ran off yards of poetry on a teleprinter. The machine was programmed with 100 different words, and a sample read: 'The dawn of bliss is the time of freedom'... The teleprinter was on a telephone link to a computer in Great Portland Street.[1] In the upstairs workshops there were live TV shows of the people downstairs, and videotapes, plus a cybernetic light show with photo-electric eyes processing light impulses into sound, and electronic music performances. 'Toys' for visitors included abstract linear designs of fluorescent light strips and fibreglass domes constructed with special moulding techniques. ... Fifteen theatre groups already use the place and the London Filmmakers Co-op with the world's largest catalogue of underground films is based here."[2]

Visitors coming to the opening party (following a ten minute walk from Euston Square, Warren Street or Mornington Crescent tube stations) discovered what many probably initially mistook for a fire station. The four-story building at No 1 Robert Street had tall folding doors right across its street frontage, which we painted bright red. Entry was by one fold of these doors; there was a single door to the right, but this only gave access to the upper floors which meant missing the reception desk, so when the building was open to the public it was often kept locked. David Cleall, a young man passionate about alternative theatre, and later a dedicated researcher of the subject, particularly remembers the folding

doors; "To get in, you had to really wrestle with the door, and then you made a dramatic entrance when it gave, and you kind of stumbled in, into what was a very large gallery-space on the ground floor, and at the back of that was the cinema … There was – you couldn't call it a bookshop – but there was a reception where they sold underground press and short-run pamphlets and booklets and things like that. Eventually a macrobiotic restaurant was opened in that space as well."[3]

The gallery space gained some daylight from a narrow glazed roof that ran along its East side. Beyond it, the cinema, a black box, had authentic tip-up seats rescued from a flea-pit in South London (inadequately fixed to the concrete floor, they wobbled, and a row partly collapsed on one occasion); even more conventionally, it had a proper fire exit to an alley behind. Stairs from that back exit led up to the Film Co-op Workshop on the first floor, the theatre's storage and wood-workshop on the second, and a metal/plastic workshop on the third. At the front, stairs led out of the Gallery to the upper floors with the theatre and electronics / cybernetics workshop on the first floor, John Col-

Institute for Research in Art and Technology
J G Ballard Dr P Reyner Banham Dr Christopher Evans
Councillor Christine Stewart-Munro Joe Tilson

invite you to the opening of the
London New Arts Laboratory, 1 Robert Street NW1
on Friday October 3rd, 6pm onwards
films exhibition music tv events (we can't afford drink)

phone 387-8980

Above:
The 'bag of treats' that formed the invitation to the Lab's Opening Party, October '69'. William Cobbing collection.

Below:
Inside the red folding doors – a kids' workshop in progress, Autumn '69.

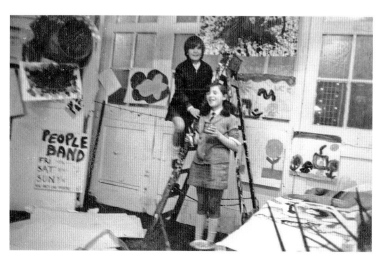

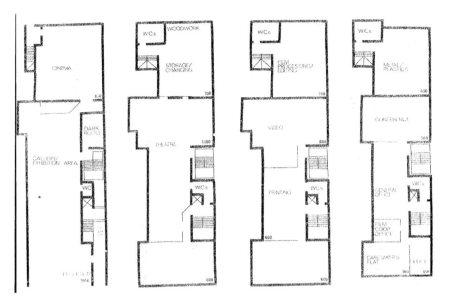

Floor plans – showing the allocation of space.

An early attempt to encourage membership.

lins's printing workshop, a rehearsal space and Hoppy's video workshop on the second, and offices and George's flat' (a room) on the third. The top-floor offices were magnificently glazed, like a greenhouse, so froze in winter and baked in summer. There were spartan loos on each floor. There was no heating system, so we invested in industrial gas space-heaters – some like jet engines that roared, others like radiant grills on stalks; but basically in winter months we wore heavy coats at all times, and hoped our visitors would learn by experience to do the same.

Greater democracy, one of the new Lab's organisational aspirations, was to be pursued by means of planned weekly meetings of all those involved in scheduling events. In reality, meetings of all staff only rarely happened as we all had so many other commitments, among them the demands of our other paid employments. Biddy, as the person who attempted to keep accounts, was most aware of the Lab's financial position, and struggled to keep the meetings going. She was also the one most aware of the looming deadlines of

the Lab's own printed schedules and the *Time Out* and *IT* 'listings' pages, and was often faced with the task of pursuing her fellow artist-workers for their contributions. A full-time administrator was sorely needed, but there was never a budget to pay for one.

Endnotes

1. This was "an ASR30 Teletype, operating on an off-peak telephone service", shown for the first time at *Event One*. Catherine Mason 'the 40th anniversary of Event One' www.catherinemason.co.uk.

2. 'C.A.' 'Life In The New Lab' *Hampstead and Highgate Express*, 10 October 1969. Mike Leggett recalls that a few shots in the film *Sheet* were recorded at that event!

3. unfinishedhistories.com Biddy thinks we later knocked through a new entrance from the single door at the right directly into the gallery space.)

The Cybernetic Theatre

Many of the groups that had come into being thanks to the Drury Lane Lab's theatre during its two years of active life in due course made their way to Robert Street. But the New Lab could never claim to be alternative theatre's cradle, as Drury Lane had been; other venues had begun to show their interest.[1] Also, with the loss of Will Spoor and David Jeffrey, the Robert Street theatre's management passed from hand to hand, with a predictable loss of continuity. John Lifton fed occasional projects into the programme but wasn't in charge; Roland Miller initially accepted that role, then passed responsibility to his wife Victoria who shared it with Dianne Lifton, who then handed it to theatre director Martin Russell and eventually to the ambitious producer/director Michel Julian.[2]

The theatre opened with *Round – a Playtime for People* – 'a mix of theatre play and happening with audience participation' – written and directed by Viqui Rosenberg. "*Round* was my first and only theatre production. … [it] was an audience participation play, product of some Argentinian trends and my understanding of what the Living Theatre were doing at the time … . Instead of a ticket, the audience was given a parcel wrapped up as a birthday present and they entered into a room that was set up as a children's birthday party. They were largely infantilised and made to watch and to participate in a show apparently addressed to children that had rather sinister and menacing overtones (a magician whose trick was to shave and ended up making cold and calculated cuts on his face). It all ended in tears and the audience was ushered out of the room. My actors were recruited largely from people hanging out at

Poster designed by Carlos Sapochnik.

round
a playtime for people

at the london
new arts laboratory
1 robert st, nw1 eus 2605
from october 10th
every friday
saturday and sunday
at 8 pm
admission 6/-

the Lab and the show got a positive review in *Time Out*. (A down-and-out man called Eric became a regular attender and ended up coming to crash on our sofa for a week or two.)"[3] Viqui's husband Carlos Sapochnik designed the striking poster but remembers a struggle to get it circulated in time.[4]

November saw *Underground Lovers* by the Pip Simmons Group, another Tardieu translation, followed by Tony Crerar's *A Mime for One Player* based on *Act Without Words No 1* by Beckett.[5] The People Band played in early December alternating with a new comedy by the North End Troup, Ron House's *SHAM*, with Tony Crerar's show continuing in a late night slot. From the middle of the month the one-man show *Monsieur Artaud* written Michael Almaz[6] directed by Tony Parr, shared the evening with *T.N.T*, two comedies by Bob Mandel directed by Judy Zellweger, and there was a proposed workshop for kids *Children's Participation Theatre*, 'every Saturday morning in December' to be arranged by Viqui Rosenberg.[7] That first autumn, audiences at the Lab were slow to build, and in an attempt to boost them, we began 1970 with a New Year's Eve spectacular "one ticket admission to whole building: People Band, the People Show, Tina's Light-show [video artist Tina Keane making her first public appearance] Video Rock environment [Hoppy's crew] Multi-screen Films [Malcolm, Fred and others], Swiz Prix [inflatables by Scottie], the Lab's own group The Inquisition. And much more."[8]

In January '70, the People Show took up a residency. The group's membership was changing; that month Jeff Nuttall departed and by the end of the summer Roland Miller and John Darling had left too, (the latter only temporarily), and the chronology of performances on the People Show website suggests that no new show were added to its roster during the year – (there had been fourteen in 1969!) And while 'no new shows' is clearly wrong, it perhaps more correctly reflects that there was a degree of turmoil in the group at that time. Positively, an uncredited *Time Out* reviewer recalled that by October '70, "Mike Figgis, who had been providing musical accompaniment … had taken over Darling's role as creator of the shows' soundtracks, and in [the show] *Kurt Schmidt* became 'an assured performer in the People Show tradition'. [Also…] When the company had access to more sophisticated theatre spaces their work often became tightly structured. For example *Glass* at New Arts Lab … was exclusively a montage of static images with precisely timed lighting and sound cues."[9]

In his notes, David Cleall describes another of their performances at Robert Street, with its typically oblique audience-attack: " … 8pm came and went, [and] all there was, was the queue of people for the People Show. Suddenly a big noise, and the appearance of a drunken waiter-type

person collapsing on the stairs – general mayhem on the staircase, everyone puzzled by what was going on and keen just to see the show … but after approximately half an hour realised this was the show, and we were actually in the show. Also, as well as the price of admission, audience members were required to hand over something else to persuade the theatre group to let them in. Inside the theatre itself there was nothing. The theatre was quite small, seating approximately 50, organized in the round. Four players in the People Show; Mark Long and Laura Gilbert were most identifiable. Not much structure, and for audience members worry setting-in about getting their possessions back. … Theatre of this period was often challenging the relationship between the audience and the performer. When the People Show appeared again, it was a completely different event; like a series of images, still lives, working with the theatre lights and sound tapes; but again, they really specialized in wrong-footing you. The People Show was exquisite and slightly surreal."[10]

'Images ... lights and sound-tapes'; these ingredients perhaps also reflect the Lab theatre's commitment to new technologies. The newest of these dramatically came together in February '70 in a two-day event *UFO / TV Communications Network* involving John Lifton (computer-interaction), Hoppy (live video courtesy of Paul Barnes and his Goldsmiths' College TV equipment), the progressive improvisational rock group Bachdenkel,[11] the People Band and "happenings provided by BBC's Damian Brown, BIT's Robin Farquharson and *OZ*'s Richard Neville"; and "we started making television" as Hoppy later reported in *IT*.[12] And again in June, in *Sensepak!*, an event designed by John Lifton alone, "a mixed theatrical event featuring a computer controlled environment, natural and electronic sound, dance, cybernetic projections and giant pneumatic breasts", these last apparently being stock items supplied by the electronics workshop![13]

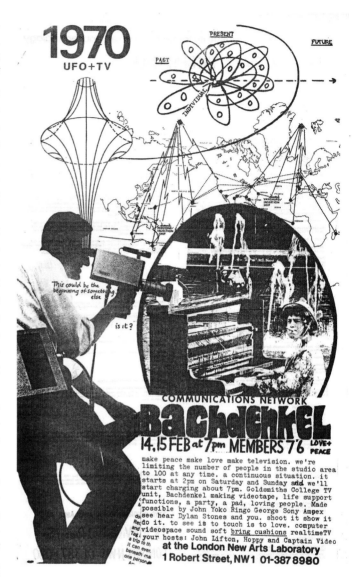

The first of several multimedia events organised by John Lifton and Hoppy.

Flier designed by John Lifton

This latter is perhaps the event remembered by Carlos Sapochnik which "… used a technology where movement was detected by a sensor, and this impulse affected a small rotor with a spring, and a slide projector which projected still images onto a tensile surface …, and the images were therefore in movement and distorted. The slides were abstract or semi-abstract images … which were already out of focus before processed that way. Dianne Lifton … danced to a soundtrack, and the conjunction of jerky patterns on the screen and on Dianne (and her shadow on the screen) was the show."[14] John Lifton clarifies that there were two dancers, the second one being Dianne's friend Niamh Mulrooney, and suggests "this was the system that I first showed in the Computer Arts Society's *Event One* at the RCA. It made music from movements that it could see, and Di and Niamh did some performances with it, partly using computer-generated mime scripts and partly freeform movement."[15] It is sad that no video record survives of these pioneering mixed media events; they spearheaded the exploration of the then very new, but now familiar relationship between technology and live-performance. John collaborated

with a very different musician, Michael Nyman, on a similar event called *Mediarena* on the occasion of the Arts Council's formal visit to the Lab in February (a *non*-visit, as it happened, of which more later).

March brought further performances by the People Show, productions of Sam Shepard's *Red Cross* and Bob Mandel's *Florence Nightingale's Song* staged by The New York Workshop and the Richmond Arts Workshop Folk Theatre's productions of *Confusion and the Mind in Conflict* and *A Child's Dream of a Star*, apparently 'a combination of songs, music, poetry and drama'.

In January,[16] Martin Russell took over the theatre's management and the first productions issued fully under his banner were probably April's *Sitting Room Blues*, a new musical 'by and about London teenagers in Notting Hill Gate' by the youth ensemble London Heatwave, followed by two productions (unnamed in the schedules) by Brian Lane. Then in early May, *Scribbled Words* by Graffiti Theatre and later, *Keith Johnstone's Theatre Machine.* Johnstone was from an older generation than most performers at the Lab, and brought with him experience of directing and teaching at the Royal Court Theatre.[17]

Also at the end of May, the theatre was host to The Real Camden Arts Festival Fringe (Camden's second attempt). Perhaps as part of this, in mid-May, *A Ritual to Awaken M. Antonin Artaud from the Dead* was enacted (it's uncredited by whom; most probably by Michael Almaz).

Jean-Pierre Voos, who appeared with his newly formed Experimental Theatre Group in June, was another relatively seasoned theatrical producer, having previously run the Mercury Theatre in London.[18] His productions at the Lab were perhaps his bid to escape the responsibilities of venue-management, and instead to run his own itinerant group. He staged 'two important American underground plays' *Thank You Miss Victoria* by William M Hoffman and *Poison Come Poison* by Michael Weller.[19] Hoffman's offering began life as a short story told

Section of a computer-generated mime script created by Dianne & John Lifton. Collection Di Clay.

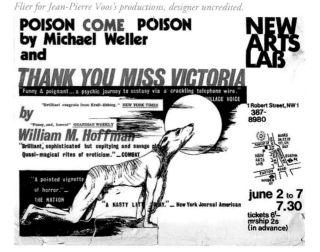

Flier for Jean-Pierre Voos's productions, designer uncredited.

TOUCH EXPERIMENT

A GROUP OF PEOPLE TAKING SEPARATE ROUTES APPROACH PEOPLE IN THE STREET AND PHYSICALLY TOUCH THEM IN A DELIBERATE MANNER.
ON EACH ENCOUNTER THE IDEA OF THE EXPERIMENT SHOULD BE DISCUSSED AND A LEAFLET ON THE SUBJECT GIVEN.
IF THE PERSON IS SYMPATHETIC SUGGEST THAT HE/SHE TAKES SEVERAL LEAFLETS AND CONTINUES THE EXPERIMENT WITH OTHERS.

THUS A SERIES OF SPONTANEOUS AND CONTINUOUS HAPPENINGS OCCUR.

"PERSONAL RELATEDNESS CAN EXIST ONLY BETWEEN BEINGS WHO ARE SEPARATE BUT NOT ISOLATES. WE ARE NOT ISOLATES AND WE ARE NOT PART OF THE SAME PHYSICAL BODY. HERE WE HAVE THE PARADOX, THE POTENTIALLY TRAGIC PARADOX, THAT OUR RELATEDNESS TO OTHERS IS AN ESSENTIAL ASPECT OF OUR BEING, AS IS OUR SEPARATENESS..."

R.D.Laing, "The Divided Self"

IN OUR SOCIETY GENERALLY, TOUCH IS A METHOD OF CONTACT USED ONLY IN RITUALISED SITUATIONS, FOR EXAMPLE DANCING, SHAKING HANDS OR AN EMBRACE BETWEEN FRIENDS, SOME PARTY GAMES ETC. (CHILDREN ARE MUCH LESS INHIBITED ABOUT TOUCH AND MANY OF THEIR GAMES INVOLVE MUCH PHYSICAL CONTACT BETWEEN THEM).
THERE ARE SITUATIONS WHEN TOUCH IS ACCEPTED THOUGH MAYBE NOT DESIRED, FOR EXAMPLE CROWDED TUBE TRAINS WHEN A LOT OF PEOPLE ARE IN VERY CLOSE PHYSICAL CONTACT BUT ACCEPT IT AS BEING UNAVOIDABLE.

TOUCH FOR NO REASON
TOUCH TO COMMUNICATE
RELATE TO OTHERS
AND RECOGNISE COMMUNICATION

A PERSON IS TOUCHED AND, UNWARNED IS SUDDENLY CONFRONTED WITH SOMETHING NEW TO DEAL WITH AND THINK ABOUT.

HE NOW FINDS HIMSELF VULNERABLE – TAKEN OUT OF HIS "SECURITY" OF ISOLATION.

FINDING HIMSELF IN THIS SITUATION MAY HAVE A THERAPEUTIC EFFECT – BARRIERS BETWEEN HIMSELF AND OTHERS BREAK DOWN – HE IS MORE AWARE OF BEING PART OF A COMMUNITY

HE HAS THE OPPORTUNITY OF CONTINUING THE EXPERIMENT HIMSELF DEMONSTRATING THE POSSIBILITY OF SPONTANEOUS HAPPENINGS ANYWHERE ANYTIME INITIATED BY THE ATTEMPT OF ANYONE TO MAKE CONTACT WITH ANOTHER BY TOUCH.

Contact: Dianne Lifton 19 Elgin Crescent W.11

Dianne Lifton's 1968 'experiment', surely the inspiration for Harvey Matusow / Anna Lockwood's Dark Touch?

entirely in dialogue, and "concerns Harry Judson, an indolent, self-indulgent young man who, simply to amuse himself, phones a dominatrix in answer to her advertisement in a magazine seeking a male slave. During the course of their conversation, of which the audience hears only the man's side, Harry is led on a discovery of his true and essential self."[20] June also saw the return of the Pip Simmons Theatre Group, the People Show and the (otherwise unidentified) Group Touring Theatre.

In July, Russell introduced a 'brilliant, one-woman triple bill of plays' (all British premieres apparently, but un-named in the surviving schedules) featuring the actress Eva Sigsgaard.[21] Russell had a vision for the theatre, his own sense of what was experimental, and alongside the regulars, he was attracting new groups to the Lab to show their work, three of which he persuaded to come together in September as the Triple Theatre Centre (TTC), which was to offer a range of drama classes. The first was Hanna – No, a team committed to playing classic theatre in masks in the Greek tradition, founded by the young Armenian director Hovhanness I. Pilikian who had graduated from RADA in 1967. At the Lab he staged *The Death of Kikoss* by Gail Rademacher, 'based on a classical legend' (a folk tale by the Armenian poet Hovhanness Tumanyan) and in December '70 – January '71 a double bill of Chekov productions *The Bear* and *The Proposal* in translations by Rademacher.[22]

The other two groups in Russell's Centre were A Roomful of Hermits run by Sue Gittins (which seems to have been a self-empowerment group similar to The Human Family), and Steven Rumbelow's newly formed Triple Action Theatre Group which at the end of July staged *Manfred* (Lord Byron) and *Prometheus Bound* (Aeschylus/Byron), in the Group's first public appearance. Rumbelow had worked earlier for the Bristol Old Vic and the R S C, and his *Faustus* (after Marlowe) which ran at the Lab in November was an immediate success, and he was still touring this production in the late 90s. Russell wrote of TTC's aims: "Mime, dance and drama, often taught and practised as separate arts, are the basis of today's theatre. Instead of treating these arts as independent, TTC offers

a flexible curriculum which incorporates all three in a single art of Total Theatre. TTC has been established at the Arts Lab by the artistic directors of Hanna-No, Europe's unique mask theatre, Triple Action Theatre and A Roomful of Hermits to give students and professionals in the theatre the opportunity of discovering and developing techniques of a less inhibited theatre. ... The groups' respective directors ... will all give separate classes in their own respective techniques... Guest teachers will also be invited to give classes to complement the Centre's curriculum."[23]

July also saw a triple bill of new plays, *In Praise of Mickey Mouse* and *Dialogue for two Mrs Browns* by Peter Stark (directed by Paul Bettis) and *Witto the Marvellous Clown* by the American writer/director Ken Raabe (directed by Russell).[24] Towards the end of July, in possibly their last appearance at the Lab, the People Show offered "A totally new show ... developing each night into *another* New Show. Each fresh excursion into the gaps between people is dangerous because there will be threads cut and legs and arms nailed together. Heads and minds put through the mincer. Everyone gets mixed up together and it makes lovely sausages." (More schoolkid surrealism, but further evidence that they *did* mount new shows in 1970).

In August, Anna Lockwood and Harvey Matusow offered a participatory show, *Dark Touch* "a totally dark, sound-touch environmental experience for all the outer senses but the eyes. The audience will enter, each at a three-minute interval, holding onto a guide rope – every so often there will be an object to touch – then your hands and fingers become your eyes – discover wood, bronze, glass and other shapes and forms – all the while the sounds created by Anna Lockwood swim around creating their own space – becoming [a] total space within the individual."[25] The press release was stamped 'nude critics only,' the suggestion being that nakedness would enhance the experience.[26] September promised 'a super production tbc by Paul Bettis';[27] and a 'media integration experiment' aka *Mindblown Videotape* by TVX in the theatre from 3pm to 11pm daily. Then in October, what should have been Russell's *coup* (and was perhaps Bettis's 'super production'), 'a new work commissioned by New Arts Lab from Marguerite Duras – *Ah, Ernesto*'.

Ah, Ernesto features a young boy who refuses to go to school 'because

North London Press*'s response to* Dark Touch.

they only teach him things he doesn't know'; four characters talk, Ernesto, his mother, his father and the schoolmaster. Their mutual incomprehension makes their exchanges absurd, revealing the gulf between the individual and social conventions. The Lab's theatre schedule confidently gives the playdates and quotes Duras saying "I feel at home in a place like this centre for free artistic expression", yet it seems unlikely that it happened, for there are no contemporary reviews.[28] What went wrong? Did Duras take fright at the Lab's actual resources? Were there casting problems? Who knows? In the unlikely event that it did take place, it shared the evening with *Strange Devyse Theatre*, a 'total fantasy / life-size puppets / mechanical scenery / bubble machine / popcorn fountain'. This was followed later in the month by Pip Simmons Theatre in *Superman* 'following its very successful appearance at Edinburgh Festival', the sole

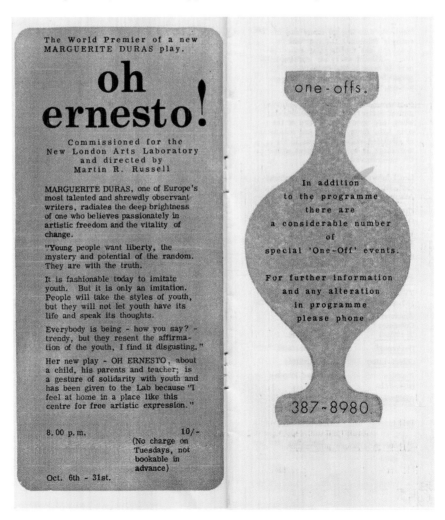

Duras's play – as announced in Martin Russell's booklet of current and up-coming productions, Autumn 1970.

appearance of A Roomful of Hermits in an unnamed production, and then *And So To Bed*, 'a review', uncredited.

November and December saw Triple Action Theatre's *Faustus* and their *Priest High Time*, the Brighton Combination in two productions, *The N.A.B Show* and *The Tat Show*, and more from The Pip Simmons group, a return of *Superman*, a version of *The Pardoner's Tale* and an N F Simpson revival, *The Theatre Machine*.[29] By December, Michel Julian had fully taken over and Stephen Berkoff's London Theatre Group staged "a series of mini-dramas [which] explore their already established techniques, previously seen only in Berkoff's full-length productions [*Macbeth* and *Metamorphosis*]". In January, Hanna-No returned with the Chekov double bill *The Bear* and *The Proposal*, and Julian initiated a Grand Guignol season of 'Theatre of the Ironical and the Macabre' beginning with *The Man Who Cheated Death*, (author uncredited).[30]

In January, *Time Out* reported that "Michel Julian has re-organised the Arts Lab Theatre for the start of their 'International Alternative Theatre' season. He has doubled the size of the office, doubled the number of seats (to 120) and lamps (now 10) and heating." The Grand Guignol season continued with *The Mermaids Rose from the Depths* by the Players Theatre of New England, a mime and yoga based company. In February *The Decline and Fall of Lesley West* by the 'Bird in Hand' Theatre of New York, and *Loki* by Incubus. In March Graffiti Theatre in *Party Without a Host*, Sweden's Popularteatum with *The True Story of Ah Q*, the workshop of the Théâtre de l'Épée de Bois in Paris with *Mythus and Sexus*, and finally, Triple Arts Theatre in *Oedipus*.

In a late March *Time Out* listing, the last to feature an Arts Lab event, Julian announced: "The Arts Lab exits gracefully on 26 March and will continue up the good road with rehearsal space"; the 'good road' presumably the Hampstead Road, leading to Prince of Wales Crescent and the Dairy, to which Julian and some of those involved in the Lab would move.[29]

Endnotes

1. Symptomatically, the People Show and other alternative theatre companies were invited by Bill Gaskill to perform at the Royal Court's *Come Together Festival* in October 1970. Also, David Cleall reports "As Drury Lane spluttered to an end, Peter Oliver at Oval House created a home for the Drury Lane Arts Lab theatre companies, and that changed the context in which the Robert Street IRAT theatre would operate. Peter gave the companies very cheap rehearsal space on the understanding that they would premiere work there." Email 26 June 2018.

2. John and Dianne drifted apart during the IRAT's two year life, as did Roland and Victoria Miller, Roland leaving the People Show and joining forces with the performance artist Shirley Cameron. Martin Russell had earlier been at the Belgrade Theatre, Coventry, and had made contact with Jim at Drury Lane in October 1968 [Napier letter]. Michel Julian would be in charge of the theatre as the Lab closed, and as the Lab's administrator, took with him the IRAT company name, trading with it for several years, on projects unrelated to its earlier activities.

3. Email 24 September 2018. Rosenberg became a psychoanalyst, and is author of the novel *Time Secret*, Longstone Books 2009. Eric had also been a 'regular' at Drury Lane.

4. "[The poster] was sent to be printed by The Word, in Notting Hill, and was expected to arrive before the Lab's opening party. I waited anxiously at the door, the printer delivered the posters when the party was already on, and I ran through the building putting up the posters to generate a possible audience for the opening of the show on 10 October." Carlos Sapochnik, Email 22 September 2018.

5. Crerar later worked as mime artist with the rock group Hawkwind.

6. Almaz earlier wrote *The Rasputin Show* (1968) for the Brighton Combination and in 1974 he founded the Artaud Company, named after the success of his *Monsieur Artaud*.

7. This was announced, but Viqui only remembers involvement in the contemporary The Young Playmakers, a group based in a public library then a basement in Crowndale Road, King's Cross, run by Lesley Seid. VR Email ibid.

8. Flier Robert St file. Who exactly The Inquisition were, is a mystery. Scottie learnt the art of inflatable-making in the studio of Graham Stevens.

9. www.unfinishedhistories.com.

10. David Cleall 'Theatre groups at New Arts Lab – the People Show'. unfinishedhistories.com.

11. A Birmingham-born group (they performed fund-raisers for the Birmingham Arts Lab); recorded their first album *Lemmings* (1970) shortly after appearing at Robert St, then promptly emigrated to France.

12. 'Reel Time Television', *IT 74*, 1970.

13. From the published June theatre schedule [Robert St file].

14. Carlos Sapochnik Email 8 October 2018, he continues "I remember this little show first at IRAT and then Viqui and I came along to help at a performance at Cambridge Student's Union".

15. JL Email 27 October 2018.

16. "The theatre was originally run by a committee but experience showed this to be impractical and in January Martin Russell took over responsibility (subject to the weekly Lab meetings) for the programming and functioning of the performance and rehearsal areas." Tim Harding 'It's all at the Co-op Now' *ISIS*, 30 June 1970.

17. Before that, in the 1950s, he had taught at a working-class school in Battersea, an experience which fed into a play he wrote for the Royal Court in 1956. His website suggests that at the Royal Court, "he chose to reverse all that his teachers had told him in an attempt to create more spontaneous actors". In the 1970s, he moved to Calgary, Alberta to teach at the University of Calgary.

18. He later set up the International Theatre Research Group KISS.

19. Weller was based in London at the time. He continued to write plays and screenplays for films including Milos Foreman's *Hair* (1979); Voos later worked in France and Australia.

20. www.glbtqarchive.com/literature/hoffman_wm_lit_L.pdf. Hoffman later wrote *As Is* (1985), one of the first plays to reflect the contemporary and escalating AIDS epidemic.

21. 'Siggstard' in the listings! She also appeared in a short documentary film about Jean-Pierre Voos's group KISS, *'Kiss' et le théâtre de la cruauté* (dir Philipe Bordier, 1973).

22. *The Death of Kikoss* had played at Drury Lane in June '69. Pilikian subsequently produced Euripides's *Electra* at the Greenwich Theatre, in which a young Derek Jacobi played Orestes (1971).

23. 'October, November, December' Theatre schedule, publ. September 1970 Robert St file.

24. Ken Raabe returned to America and became a minor theatrical institution in Chicago working with John Szostek in mime, mask theatre and burlesque at the Piccolo Theatre and elsewhere.

25. Press release. This production seems to owe much to Dianne Lifton's earlier 'A Touch Experiment', about which she had given a full account in *New Society*, 15 August 1968.

26. This ensured that there was indeed some press coverage, hence the jokey piece in the *North London Press* 28 August 1970.

27. Bettis appears to have been based at Bristol University's Drama dept. from 1967 to 1970, where he designed and directed *Ants and Architruc*, (1970). He later emigrated to Canada.

28. Billed initially as *Oh, Ernesto*. If it didn't show, this perhaps explains Russell's departure soon after.

29. Simpson's *One Way Pendulum* (1959), about an introverted young male who tries to train 500 speak-your-weight machines to sing the *Hallelujah Chorus*, had been a commercial success in the early 1960s.

30. In the Lab's closing months, Julian took over more than just the theatre, becoming administrator of the whole project, some IRAT letterhead appearing in 1971 with 'Secretary-General' attached to his name.

31. *Time Out* No.60, 21 March – 4 April 1971.

The Gallery

As at Drury Lane, the Robert St gallery space doubled as a reception area. At Drury Lane, visitors happily sat on the floor and socialised, with the artworks usually serving as a backdrop. At Robert St, the much larger gallery space had a concrete floor and unforgiving industrial strip lighting, and was almost always extremely cold. It thus presented artists with a different set of opportunities and challenges. Like the theatre, the gallery passed from hand to hand. There were periods when little was on show, but what *was* on show was often remarkable. The first exhibition for which records exist appeared in November and consisted of 'environmental structures with inflatables for use with children' designed by Ken Turner's Action Space.[1] Ken was then teaching part-time at the Central School of Art and had become involved with Joan Littlewood's Theatre Royal Stratford East and her plans for 'instant cities' in which art, theatre, technology and entertainment would come together as a total public theatre of the arts. He recalled that in the summer of '68, "as I had been experimenting with performance in the streets of Barnet and experimenting with the students in wood, metal and plastics, building models for the environment, linked to ideas inspired by the Bauhaus, I was only too ready to make something big in structure, [that was] environmental and participatory, as an 'environmental art form'".[2] This became an environment called *The Plastic Garden / Paradise Garden* that was created alongside other artists' and architects' visions of new, interactive environments in Littlewood's *Bubble City*, next to All Hallows-by-the-Tower in the City of London.[3]

An Action Space 'air structure' c 1970 (photo imaginativeeye.co.uk).

What was on show at the Lab was the product of Ken's follow-up project in Wapping, involving children, structures, inflatables and painting materials. *The Times* reported: "the group built a world of fantasy and glamour in Wapping Gardens – complete with monsters breathing fierce orange-coloured smoke, flexible buildings with clip-on walls and plastic roofs, stepping stones, sticks and ribbons – [which] helped the children to explore space. They built, and painted and destroyed, making costumes and producing astonishing paintings on large sheets of brown paper … the results of which

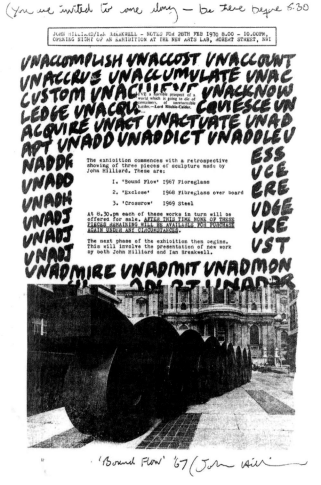

(You are invited to come along – be there before 6.30

JOHN HILLIARD/Ian BREAKWELL – NOTES FOR 28TH FEB 1970 8.00 – 10.00PM,
OPENING NIGHT OF AN EXHIBITION AT THE NEW ARTS LAB, ROBERT STREET, NW1

**VNACCOMPLISH VNACCOST VNACCOVNT
VN ACCRVE VNACCVMVLATE VNAC
CVSTOM VNACHIEVE VNACKNOW
LEDGE VNACQV... CQVIESCE VN
ACQVIRE VNACT VNACTVATE VNAD
APT VNADD VNADDICT VNADDLE V
NADDR ESS
VNADD VCE
VNADH ERE
VNADJ VDGE
VNADJ VRE
VNADJ VST
VNADMIRE VNADMIT VNADMON**

IVE a horrible prospect of a
world which is going to die of
containers, of unattainable
Battles.—**Lord Ritchie-Calder.**

The exhibition commences with a retrospective
showing of three pieces of sculpture made by
John Hilliard. These are:

1. 'Bound Flow' 1967 Fioreglass
2. 'Exclose' 1968 Fibreglass over board
3. 'Crossrow' 1969 Steel

At 8.30.pm each of these works in turn will be
offered for sale. AFTER THIS TIME NONE OF THESE
PIECES REMAINING WILL BE AVAILABLE FOR PURCHASE
AGAIN UNDER ANY CIRCUMSTANCES.

The next phase of the exhibition then begins.
This will involve the presentation of new work
by both John Hilliard and Ian Breakwell.

'Bound Flow' '67 (John Hill...

*Hilliard's invitation to the joint
exhibition – with its image of*
Bound Flow *at St Pauls.*

– and some of the Wapping children – will be at the Arts Lab till November 16th."[4] There was a related conference on the 9th at which "artists, play-leaders, local government and community workers will establish a programme of action".

In December, *Mapping New Music* was an exhibition of modern music scores – many of them wonderfully inventive in their graphic shape and form of notation – collected and lent by the composer Gavin Bryars.[5] This prompted a series of concerts by some of the featured composers running through late November, December and into January '70, including 'Julian Silverman and Group – *Musical Conjunctions,* baroque broadsides and modern music, recorders, violins, guitar, spinet'; a performance by the German experimental musician Hans Joachim Roedelius;[6] works by painter-composer Tom Phillips;[7] Hugh Davies and Anna Lockwood, 'two composers/performers who specialise in unusual 'found' and specially constructed musical instruments'; John Tilbury performing piano works by Cardew, Wolff, Phillips and Bryars; a performance by Edward Fulton, Chis Nay, Phil Gebbet and Gary Manning of *Autumn 60* by Cardew, and finally, Mike Smith with recorded music from EARS with slides, 'a butterfly event', *Gramble* (a piece by Richard Reason and Cornelius Cardew) and 'a musical sculpture'.

December's schedules promised that another survey-show would occur the gallery in January, this time 'of Light Shows and Experiments with Light', and the New Year's Eve spectacular which featured lightshows may have been part of it, but January's own schedules billed the gallery's offering as '*FUN FAIR* devised by Carlos Sapochnik'.[8] Carlos has no memory of organising such an exhibition, so *Fun Fair*, if it happened, remains a mystery.

At the end of January there was a joint exhibition by John Hilliard and Ian Breakwell that would memorably encapsulate many of the changes then transforming British sculpture, as it shook itself free from the influence of Anthony Caro and the 'New Generation' sculptors. (The St. Martins students' show *Sketches from a Hunter's Album* at Drury Lane had been

another such oedipal response). On a flier, the artists described the show's evolution over its planned four weeks: "The exhibition commences with a retrospective showing of three pieces of sculpture made by John Hilliard. These are: (1) *Bound Flow* 1967, fibreglass; (2) *Exclose* 1968, fibreglass over board; (3) *Crossbow* 1969, steel. At 8.30 pm each of these works will in turn be offered for sale. *After this time, none of the pieces remaining will be available for purchase again under any circumstances.* The next phase of the exhibition then begins. This will involve the presentation of new work by both John Hilliard and Ian Breakwell."[9]

In an article drafted for *Studio International*, the account continues, now reporting the actual events: "as each piece came up for sale, Ian Breakwell and two assistants began to wrap or shroud them in paper covered with the word 'UNSCULPT', effecting a visual transformation of the exhibits. This procedure being complete and no one having offered to purchase any of the three pieces, Breakwell, Hilliard and two assistants armed with sledgehammer, axe hammer and spanner began to demolish/dismantle the sculpture and to dispose of the remains into a rubbish skip outside the gallery, thus clearing the space for the erection of the first new work. The events of the opening, recorded up to this point on video-tape, were now played back to the audience.[10] At the same time Hilliard and his two assistants commenced the erection of a structure built of scaffolding poles. ... As the last pole was positioned, the gallery lights were extinguished and ultraviolet 'black' lights were switched on. Hilliard then began to paint the scaffolding with fluorescent blue paint so that the forms emerged under the light as he proceeded. Completion of this activity terminated the opening and the resultant work remained in situ for four days. ... [A week later], using three stockinet tubes each thirty feet long and sheets covered with words, Breakwell installed a large static work. There was in addition an aluminium-framed clear polythene

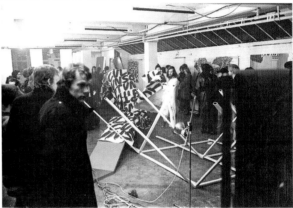

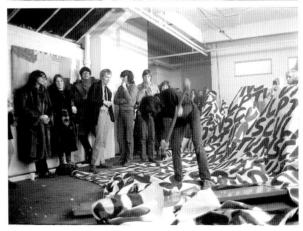

(top) John Hilliard's sculptures and some wall works by Ian Breakwell before the Breakwell/Hilliard performance starts; (middle) Ian Breakwell in white overalls begins wrapping the sculptures, David Kilburn and DC standing at left); (bottom) John Hilliard smashing the wrapped works with a sledgehammer, (visible in the picture, George Craigie with hand at his mouth, Cliff Evans videoing the event top right). Photos Mike Leggett.

UNWORD

A film by MIKE LEGGETT of a performance by IAN BREAKWELL

1970. 16mm. Black & white. ¼ inch 3⅜ tape soundtrack. 50 mins. (N.B. Can only be projected at 2 frames per sec. using a Spectro Analysis Projector : a machine available in Science and Engineering Depts. of many educational establishments ; or approx. £2 – 10 – 0 per day hire from photographic suppliers.) Or one of the film-makers will personally project the film for a fee by negotiation.
Hire fee : £2-0-0.for UNWORD film alone.

Available in early 1971 will be a shortened version of UNWORD suitable for conventional 16mm projectors.

UNWORD : " a hypnotic collage of rapidly changing word-imagery and physical action."

SHEET

A film by MIKE LEGGETT and IAN BREAKWELL

1970. 16mm. Black & white. Magnetic Sound track. 21 mins. Hire fee : £4 - 10- 0d.
A film about a white sheet and the locations in which it is filmed. Impossible to describe.
A totally visual, dream-like film. Featured at N.F.T. Festival, London : Sept. 1970 , and on Belgian T.V. : Dec. 1970.
" It's the best English film I've seen this year (and probably last year too....). "
 – David Curtis. Organiser N.F.T. International Underground Film Festival.

Both films available from : London Film-Makers Co-op, 1 Robert St. London N.7.1
Tel. 01 387 6573
or direct from : Mike Leggett, 82 Frithville Gardens, London W.12. Tel.01 743614

Flier designed by Leggett & Breakwell to promote their collaborative films.

greenhouse, the contents of which changed regularly (this remained throughout the rest of the show); in one instance invited guests arrived at the gallery wearing costumes of their own making which they then discarded in the greenhouse." And another week later, "Hilliard erected a second scaffolding piece, again under ultraviolet light. The exhibition then terminated".

In the same article, in a sectioned titled 'New Generation ephemera – observations and responses', Hilliard commented on this transformation in his concerns: "if this kind of sculpture gets shown [his Caro-like pieces initially exhibited] … it falls apart … [My Arts Lab show] demonstrates that there is no real need or market for works of that kind."[11] Instead he embraces the making of ephemeral works that can be recorded photographically or on film, hence the videoing of the act of destruction of these works, and the performative nature of their replacements.

Comparable, too, is the contemporary Mike Leggett / Ian Breakwell film *Sheet* (1970), exhibited during a one-day event at the Lab in June, in which the title-subject – a large white sheet – is placed in a variety of urban and rural contexts and occasionally 'performed', moved, blown-about, revealed and concealed, the film being a record of this ephemeral behaviour. At the June screening, simply billed as *Expanded Cinema Event by Ian Breakwell & Mike Leggett*, this premiere of *Sheet* was accompanied by that of another joint film *Unword* (1970), this latter being shown on an analysis projector at two frames a second. *Unword* was itself the record of earlier eponymous performances by Breakwell which took place in London, Bristol and Swansea, each incorporating the simultaneous filming of the event by Leggett and the projection of the filmed trace of its predecessor, forming a work in continuous evolution.

The Robert Street exhibition that attracted the most attention, both at the time and subsequently, took place in April 1970. J G Ballard's *Crashed Cars* 'technology meets life' was his 'first exhibition of sculpture' and one of several precursors to his celebrated novel *Crash* (1973).[12] Much later, Ballard described his exhibition's origins, winningly noting 'the deviant possibilities' that 20th century technology offers the human imagination. "Film and television are saturated with stylised violence that touches our imaginations but not our nerve endings. … The car crash, in particular,

taps all sorts of ambiguous responses, as I found when I mounted an exhibition of crashed cars at the New Arts Laboratory in 1969 [actually April 1970], shortly before I began to write the novel. The exhibition was a calculated experiment, designed to test the hypothesis that a repressed fascination lies behind our conventional attitudes to technological death and violence, a fascination so obsessive that it must contain a powerful sexual charge. The three crashed cars were exhibited without comment under the neutral gallery lights, at their centre a telescoped Pontiac from the great tail-fin era."[13]

NEW SCULPTURE BY J. G. BALLARD

"CRASHED CARS"

**PRIVATE VIEW
FRIDAY, 3 APRIL, 7;30 PM
WINE**

EXHIBITION OPEN 4 APRIL - 28 APRIL
CLOSED MONDAYS

**LONDON NEW ARTS LABORATORY
GALLERY, I.R.A.T. 1 ROBERT STREET.,
LONDON N.W.1. 387-8980**

'Technology meets life', J G Ballard's invitation to his exhibition.

He colourfully continues, memory perhaps embellishing the events "I have never before or since seen a launch party degenerate so quickly into a drunken brawl. The cars were abused and attacked, as they were during the month-long exhibition, overturned and slashed [splashed?] with white paint. A woman journalist from *New Society*, then a bastion of approved thinking, was so deranged by the spectacle that she was speechless with rage. All this, needless to say, I regarded as a green light and I began to write *Crash*, which I think of as my best and most original novel."[14] I don't remember these attacks, but, whether actual or Ballard's rich imaginings, they clearly helped fuel his writing. *Crash* is a work that still resonates half a century later. (At the time, we workers at the Lab were more struck by the sickening smell of leaking engine oil that pervaded the building for the duration).[15]

In May, there was 'an open access exhibition' (did anyone submit anything?) and in June, a joint show *Judith Clute*: *Diagrams / Similes* and *Pam Zoline: Things in the World*. The schedule invitingly suggested that Pam's work 'combined the use of walls with the use of the floor area and includes a game to involve people'.[16] An unsigned tongue-in-cheek press release (composed by Judith's partner the writer John Clute[17]), described their work.[18] If the mock art-speak now sounds patronising, the description of Pam's portrait boxes and the summary of Judith's image-repertoire is usefully evocative.

Ballard's cars were not for sale; his 'calculated experiment' had other purposes (a tabloid journalist saw the young Sally Potter at the Lab and persuaded her to pose with his price tag) (photo Getty Images).

At the beginning of July, Carla Liss staged a one-day FLUX event to coincide with a screening in the cinema of *The Fluxus Anthology* – the collection of films by Fluxus artists assembled by George Maciunas that had come to the Film Co-op with the New American Cinema collection. Her display probably included some of the Fluxkits that she and Maciunas were then assembling and offering for sale. Fluxkits were boxes of objects, some being a collection of small artworks by fellow Fluxus artists, others just 'found' things, such as the used tickets stubs and bus and boat timetables that formed her *Travel Fluxkit* made with Maciunas after she left London and the Co-op in 1972.[19] I remember her selling tiny Fluxus 8mm film viewers – little more than an eye-piece and a crank-handle that animated a tiny loop of film – offering perhaps a blaze of colour frames by Paul Sharits or Yoko Ono's blinking eye. Sadly, I couldn't afford to buy one at the time.[20]

Also in July was an international survey of concrete poetry organised by David Kilburn, which featured his own publishing venture *Green Island,* together with work by Bob Cobbing, George Macbeth, Robert Lax, Emil Antonucci, Ian Hamilton Finlay, A.G Fronzoni, two Japanese exhibitors and members of the Italian *Amodulo Art* group, Gian Roberto Comini, Enrico Pedrotti and Valentino Zini. David had been assembling a collection of concrete poems since the mid '60s. "I contacted a number of practitioners, nearly all of whom agreed to participate and sent materials. ... [This show] also paved the way for a subsequent exhibition in the Royal Festival Hall – *Visual Poetry* curated by Mike Kustow, that ... included a lot of the work shown at the Arts

Diagrams/Similes; Judith Clute
Things in the World: Pamela Zoline.

Exhibition: London New Arts Lab, 1 Robert St, London N.W.1.
Private View, Thursday 4th June 1970
(press and by invitation)
Exhibition open 5th-25th June, 2-10 pm. Closed Mondays.

Claims dark-haired American London -based artist Pamela Zoline, 28, " I want to make an art which takes on the whole world, like Time Magazine", in the style of Time Magazine. Conceptual art (ha ha), paintings like dictionaries, encyclopaedias, giant lists, games, systems, portrait boxes (a portrait box is a small room, about the size of a telephone kiosk, filled with artefacts, objects, references, clothes, photos - all referring to an individual; "an attempt at a modern equivalent for the traditional portrait; the flat image doesn't pack so much punch with photographs everywhere" short Miss Zoline, Illinois-born, insists) philosophical games, Luddites, cows, American Indians, painting Apes, Mondrians, maps, charts, information systems; the work attempts to catalogue things in general. She is fascinated by the multiplicity of the world, wants to make an art world that stands alongside the real world, to describe, explain, play with the real. "Grandiose, an impossible task, but even if it's a failure it'll be as big as Texas" polymath Zoline apostrophised.

Claims somewhat taller Canadian London-based artist Judith Clute, younger at 27, " I want to make an art that reflects Time Magazine and parts of the world with the deadpan eye of a child though not the style." Compared to conceptual statements, her precisely-drawn diagrams of the intersections of data and things are introspective and self-contained. " I was a quiet child" brown haired Clute, married to an unemployed forktruck driver, concedes. But her paintings have a hard colourful edge, mount campaigns against easy reading, include references to Easter Island scripts, Austin A40s, rabbits, geometries, sprayguns, clothespins, swans, forktrucks. She reminisces about her apprenticeship with Pamela Zoline in the famed Vancouver-based Stegman/Andre studio in 1961, where she was first stimulated by the then unknown Canadian masseur Marshall McLuhan. "Making it has always been a challenge" she claimed. " as the world is full of likenesses and very big". It's about as big as Texas" she finalised.

Lab."[21] A flier Comini produced included extracts from the *Amodulo = Art Manifesto*, an anti-establishment, pro-experiment rallying-call typical of its time. "The Amodulo group sees the traditional art situation as grounded in the production of aesthetic 'cliches' which aim to establish a precise identification of the author. [The dreaded cult of the individual artist!] … Amodulo believes it is imperative to operate in a climate of absolute freedom of research. … This experimental search brings with itself the possibility of the production of objects, happenings, posters, shows, etc., presenting widely different characteristics within a short period of time …" So, wholly appropriate to the Lab.

Box lid designed by George Maciunas.

In September the gallery hosted another mixed media exhibition, '*An Elephant at the Arts Lab – Photographs, Slides, Films, Electronics and Inflatable Sculpture*. Contributors include Ian Robertson, John Lifton, Ian Breakwell, Fred Drummond, Graeme Ewens and George Fratwell'. No further details survive. The source of many of the inflatable artworks seen at the time was Graham Stevens, who had pioneered the 'participatory inflatable' as a form of social-interaction-art. His long, environment-altering tubes, held aloft by and sometimes entangling the audience, graced events at Better Books, UFO, the *14 Hour Technicolor Dream* and elsewhere. He was later famous for his *Desert Cloud* interventions in Arabia, plastic clouds held aloft by thermal buoyancy

Visual Poetry (1972), organisers and exhibitors including Scottie and Michael Kustow seated, David Kilburn (bowtie). Photo courtesy Clare Wood, South Bank Centre.

alone to trap precious dew, a pioneering attempt to exploit renewable energy.[22] On this occasion, or perhaps earlier in the summer, Graham offered visitors to Robert Street the opportunity to design and make their own inflatable artworks. "The IRAT show was just my JP19 High Frequency [plastic] Welder with free PVC for participants to make their own structures with."[23]

In the autumn of 1970, responsibility for programming the gallery passed to Annabel Nicolson, then a postgraduate student at St Martins, and she launched her series of shows with her own *Exhibition of Paintings by Annabel Nicolson* – a series of large abstract can-

Graham Steven in one of his own inflatables, photographed at the Drury Lane Lab by Nina Raginski for 'Air Art' Studio International *n175, May 1968.*

vases. Annabel had studied painting at Edinburgh College of Art and had drifted towards the Robert Street Lab where she met Malcolm and began her long-lasting involvement with the Filmmakers' Co-op. At the time of her paintings show, Annabel was already beginning to make films, but didn't include them in her exhibition, though she probably showed them at a contemporary open screening. Annabel was in touch with conceptual art to a degree then rare among her generation of filmmaking artists.[24] She became cinema programmer at the Co-op a number of times in its later history, wrote articles, and continued to make films and works of art in many media.

The show of Annabel's own paintings was followed by *An Environmental Installation* by Jon Fox, a sculpture student at the Slade. Annabel remembers "I met Jon when he wandered into the gallery and I thought his ideas sounded interesting so I invited him to show work in the space. He worked with materials including feathers, chicken wire and straw using the gallery space as a studio." It was Jon who apparently suggested the three artists [from St Martins] for the shows following his. "He described what they were doing and I asked him to contact them on my behalf." The initial idea was for an evolving sculptural installation. "The first set up an installation with basic studio materials for a week. The second one responded to this and developed it over the following week [and so on]. The materials were very simple, the kind you might find in a fine art studio. I remember there was coloured pigment in powder form and someone set up a drip of water causing a stain to spread slowly over the days, possibly on a sloping surface. The three, all sculptors, were Roderick Coyne, Carl Plackman and Elona Bennett."[25]

It's unclear how closely the artists followed this brief, though Bennett remembers working with Coyne on *Concatenation*, 'an installation that kept changing', and recalls one unusual ingredient that she contributed: "At that time you could go into what looked like a phone box (can't believe this is true?) and make a record. I recorded the BBC ... eight o'clock news and repeated it over and over during exhibition. The other fact I remember is that the private view at the Arts Lab coincided with the disruption of the *Miss World Contest*. [The Albert Hall, 19 November

1969.] Being an active member of Women's Liberation, if it hadn't been for the private view, I might have been arrested as several of my women friends were!"[26]

One part of the evolving work became Roderick Coyne's *Wing* (1970), a drawing on the floor made in yellow tape, plus a significant shadow cast by the square column in the gallery, so was also a direct response to the space.[27] He recently wrote "The idea of 'landscape', both literally and figuratively, has qualified much of my work. My early sculptures took the form of ephemeral constructions made largely with 'found' materials that were presented either inside or outside the studio. Later I began to formalise my activity by setting up dialogues between different categories of material statement which usually began with an acknowledgment of the limitations of the chosen site."[28] Sadly, there's no record of Plackman's contribution.[20]

Roderick Coyne's 'Wing' as recreated at P3 in 2010. Photo courtesy Ambica P3, University of Westminster.

Endnotes

1. Ken Turner 'Action Space and its Development' www.imaginativeeye.co.uk/historical%20present.html.

2. 'Action Space and its Development', ibid.

3. This was a try-out for Littlewood's unrealised *Fun Palace* that Cedric Price was in the process of designing.

4. June Rose; 'An Introduction to Art', *The Times*, 3 November 1969. It is possible that Ken Turner provided the 'toys' for the Lab's opening party.

5. Also listed as *Scores of Modern Music*. Many years later, the Serpentine Gallery would restage this eye-opening show, probably unknowingly.

6. Co-founder of the Krautrock groups Cluster and Harmonia www.allmusic.com/artist/hans-joachim-roedelius.

7. Tom Phillips had just won a painting prize at *John Moores* 7, Liverpool.

8. Carlos later became a noted a graphic designer, typographer, illustrator, printmaker, and organisational consultant within a systems psychodynamic framework specialising in mental health, higher education and the voluntary sector.

9. Flier Robert St file.

10. "Cliff Evans [Hoppy's co-worker] videoed, I filmed and photographed, others also photographed". ML Email 19 March 2018

11. 'New Generation ephemera – observations and responses – John Hilliard'. Draft article for *Studio International*. Robert St file. Hilliard remembers: "Tony Caro actually came to the opening, but (perhaps fortunately) left to go to the theatre before all the 'theatre' at the Arts Lab started. [Also], just as a matter of interest, I performed in Ian's *Unword* event at the ICA that year – filmed by Mike using single-frame shots. Mike said his fingers were like bananas afterwards." Email 1 March 2020.

12. Other precursors included the essays 'The Atrocity Exhibition', *New Worlds*, September 1966; 'Crash!' *ICA-Eventsheet*, February 1969, which became chapters in the book *The Atrocity Exhibition*, Jonathan Cape 1970. Ballard was a friend of Pam, and through her had become a trustee of IRAT, together with Peter RaynerBanham, Dr Christopher Evans, Richard W Evans, Cllr Christine Stewart Munro and Joe Tilson; Patron Lord Harlech (known to Hoppy through a former girlfriend); Sponsor Lord Burgh.

13. The other cars were an Austin Cambridge A60 and a Mini.

14. *Guardian* 'Weekend' 19 May 1990. Elsewhere, the critic Simon Ford adds more, again citing Ballard as the source: "The exhibition continued to act as a stimulus to transgressive acts well after the opening party. In the following days visitors repeatedly attacked the cars, daubed them in paint, broke windows, tore off wing mirrors, and urinated on the seats. Such was the violence directed at the cars that

the staff at Motor Crash Repairs were shocked when Ballard returned them to the yard." http://www.slashseconds.org/issues/001/001/articles/13_sford/index.php.

15. There are echoes of Ballard's wounded cars in Jeremy Deller's even more sobering *Baghdad, March 5th 2007*, the remains of a vehicle damaged in a car bomb attack on the book market in central Baghdad, recently displayed at the Imperial War Museum.

16. London Region (cont) from Arts Labs Newsletter. Robert St file.

17. Already an authority on speculative fiction.

18. Among Zoline's portrait subjects were Ted Hondrich (author of *Oxford Companion to Philosophy*, 1995 and writers Michael Dempsey and Elspeth Burroughs.

19. She later recalled "In '72 George and I travelled around the Greek Islands looking to purchase land for Fluxus. However, on arriving we learned at that time it was almost impossible for a foreigner to purchase Greek land. Out of that trip came my *Flux Island Souvenir Kit* and *Flux Travel Kit*." – Carla Liss to Harry Ruhe, *Fluxus, the Most Radical and Experimental Art Movement of the Sixties*, "A", Amsterdam, 1979. She was probably then collecting samples for her *Sacrament Fluxkit* (c1969–1976), now in the Tate archive, a box containing vials of water labelled 'well', 'faucet', 'pool', 'rain', 'brook', 'lake', 'snow', 'river' and 'sea'.

20. Jonas Mekas describes Carla's film-performance *Dovecot* show at the second NFT Festival (1973) which featured these same viewers: "In the room, five or six 8mm projectors throwing images of doves, flying or just strutting, as seen from the depth of [the] tower … they fly in this round circle against the sky, as the sounds of the fluttering wings and cooings is reproduced in the room from all sides. Tiny loop viewers are passed around in the audience, with fragments of the images that we see projected on the walls, and the little cranks of the loop viewers begin to make a sound in the room that becomes a further extension of the dove's happy cooing. A very lyrical, peaceful piece." 'Movie Journal', *Village Voice*, 11 October 1973.

21. Kilburn email 26 February 2018. The Festival Hall exhibition (25 April – 22 May 1972) was organised in association with The Poetry Society. Clare Wood, SBC, Email 4 March 2019. In 1975 Kilburn published a word-piece by Comini in his occasional folded one-page, free, poetry magazine *Green Island*. He also published Breakwell's *Unword No1* under this imprint.

22. His film *Desert Cloud* (1974) is in the collection of the Pompidou. Graham's work was included in Willoughby Sharp's celebrated *Air Art* show (USA, 1968) alongside works by Hans Haacke, Les Levine, David Medalla, Robert Morris, Andy Warhol and others. Jeffrey Shaw and Theo Botschuijver visited Graham's *Pneumatic Environment* (1966), exhibited in Battersea Park as one of 100 international artists participating in *Destruction in Art Symposium* (DIAS), and invited him to participate in the *Holland Festival* 1967, after which they formed Event Structure Research Group, and Graham's ideas became widely adopted by other artists.

23. Stevens email July 2018.

24. See for example, her 'Artist as Filmmaker' *Art & Artists*, December 1972. Rep Lux Online.

25. AN letter January 2018. Tim Head, who Annabel thought was also in the show, remembers instead exhibiting with the same artists a few months earlier: "After leaving the one year graduate sculpture course at St Martins in 1970 I was in an Arts Council touring show called *New Sculpture* [May 1970–] with Elona Bennett and I think also Rod Coyne and Carl. It was a mix of ex-St Martins and RCA students." Tim Head – Email January 2018.

26. Bennett email 27 July 2018. Bennett attended the Advanced Course in Sculpture at St Martin's 1969–1970. "I was teaching part time in the sculpture department at Maidstone, encouraging women students to be aware of themselves as women artists. … I was also in the Artists Union, I designed the membership card … The group of women in the Artists Union got Mary Kelly voted as director, upsetting a few people. We were well organized … I had been working on large steel structures but my involvement in the Women's Movement led me to question my work … in 1970", ibid.

27. Coyne reconstructed it for the Ambica P3 gallery show *From Floor to Sky* (2010).

28. roderickcoyne.and.org.uk.

29. Plackman was later an influential tutor at Goldsmiths College, London whose students included Tony Cragg, Damien Hirst, Liam Gillick and Alison Wilding.

Music / Poetry / Talks

The People Band was a frequent provider of music at Robert Street in the Autumn of 69, playing regularly in November, December and into 1970, Mike Figgis then joining the People Show as a performing member (as already noted), returning to the Band later.

Hugh Davies's astonishing series of concerts staged in the context of the gallery's *Mapping New Music* may have exhausted his energies, for the surviving record suggests that his subsequent offerings became infrequent, but on Sundays in June there were concerts featuring John White's 'machine' based compositions; including works for 'C Major Machines', his piece *Cello and Tuba Machine for Cornelius Cardew*[1] and 'newspaper-reading and photo-finish machines'.[2] In June the Jan Steele Quintet played for four nights, and in early July the Spontaneous Music Ensemble offered 'a group improvisation towards a unity with the audience'! From November 1970, there were 'Quiet Sounds: Jazz / Asian / Experimental, every Wednesday at 10.30'. There was 'poetry in the theatre' in May, and later the same month, William S Burroughs' publishers held a party at the Lab to launch his book *The Last Words of Dutch Schultz,* (though

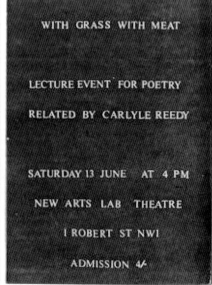

WITH GRASS WITH MEAT

LECTURE EVENT FOR POETRY

RELATED BY CARLYLE REEDY

SATURDAY 13 JUNE AT 4 PM

NEW ARTS LAB THEATRE

1 ROBERT ST NW1

ADMISSION 4/-

Carlyle Reedy's 'lecture event for poetry'
(image courtesy Karen Di Franco).

it's far from certain that Burroughs himself attended). Another public party, in April, marked the wedding of Carla Liss and Nicholas Albery, a *mariage de convenance* that allowed Nicholas to inherit, and Carla to remain in the country, memorably celebrated with powerful hash cookies.

In mid-June, Carlyle Reedy staged a 'lecture event for poetry' entitled *With Grass, With Meat*. The writer/curator Karen Di Franco has characterised Reedy's life-work as "a collection of activities in flux … Collaged art works … assembled from the detritus of the domestic environment, occasionally composed with archival photographs or letters that expose autobiographical fragments, the trace of a narrative …"[3] Reedy remembers *With Grass, With Meat,* as "involving the artist on three levels: *one dimensional* (as speaking language, giving a lecture); *two dimensional* (show-

One of the few surviving fliers for music events at Robert St.

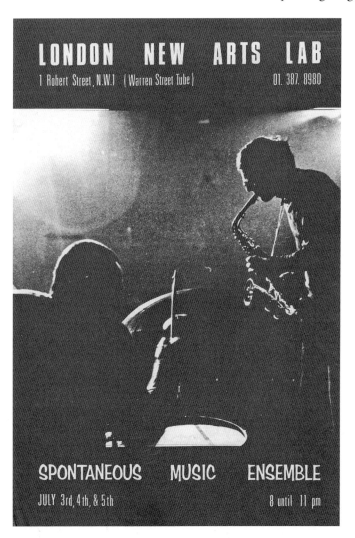

Poetry event flier designed by its performers.

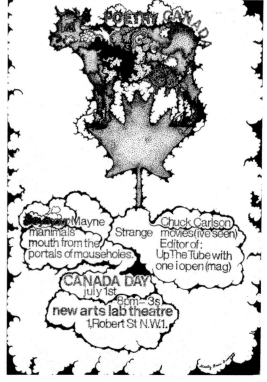

ing a 'theatre of slides on a large screen); and *three dimensional*, finally stepping into a scenario to meet a completely new, previously unexperienced existential challenge. The speeches were dislocutory / intensely creative / poetic / prosaic. These related to a selection of approximately 100 slides of young males of an age-range of 16–21 who had become 'fodder' for the Vietnam war conscription effort, interspersed with surreal war pictures. The scenario involved a playpen, a police car, some pig food and a rocking chair. … It was 'off the cuff' if you like in terms of traditions in this country, but it was very exciting."[4]

Poetry Canada, an event for Canada Day in the theatre, also in July, featured the writer Seymour Mayne and artist/writer Chuck Carlson, both associated with the artist's book publishers Very Stone House in Vancouver. Mayne's contemporary offerings included *manimals / mouth from the portals of mouseholes* - perhaps he performed them? Carlson's included *Strange Movies (I've Seen)* and the magazine *Up the tube with one i open.* It seems likely that they also showed their poster-poems,[5] but it's not recorded. The artist Katherine Meynell remembers another occasion in October 1970 when her uncle the Fluxus artist Geoffrey Hendricks and his then partner Bici Forbes Hendricks performed their *Terminal Reading* around a brazier, reading their texts then committing them to the flames.[6]

A Gestetner-printed schedule from autumn '69

The schedule text reads:

...ursdays late night (10.30pm), Fri/Sat... 6.00, 8.00 & 10.00pm and Sun. at 6.30 & 8.30 we are amazed to be able to present ANDY WARHOL's LONESOME COWBOYS

MUSIC

November 30th. Sun. 5.00pm. Julian Silverman & Group. MUSICAL CONJUNCTIONS — baroque Broadsides and modern music. Recorders/violins/spinet/etc

December 7th. Sun. 5.00pm. Tom Philips: recipient of prize at John Moore's Exhibition Liverpool, performs his graphically notated works.

14th. Sun 5.00pm. Hugh Davies and Anna Lockwood: two composers/performers who specialize in unusual 'found' sources and specially constructed musical instruments.

21st. Sun 5.00pm. John Tilbury: Pianist, has given many important first performances of works by Cardew, Wolff, Philips, Bryars etc.
28th. Sun 5.00pm.

January 4th. Sun. 5.00pm. Edward Fulton: ring for details.

11th. Sun. 5.00pm. Cornelius Cardew: internationally-known composer/performer founder of the Scratch Orchestra (with whom he performs) leader of the AMM.

EXHIBITIONS

Wednesday December 3rd to December 31st. MAPPING NEW MUSIC — an exhibition of new musical notation — with scores — odd — large — small — graphic — and in most of the different languages of contemporary music — concerts other than those listed ablove may be scheduled at short notice — ring for details.

December 10th & 11th. (Special Show) LOCAL TV DEMONSTRATION arranged by John Hopkins of the Video Dept. see below.

January 8th to 29th. FUN FAIR devised by Carlos Sapochnik.

MUSIC/THEATRE

Every Saturday afternoon between 2pm and 7pm THE PEOPLE BAND will perform: ring to confirm.

WORKSHOPS

The Video Unit is currently touring key cities in the U.K. at the request of bodies ranging from Universities to Arts Labs, demonstrating portable TV equipment and collecting material for the Local TV Demonstration at Robert st on Dec 10th & 11th. It is also taking part in the 2000+ Exhibition in Liverpool.

The Film-makers Co-op has been given on indefinite loan between £2000 and £3000-worth of processing printing and editing equipment (16mm). This machinery will be available for the use of Film Co-op Production Members in about 4-7 weeks time (dependant upon delivery and installation dates). Before that time so the workshop space has to be remodeled (to put it politely). Assistance with this work will b well rewarded later. Contact Malcolm Legrice or Fred Drummond at 01 387 8980.

The Photo Co-op now has darkroom facilities at the Lab. These are capable of handling: Printing — B/W any size up to 12'0", Colour, Line, Photo Silkscreen, Drying Glazing etc. also commissions for photos, copying etc. Facilities are for the use of Photo Co-op members. Practical, theoretical and teaching sessions will be held from time to time — for all details contact Ian Robertson. 01 387 8980.

The Computer Terminal is available for use by artists between 6.00 and 12.00pm nightly. Those interested in using it should contact John Lifton before 6.00pm at 387 2605.

The Silkscreen Workshop has a limited amount of equipment available for use. It also accepts some commissions. For details contact Judith Clute at the Lab. (387 8980)

FOOD & DRINK

We hope to have a Macrobiotic food bar (evenings) and an ever-ready hot drinks machine operating in the Lab by early December.

Year One Party folded invite designed by Biddy Peppin.

On 4 October, the Arts Lab celebrated a year of existence with a Birthday Party and on the 19th, there was an open meeting of the 'international coalition for the liquidation of Art' summoned by the *East Village Other's* itinerant correspondent Alex Gross. This preceded a planned intervention "at 10 am at the headquarters of the British Modern Art System the Tate Gallery where [on the 20th] they will spend the day in discussion and will seek a confrontation with members of the staff in the afternoon". Despite the coordinated local input of Gustav Metzger, Stuart Brisley, Sigi Krauss, John Plant and Felipe Ehrenberg, the British Modern Art System appears to have survived this assault.[7]

Endnotes

1. Initially composed 1968, it was played again at the Elizabeth Hall by the composer and Cardew in May 1971.

2. White was an inventor of 'process systems of repetitive minimalism, using all sorts of random means – knight's moves, dart throws, random number tables and telephone directories'. Article by 'Virginia' 5 April 2016 http://experimentalmusic.co.uk/wp/happy-birthday-john-white/.

3. Karen Di Franko *Icons of a Process – CARLYLE REEDY*, Flat Time House, 4 September – 28 September 2014. Press release.

4. *CARLYLE REEDY, Icons of a Process.* Catalogue edited by Karen Di Franco and Guy Brett. Publ. Flat Time House in conjunction with CHELSEA Space, September 2014.

5. Mayne's poster poems included: *Mutetations, Anewd; dear seed ear; the gigolo teaspoon: poster poem five,* (all 1969).

6. KM Email 5 February 2020 Bici is now Nye Ffarrabas.

7. They met with Tate curators Ronald Alley and Michael Compton. See 'Mapping the City – Felipe Ehrenberg in London' Carmen Juliá – *London Art Worlds, Mobile, Contingent and Ephemeral Networks.* ibid.

The Print Workshop

Given the extreme financial challenges of the organisation, the existence of a print workshop at the Robert Street Lab, able to produce its fliers and schedules at near-cost, was vital to its survival. John Collins was an extreme film-buff whose taste encompassed everything from underground movies, art cinema, Hammer Horror films to spaghetti westerns. His frustration at the lack of any proper guide to current releases in the daily press and the feebleness of the London guide *What's On*, convinced him that he should write and print his own weekly publication. The examples of *IT* and the newly established *Time Out* convinced him that self-publishing could be done.[1] John's publishing venture "was … to be called *London Film Guide*. I was horrified by the quotes I was given by printers, so decided that it would only be viable with full control of its printing."[2] Until this point, most fliers, schedules and posters at both Labs had been produced on an overworked Gestetner, requiring the typing of text onto wax stencils, with no possibility for the inclusion of photos unless one had expensive photostencils made commercially. Or else, like Biddy's posters, silk-screen stencils could be hand-cut then printed one at a time. (Photocopying had recently been invented, and for a short period after Robert St Lab opened, some of the film programmes and fliers were taken to a small commercial print shop nearby).

John's leasing of offset litho printing machines and a golf-ball typewriter meant that we could assemble complex artwork using different typefaces and even images, which could then be photographically reproduced

Artwork for a professionally scanned but Gestetner-printed schedule; the best we could do until John Collins set up his press. Layout by Biddy Peppin.

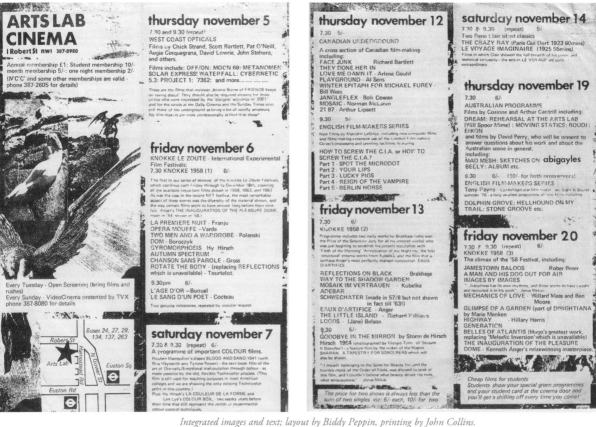

Integrated images and text; layout by Biddy Peppin, printing by John Collins.

and printed on-site. Once his workshop was fully established in March/April 1970, the Lab's schedules became experiments in the use of different coloured inks, different paper sizes and, towards the end, automatic leaflet-stapling. Sadly, the demands of the workshop, his other jobs, and perhaps the growing success of *Time Out,* overwhelmed John's own publishing plans and his *Guide* never appeared, but the Lab was the true beneficiary of his investment, and his workshop carried on as a private printing company after the demise of Robert Street.

Endnotes

1. He recently recalled "in August 1968 I was in the [Drury Lane] Lab when Tony Elliott brought in his first broadsheet issue of *Time Out* to ask if the Lab would sell it: the answer was obviously yes". Email 17 November 2017.

2. Ibid.

Video – TVX

During the first few months at Robert Street, Hoppy's video unit was scarcely visible.[1] A schedule for November explains the absence: "The video unit is currently touring key cities in the UK at the request of bodies ranging from Universities to Arts Labs, demonstrating portable TV equipment and collecting material for the Local TV demonstration at Robert Street on 10 and 11 December".[2] Again, in January, Hoppy vanished, spending more than a month in the USA making contact with radical video groups on the West Coast. But he came back with a renewed vision and began a series of articles in *IT* and *Friends* in which he shared his evolving thoughts about the nature of television and the video image. (No-one else at the Lab was publicly sharing their thinking about our new media in this way.) He asked "What sort of *living thing* is television? … The answer is that it lives SOME of the time and not necessarily all at once. At the New Arts Lab we are going to be asking this question and see what sort of answers arrive." He then described his Unit's more prosaic current offerings at the Lab; videotapes of John and Yoko and the Plastic Ono Band, Rolling Stones in Hyde Park, Dylan, Ringo Starr and a lot more people", before re-asserting that "there are very few people in the world who know anything about the nature of TV in its own terms".[3]

In another issue, he enthusiastically reported on his visit to Brice Howard at the National Centre for Experiment in Television in San Francisco, an off-shoot of the educational cable station KQED.[4] There he had seen image-mixing happening in real time and being multi-track recorded on video tape, similar to innovations in contemporary music recording. "While I was there I saw the 8th and 9th passes of a colour videotape of a couple of local groups. The effect is eyeblasting."[5] He described the Bachdenkel / John Lifton / Goldsmiths event which had just taken place at the Lab; clearly an attempt to equal Howard's achievements. "Several things became clear … We were operating the TV studio or media nucleus of the future. People and events were happening in real time." Then, in a change of tack, perhaps because with portable equipment mixing and multi-track recording were still impossible, "Sony have promised to lend us a set of their latest portable equipment for a month, and when it comes there'll be London's first head TV news service, six days a week.

Page 10 Friends 18 November 13 1970

it is mine

VIDEO

BBC to Broadcast Video Cassette Material in Pop Programme

A four minute sampler of TV in the future will be broadcast as part of Disco 2 on Saturday, 24th October at 7.30. p.m Called the 'Electric Newspaper', it is a video tape treatment by TVX of a track from the LP by the American group 'Area Code 615'. Cliff Evans of TVX describes cassette material:"It will have the information density.

The Electronic Newspaper – as summarised in images in Friends *n18 November 1970.*

John Lifton and I hope to see you at the New Arts Lab inventing the future of television with us. Soon. To see is to touch is to love."

In fact, he and his ever-changing TVX crew got a taste of 'mixing' elsewhere. He reported on a visit to a colour TV studio "at the kind invitation of a turned-on director. ... We started to use the system as we understood it, directly, and very soon were (however inefficiently) doing things that had probably never been done before in that studio. ... Fortunately we didn't know what you were supposed to do with a synthesiser or a vision mixer, so discovered some things. Most of these things we don't have names for yet."[6] His friendship with this turned-on director eventually allowed him to announce that "a four minute sampler of TV in the future will be broadcast as part of [BBC2's] *Disco 2* on sat 24th October [1970]. Called *The Electronic Newspaper*, it is a videotape treatment by TVX of a track from the LP by the American group Area Code 615. ... It will have the information density of 30–100 times that of existing studio-made TV. Creating it in the first place requires concentration and skill similar to that of a pop group making an LP."[7]

In his *IT* column, Hoppy attempted to theorise the TV-viewing experience too. "At the New Arts Lab, we are slowly working out a language which describes *our experience of television*." He drew diagrams describing the overlapping areas of individual and shared experience when both 'making' and 'viewing'. In another article, he analysed the experience of watching an event and its simultaneous transmission on-screen: "Tony Crerar came in and did some mime the other day, in which he's a man in space. He 'gets in a rocket and he goes up'. He's sitting on a bucket, and when he 'gets into space' he suddenly pirouettes on this bucket and become free-floating. ...When they turned the camera around – see, he was suddenly floating upside down. ... With video, ... you're experiencing 'transferred experience' through that little screen ..." Video-magic adding to the magic of mime.

TVX's public events at the Lab continued to be occasional and often unannounced. Mentioned in *IT*, but with no indication of when it might be seen, was what might have been an early piece of video art, '*Trees* by Joe Pattiniott and Dermot Harvey', two TVX workers.[8] Also mentioned were "regular sessions with students from Paddington Technical College; the Macklin Street Youth Club; a talk with some establishment heavies and some private media classes for people who appear on TV and want to brush up their 'being interviewed' technique". Lack of money and the non-availability of equipment was a perennial problem. In March Hoppy reported "Ringo has just given equipment; we had Lennon's but lost it ... we've only got one reel of video tape at the moment because we haven't got the money, but you can re-use it and you can look at it 50 times".[9] But with one reel only, nothing of what was created could be saved; a true measure of impoverishment.

On a Lab schedule for May, he reported 'TVX News': "starting with two people in February, the Video Co-op has now grown to about 40 people and is due to formalise membership and put out a newsletter. Equipment is on order and when it arrives it is expected to be in constant use for training and production. We expect to be running courses all summer, turning out media guerrillas by the dozen, preparing to decentralise all media technology at the fastest possible rate concomitant with survival." Hoppy did hire equipment for a while, so these courses may have run, but access was always an issue. The lack of equipment was also restricting screenings. His May report continues "As soon as equipment arrives, showings will resume. ... Recent activities include recordings of The Incredible String Band in '*U*' at the Roundhouse, an interview with William Burroughs (associated with the *Last Words of Dutch Schultz* book-launch) and an 'election night TVX special' at the Arts Lab" (the night of 18 June; a gloomy occasion in the event, as the Tories returned to power). He closed his report, typically "Come and get involved! Remember, personality changes accelerate among groups of video users. This is the most powerful communications device ever invented."

In July, TVX headed off to Ecclesden Common near Worthing, hoping to record bands appearing at the shambolic free festival *Phun City*, but found itself competing with Ronan O'Rahilly's Lion TV colour video unit that had secured exclusive recording rights. In the *Phun City* programme, Hoppy wrote in exasperation:

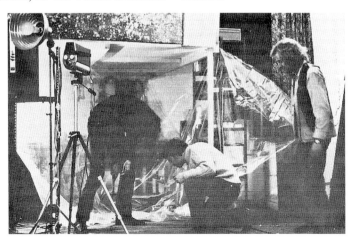

The TVX workshop, with solitary camera (l) Cliff Evans (r) and two unnamed co-workers.

A TVX event coinciding with the end of the 1970 NFT International Underground Film Festival. The inclusion of Robert Crumb's anarchic Mr Natural perhaps reflects Hoppy's new vision of video's role in society.

"The TVX production is minimal on account of no bread to get equipment/videotape. So why not come and fuck on video – something Lion TV won't dare to record"! In the autumn of 1970, the Lab was raided by police looking for drugs and he videoed the event and managed to get footage transmitted by the BBC the same evening. He was also present at the famous invasion of the *Frost Programme* in November, when a group of Yippies took over the studio in which David Frost was about to interview their leader Jerry Rubin, live, on-air. (After a visible kerfuffle, the interview carried on in an adjacent studio). These events underlined his belief that the future of video was as a tool for social change, much as *IT* saw itself; now the indulgence of multi-track image-making could be left to video artists.[10]

Hoppy contributed to *Friends'* written coverage of the invasion: "The hijacking of *The Frost Programme* by media guerrillas last Saturday is the direct result of young people being denied access to television. No TV company has available to it statistics relating to age /occupation and leisure preferences. JICTAR ratings are fake; they don't recognise minority groups … consequently our interests and lifestyles are being misrepresented. … The reaction of the press to the Frost programme [hijack] is typical: *Daily Sketch* 'are these people fools or fanatics?'… and from within the TV industry, an ITA director: 'television is dynamite.. and we're leaving it around for any idiot with a match'. We are neither fools nor fanatics nor idiots. We are people who know what we want and we will disrupt any attempt to block or misrepresent our views. What we want is media-time proportional to our population density, to use the way we decide." Continuing, the statement demands "time in the TV studios for any group wishing to participate" and "the setting up of local community TV stations", then threatens "next time, we will be able to plug our own programme directly into the transmitter". It announces the merger of TVX and Paradise Productions and the new organisation's objectives.[11] These would be "access for unrepresented minorities; support international co-workers, to research technological development to accelerate social improvement, to create programmes for the videotape market – to get the problems of minority groups aired".[12]

IT n 75, March '70.

At the same time, Hoppy was becoming increasingly impatient with the world and not least with colleagues in other departments at Robert Street where he had little time for the collective struggle. He was so aggressive to Biddy who was notionally the Lab's administrator that she eventually withdrew, passing the role to Michel Julian. A particular source of friction was TVX's fondness for playing loud music late into the night. Elderly Hampstead Road neighbours kept awake would complain to Biddy, who would pass on the message, and receive an earful of abuse for her bourgeois pains. She was not the only recipient of Hoppy's rage. George Craigie was so upset that he posted a notice quoting a 'TVX lush' who had attacked him when asked to help clean the communal stairs: "… you know, 'like when our head's into something deep and really deep I mean, it's alright for you happy mind-fuckers to play at petty administration or whatever you call it, but us guys have our heads full of the kind of media that makes stair-sweeping obsolete, cooperation unnecessary and

133

'communication' left strictly for the heads at the BBC or the *New of the World*. We don't need your bullshit ideas on how to run this crystal hall of fame."[13]

After the artistic and financial success of the UFO Club, Hoppy must have been frustrated by his chosen new medium's failure to provide either popular triumphs or material rewards. But he carried on working with video for the rest of his life, and helped to put community television on the political agenda. When the Lab closed, he found an immediate cause to which he could dedicate his tape-making among the squatters occupying the abandoned streets around The Dairy, Prince of Wales Crescent, the new home of IRAT, the Filmmakers Co-op and TVX. And there he also found a new life partner, Sue Hall, with whom he would later set up Fantasy Factory, a video workshop supported by the Greater London Arts Association and the GLC that survived till the end of the century.[14]

Endnotes

1. The unit was called TVX when it appeared for the first time in May 1969, became IRATV and/or Real Time Television for a while, then the name TVX re-emerged in March 1970.

2. Schedule November–December (Robert St file). It goes without saying that the Unit made no financial contribution to the Lab's running costs during this period. TVX recorded the New Activities Committee's 'Midlands Gathering' of weekend of 12 December, and was invited to record the NAC's planned gatherings in East Anglia and Yorkshire. These recordings were shown at the NAC's 8 January meeting, where they gained a mixed response [see NAC minutes].

3. 'Real Time Television' *IT* 73, 12 February 1970.

4. I had met up with Howard in October, and passed his details plus the manuscript of his *Videospace*, to Hoppy.

5. 'Dateline 16 feb' *IT* 74, 26 February 1970, 'Real Time Television'.

6. *IT* ibid.

7. 'Video' *Friends* 18, 13 October 1970.

8. Hoppy's other close colleagues included Steve Herman, Cliff Evans, Joebear Webb, Till Roemer, John Kirk.

9. *IT* issue 75, 13 March 1970. In the next issue, he laments that Ringo's Ampex is unreliable.

10. For example – Peter Donebauer was beginning to experiment with colour video at the RCA in 1971; Lutz Becker made his film *Horizon* (1967) at the BBC working with BBC electronics engineer Ben Palmer. Becker hoped 'we might find some kind of equivalent to electronic music. We explored ways in which visual effects could be created through utilizing a feedback circle between ... TV cameras and monitors'. *Horizon* was transmitted by the BBC, 24 October 1967.

11. Paradise Productions was Victor Herbert's company, associated with Sheldon Rochlin's film of the Living Theatre's *Paradise Now* (1970), to which Jack Moore apparently contributed some video footage. One hears nothing further of this merger.

12. 'Video –The Frost Hijack. Statement (10 November 1970) by the Underground Press Syndicate which includes the Alternative Television Movement', *Friends*, 11 December 1970.

13. Flier: 'Conversation in TVX', dated 'Sun 27th 1pm' (which could either be September or December 1970). Robert St file. At the time, I asked Hoppy why he had to be so aggressive. He said he was having counselling with R D Laing, who told him 'not to bottle it up; let it all out'. Thanks R D!

14. See his pamphlet titled: *Video in Community Development*, University of Southampton (1972), initially written with Cliff Evans, Steve Herman and John Kirk, part of a research report for the Home Office Community Development Project. See also Ed Webb-Ingall https://lux.org.uk/writing/community-video-act-object and additional posts. https://lux.org.uk/writing/the-video-show-by-ed-webb-ingall. "The other piece they made was called *Tell Me You Love Me*, also made and broadcast in 1970 and three minutes long, shot on two-inch video and commissioned by the BBC. Described as a 'visualisation of a track by Frank Zappa and Band', this piece garnered a complaint from Mary Whitehouse due to the inclusion of imagery of anti-racist activists the White Panthers and resulted in the BBC terminating the contract with TVX." This last https://lux.org.uk/writing/community-video-community-tv-ed-webb-ingall. Mike Leggett recalls Hoppy in positive mode: "He helped Ian Breakwell and me with the CCTV component of the *ONE* exhibition at Angela Flowers (1971)". Email 19 March 2018.

Cinema and Film Workshop

I look back at the film-programming I did for The New Arts Lab with some pride; it was probably the first serious attempt anywhere in Europe to create a showcase for new work and establish a repertory of classic artists' filmmaking. So it's sobering to discover that initially I contributed very little to the cinema's opening schedules; and indeed the programming I best remember was concentrated into the last nine months of 1970. That first autumn at Robert St I must have left it mostly to Fred and Carla, for Biddy and I spent three weeks of October in the USA, leaving the day after the Lab's grand opening party. My excuse for this disloyal absence was that I was researching my book *Experimental Cinema*, which entailed round-the-clock film-viewing at MOMA, the New York Film-makers Co-op, Canyon Cinema Co-op in San Francisco and the Creative Film Society in Los Angeles. And the films seen on this trip, and the contacts made, would, of course, be useful to the Lab as well.

Fred programmed experimental feature films during October and early November, the Mekas brothers' *Hallelujah the Hills* and Shirley Clarke's *Portrait of Jason* and *The Connection*, and Carla, responsible for a regular Film Co-op Repertory slot every Wednesday, started showing some of the New American Cinema films that were now in the Co-op's distribution collection, occasionally mixing in a new work by a London based artist.[1] Tuesdays were reserved for Open Screenings as at Drury Lane, run by Fred, Carla or John Collins, or whoever was around. As the film workshop gathered momentum, the Open Screenings would become a vital part of the service. Annabel Nicolson remembers: "My first attempt to show a film in the cinema was probably at an open screening in late 1969. I took along a hand-painted loop of 16mm. There was also some found footage which I had scratched-into. The film was joined together with Sel-lotape and I remember the projectionist Fred Drum-mond gently explaining that films had to be [properly] spliced, and showing me how to do it. My film was

The cinema issued its own membership card.

'Images suspended in light' :Nicolson's Shapes *(1970), image courtesy Peter Mudie.*

'A persistent transmutation of matter taking place' – imagery from David Larcher's Mare's Tale. *Courtesy the artist.*

then projected and I would have been entranced by the light and the movement. *Anju* was shown a few months later, possibly two-screen. I think *Shapes* would have been shown too."[2]

On 6 November there was a belated formal 'opening' of the cinema with David Larcher's *Mare's Tail* (1969), announced with a press screening held at the ICA, funded, as the film had been, by Alan Power.[3] David's extraordinary film was unlike anything else coming out of England at the time; not just in its length, two and a half hours, but its mix of documentary, autobiography and travelogue, and its maker's evident fascination with the filmed-image and the film-strip. More typically of its time, it offered images re-filmed from the screen during projection, or created by chemical treatment of the film-surface, or combined through superimposition, here sharing the interest in medium-specificity of the so-called Structural filmmakers now associated with the Film Co-op workshop's early years. But his was a deeply romantic vision, foregrounding personal emotional responses and a willingness "to show those parts of yourself, or to find out bits of you, that you don't know",[4] which set him apart from his peers. But also like many Structuralists, he admired the minimalist composers: "I was quite influenced by all those Americans like La Monte Young. For instance, the first eight minutes of *Mare's Tail* is black, and you have a sine wave going from inaudible below to inaudible above, and then crosses-over, [echoes of Michael Snow's *Wavelength*] and then it suddenly becomes pixels on the screen and stuff. It was also John Cage."[5]

The artist Carlyle Reedy, who would herself perform at the Lab the following June, reviewed Larcher's film in the form of an imagined conversation, interwoven with notes made while watching it: "*Shall we speak of DL's film then*? I have some notes here. I thought: but why are we watching a turtle? yes. then she gives birth in a barren place, images of death, dried fish. ... / *What do you think the film was about Carlyle?* It was about what he was thinking about, from what I could see, he was thinking on a revolution, the end was in the beginning, and that perhaps forwards may be backwards, for example. / *don't you find the first hour, which is very elementary, hard to take?* elementary? well, it's all grainy. before the film becomes figurative with turtles. the lightbulb. the mandala ... there are marks, lines down the film. studies. there was a persistent transmutation of matter taking place. / *do you think this film is trying to bridge a gap between life and film?* / ... the film is very autobiographical. D L is the film. ... / because it's his eye. he is studying the material. possibly because the film is so extraordinary in terms of technique, one is all the more aware that it is a film made by a specific person, coming out of his head. he didn't fabricate, just recorded his preoccupations ...

/ like in the birth, sex, flashback trips …"[6] (His films and digital works from the next 40 years are one of the unsung glories of moving image art.)

November saw a 'benefit' for filmmaker Piero Heliczer, former child star of Italian '50s cinema, friend of Warhol, Jack Smith and Brighton-based Jeff Keen, and an artist who enjoyed a peripatetic life lived in a state of perpetual crisis, so every screening he participated in was inevitably 'a Heliczer benefit'; all the box-office taking had to be his. (He seemed blissfully unaware of the very comparable poverty of his hosts). And at the end of the month, I restarted a 'History of the Experimental Film' as a weekly feature, then was persuaded by Jimmy Vaughan to show *The Shopper*, Warhol and his scenarist Ronald Tavel's feature-length riff on Hollywood star Hedy Lamarr's recent arrest for shoplifting,[7] starring trans-star Mario Montez as Hedy. This had a potentially poignant subject – the public humiliation of a once venerated actress with potential echoes in Mario's own life-experience – but it was not a candidate for commercial success, the sound recording being exceptionally poor in what was a very 'talkie' film.

In December, local filmmakers began to make their presence seriously felt in the schedule. There was a programme of 'English 8mm films' by Mike Dunford, Malcolm Le Grice, Fred Drummond, et al. (the schedule urging 'bring yours'), and at the end of the month 'a three-day focus on London filmmakers organised by LFMC'; double-bills featuring solo shows by Peter Gidal, Le Grice and Steve Dwoskin, all of whom were now prolific filmmakers, followed by mixed programmes featuring work by Dunford, Drummond, Naomi Levine and Simon Hartog.[8]

The cinema closed briefly 'for rebuilding' over Christmas, possibly to install an old arc-projector sold to us by the Electric Cinema in Portobello road. This was not an entirely wise move as its sound system proved temperamental, but both the projectors we had inherited from Drury Lane were reaching the end of their lives and had to be replaced. More importantly, by January the Co-op's Film Workshop was at last fully operational, an event celebrated in a further explosion of screenings by its participants, as the New Year Eve party began a four-night series of 'open live-action multi-screen events'. These once again featured Le Grice, Drummond, Graeme Ewens et al. and can be seen as sowing the seeds for what became *Filmaktion*, the loose group of film-performance artists centred around Le Grice, which fully announced itself at the Walker Art Gallery, Liverpool in June '73.

Peter Gidal announces his one man show [including the premiere of his portrait-film Heads *(1970).*

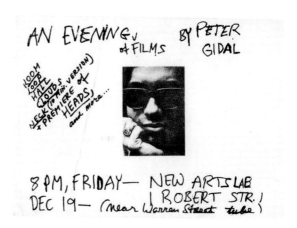

Above: Made while still at Drury Lane, Le Grice's Little Dog for Roger *(1968) was one of his first films to explore the process of film-printing.*
Left: The solarised, serially-reprinted imagery of Fred Drummond's Showerproof *(1969), among the first films to be made in the Film Co-op's Robert St printing & processing workshop.*

Malcolm Le Grice's first work-shop at Drury Lane had con-tained just a film-developing drum 'a kind of slatted wheel made of wood for developing and washing' which he built in one of the upstairs rooms, as-sisted by the American film-maker Ben Yahya, a student at the London School of Film Technique. As Malcolm became more ambitious, he created a film-printer by adapting an old 16 mm projector and used this improvised equipment to make his own early works *Little Dog for Roger* and *Blind White Du-ration*. These films attest to a new ability for artists to explore image-manipulation at the printing stage, an unprece-dented freedom, and one that would come to characterise many of the films produced in the Co-op's workshop during the next few years. Malcolm also built what he described as "a continuous film-processing machine, which was four plastic tanks, four bits of plywood coming down and a roller at the bottom and top made with drainpipe, a couple of film reels on the ends. The film went down and around that four times through the developer, straight into the fix and then into two wash tanks. It came up, went through another wooden tube and up onto a spool with a hairdryer. Amazingly, it worked!"[9]

This was enough to prove that an artist-run printing/processing facility was a workable proposition, but it became clear that what he had built was inadequate for sustained use; a professional version was needed, as he suggested in the *Bulletin*. So at some point during the interim between the two Labs, I made contact with Victor Herbert in Paris who agreed to finance Malcolm's plans.[10] Bizarrely, Malcolm was instructed to collect Victor's cash donation from the Australian painter Arthur Boyd, then living in London. "I was told to go to this house by Hampstead Heath so I knocked on the door and said, 'Victor Herbert told me to come to see you.' There was some kind of party, it was a nice sunny day, and

they invited me to stay and have a drink – then I left with an envelope with £3,000 in it!"

With this Malcolm bought a step-printer and processor for black and white film which he and Fred Drummond installed at Robert Street, not without some difficulty: "[it] was a hell of a job, because there was no electricity and no water in that part of the building ... The processor was huge, weighing nearly two tons. We had to take windows out and have it winched over buildings because there was no space to get cranes into the road. The truck with the processor went through the pavement into the cellar of the pub on the corner. We persuaded them there was no point suing us because we didn't have any money, but that Fred and I would come with some cement and repair it."[11] All this fell to Malcolm and Fred alone.

Once installed, there were attempts to establish cooperative practices. Leggett remembers "seminars were conducted initially to establish proper and consistent use of the ... processor, in particular the replenishment of chemicals, a record book being maintained to keep track of usage and individual's results, essential for advancing collective knowledge of a methodology new to most members. In addition, mentoring in the use of the two machines was necessary as they were both incredibly noisy, the processor causing the floor to shake and requiring voices to be raised!"[12] But he too was excited by the creative potential: "The processor closed the gap between exposure [filming] and projection. It became possible for members to shoot film upstairs, process and print one floor down, then project in the cinema, one floor beneath. More critically, it closed the gap between a film's inception and its conceptual development."[13] For film director Sally Potter, the workshop was simply part of an essential education: "Malcolm Le Grice helped with all things practical. ... Peter Gidal provided a useful foil with his provocative thoughts. Mike Dunford was a willing and hard-working collaborator There were allies and friends and a proposition: that it all was meaningful. It all was activism. It all was possible, with or without money. As I had no money at all that was probably the most helpful attitude of all, and has helped me navigate the brutal realities of film financing ever since. ... I can't stress enough that the practical resources – including learning how print and process at Robert St, were absolute gold dust. Hands on grappling ... It was by being able to do all that, without knowing what the 'proper' way of doing things was, that I was able later-on to delegate tasks on the basis of mistake-laden experience. And also to break any number of procedural and aesthetic rules that I didn't even know existed."[14] She was not alone in her discoveries.

Apart from money raised by selling IRAT 'club' membership, the cinema

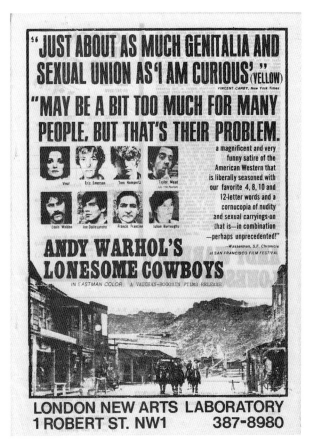

"JUST ABOUT AS MUCH GENITALIA AND
SEXUAL UNION AS 'I AM CURIOUS' (YELLOW)"
VINCENT CANBY, New York Times

"MAY BE A BIT TOO MUCH FOR MANY
PEOPLE, BUT THAT'S THEIR PROBLEM.

a magnificent and very
funny satire of the
American Western that
is liberally seasoned with
our favorite 4, 8, 10 and
12-letter words and a
cornucopia of nudity
and sexual carryings-on
that is—in combination
—perhaps unprecedented!"
—Wasserman, S.F. Chronicle
at SAN FRANCISCO FILM FESTIVAL

ANDY WARHOL'S
LONESOME COWBOYS
IN EASTMAN COLOR A VAUGHAN-BOGOSIN FILMS RELEASE

LONDON NEW ARTS LABORATORY
1 ROBERT ST. NW1 387-8980

A recycled American ad sells Warhol's last serious film.

at Robert Street was the Lab's primary source of regular income, as it had been at Drury Lane. But it wasn't earning enough. In the late autumn, as our financial plight became clear, I shared a document at a staff meeting which calculated the cinema's losses to be about £20 a week. "This figure has been aggravated by the low attendances (no publicity) and does not take into account the fact that many filmmakers and all 'staff' have donated their work for free."[15] So once again we had to look for guaranteed 'earners'. In January we gave away the Wednesday night slots to Derek Hill's New Cinema Club (NCC), and now alternated Co-op screenings and Open Screenings on Tuesdays. I suspect Derek's hiring of our space was more a gesture of solidarity with the Lab than a sound economic decision; certainly, his programming was deliberately sympathetic to ours. For example, in February Derek showed the premiere of *Messages from a Lost Planet (The Other Guys are the Joke)*, a *cinéma vérité* study of Norman Mailer's mayoral election campaign in New York, and *Pleasant Nightmare*, a portrait of Manchester by The Tattooists (Dennis Postle and Dick Fontaine),[16] then *An Evening with Steve Dwoskin*, both of which might have been part of our English Filmmakers strand. The *New York* magazine / *Telegraph Magazine* columnist Sally Beauman was present at the Dwoskin screening and recalled that while his films "really get inside your head … the lights go up at the end to reveal an audience of archetypical hands-in-mackintosh-pocket old men; the three immediately behind you, looking distinctly cheated".[17] (Promotional descriptions of those Dwoskin films in which the camera-eye is focused on a woman alone could easily be misread.)

Derek's NCC series ended in late May when he moved the club to the greater comforts of a cinema in the Mayfair Hotel, but his place in the schedule was first taken by The Viceroy Club which showed camp classics such as *Siren of Atlantis*, and in the Lab's last months by Nigel Algar's 'The Pictures', which was dedicated to classic Hollywood and the then much-discussed 'auteur' film.[18]

But in addition to this financially beneficial sub-letting, we turned again to Warhol to generate money. In January we secured the UK premiere of Warhol's subversive Western, *Lonesome Cowboys* (1968) and successfully

arranged a press screening at the Lab (I had learnt the dark art of previewing from my time spent earlier with Derek Hill's NCC). Alexander Walker gave us a mostly positive review in the *Evening Standard*, in passing not unfairly describing the cinema as overheated on one side (where the radiant gas heaters were installed) and freezing on the other: "I can see my breath!".[19] John Russell Taylor in *The Times* found *Cowboys* "lacking any apparent instinct for the film medium" when compared to Godard's *Une femme est une femme* (1961) or the "bizarre touches of characterisation" that pleased him in the Warhol / Paul Morrisey *Flesh* (also 1968), which was opening at Charles Marowitz's Open Space theatre half a mile away. But Joel Finler in *Time Out* found it 'extremely funny' and 'Warhol's best ever'… and the punters came.

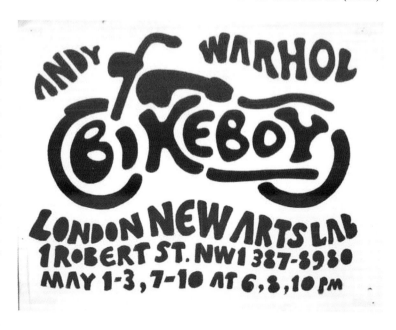

One of the last times Biddy designed and silkscreen printed a poster for the Lab.

Though unappreciated by John Russell Taylor, Warhol's *Cowboys* and his earlier *My Hustler* (1965) were arguably the last films in which Warhol *did* show any interest in the film medium. Both rejoice in an extraordinary use of the zoom lens which at times seemed to have a mind of its own as it wandered off to locate some obscure detail in the scene, far from the narrative centre of attention. Also, in *Cowboys*, Warhol employed the strobe-cut, literally the camera stopped mid-action, presumably because he – as cameraman – had become bored with whatever was unfolding, resulting in a disruptive cluster of flash-frames which both keep the spectator awake and provided a modernist reminder of film's artifice. But another unconvinced viewer was film director Joseph Losey. Front-desk-minder Mary Kay (Ricks) remembers: "I was outside the cinema door when – halfway through the film – he came striding out with a scowl on his face. He was big man … he didn't seem to be a Warhol fan".[20]

Cowboys gained a second outing in July, following a two-week season of the much less interesting *Bike Boy* (1967), Warhol's dry run for *Flesh*, but with a less photogenic male star. Again it brought in the crowds though it hardly lived up to the subliminal promise of Biddy's silkscreened poster. In June we ran an extended version of the Kenneth Anger programme which had done well at Drury Lane, paired with screenings of Max Reinhardt's *Midsummer Night's Dream* (1935) in which Kenneth

Carolee Schneemann's collage artwork for her flier for the December '69 screening of Fuses. Courtesy P.P.O.W Gallery NY.

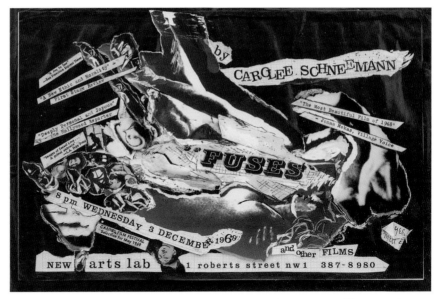

Carolee Schneemann's collage artwork for her flier for the December '69 screening of Fuses. Courtesy P.P.O.W Gallery NY.

claimed he had appeared as the infant Changeling Prince.[21] And a happy pairing of 'Three Love Films' in June, *Fuses* (Schneemann*), Un chant d'amour* (Genet), and *Ai-Love* (Takahiko Iimura) also made money (perhaps not unexpectedly), and it too was repeated several times thereafter (and by Derek Hill at his NCC, which was only fair; we owed him one).

None of this turned the Lab into a going concern, but it relieved the pressure and allowed us to build an increasingly bold cinema programme at other times. The 'History of the Experimental Film' strand continued and benefitted from my researches for my book, with several programmes devoted to the American '40s, thematic shows such as 'Dance Flix' etc., the series then morphing during the year into 'Cine-Innovation', a catch-all term that allowed for some interesting juxtapositions: 'Technology' (early computer experiments), a programme of Hollywood optically-printed special-effects and the avant-garde's equivalent, and 'Important Colour Films',[22] alongside more predictable classics such as *The Last Laugh* (F W Murnau), 'Structural Cinema', *Berlin* (Ruttmann), and so on.

In March 'The English Filmmakers' series broadened its scope to show Pat Holland's *Hornsey Film,* her film about the art school's occupation, made after the event but with the participation of many of those involved. Claire Johnston reviewed it for *Sight & Sound*, noting the innovative way in which "as the discussions between the students and the hierarchy broke down, the official position is increasingly portrayed by students wearing grotesque masks, dummies in shop windows, and, at one point, a dustbin lid closing as the students' efforts to communicate with the authorities are increasingly ignored".[23] There followed the first of several shows that

year by Jeff Keen, and in May, 'Three Films by James Scott' – his innovative arts documentaries *Richard Hamilton, Ron Kitaj,* and *David Hockney*, in June Peter Whitehead's *The Fall*, and in July a 'London Filmmakers' series starting with Drummond, Ewens and Al Deval. This sequence was interrupted by a three-day 'Agit Prop Closed Political Film Viewing Session', organised, I suspect, by Ann Guedes and Schlacke (Gustav Lamche) of Cinema Action, and then continued with Le Grice 'expanded cinema', and programmes by Gidal and Larcher. In August 'Collage Artists' with Scottie and Gianfranco Baruchello's sublimely surreal *Verifica Incerta*, then 'Steve Dwoskin – complete works, including two new films in colour' and on the 27th '8mm films by Mike Dunford and others'.

Was this August 8mm programme the occasion when Sally Potter first showed?[24] She and Mike were then close and sometimes worked together. Potter's contemporary 8mm works included *Building*, (1969) in which two filmed performers (one of them Mike) seemingly interacting with their live selves in front of the screen, already with a feminist awareness

August's cinema schedule designed by Biddy Peppin.

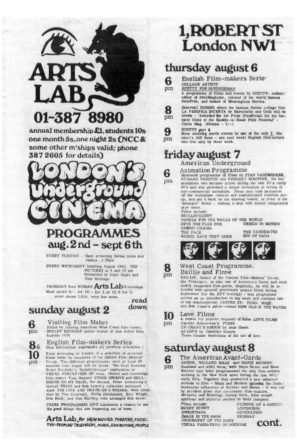

Play (1970) by Sally Potter.

of gender and stereotype, and *Play*, children's play filmed in the street but choreographed across two screens.[25] To Potter, "the Arts Laboratories, starting with Drury Lane, then Robert Street – were my education. I left school at 16 to 'become a filmmaker' but there was nowhere to go to learn. Later, I did a foundation course at St Martins (where life-drawing taught me how to look) and after a gap of several years making my tiny film poems with an 8mm camera whilst earning a living scrubbing carrots in restaurant kitchens, I studied dance and choreography at The Place, (where I learned how to listen, how to move and how to work with people) … [It was at the Arts Labs] … skulking around, watching films, films, films in the dark, and sitting in the back row … trying to pluck up the courage to speak – to argue with the Structuralist ethos (the very notion that there was such a thing as a de-signified image when I knew that information was everywhere, nothing was empty), where I practised longing; the longing to speak, to communicate. My loneliness in those days was in part the inevitable pain of the young artist, perpetually disappointed by what she could achieve; in part the isolation of the self-taught, in part just a product of the times. (The legacy of the sixties and early seventies was often misogyny disguised as freedom.)"[26]

Potter is not alone in identifying an underlying misogyny in this-called 'liberated' era. The struggle to be heard as a woman artist continued well into the 1980s. And while at the Robert Street cinema I believe we screened the work of all the women filmmakers we encountered, they remained very much in a minority in our schedules.[27] The sculptor Ilona Bennett who was becoming interested in film at the time of her Robert Street gallery exhibition, recalls how important to her were the feminist support groups of the early '70s – a counter to 'loneliness'. "I was a founding member of the London Women's Film Group [1972]; we determined to teach ourselves all aspects of filmmaking … writing directing, camera work and sync sound … I was in a women's Family Group, we read Freud, and a Marx reading group, all women."[28]

In August, Simon Hartog supportively wrote a piece in *Time Out,* suggesting that "if you wander in and out of [the Arts Lab] for a few weeks, you will get a sense of what filmmaking is today. … The 'English Filmmakers series'.. [allows you] to see what the local freaks are up to. … [concluding] any picture house that shows *The Passion of Joan of Arc* [Dreyer] and *Confessions of a Black Mother Succuba* [Robert Nelson] in the same week … . Something will happen."[29] That certainly was our hope. The frequency with which various home-grown makers now reap-

peared in the schedules attests to their increased productivity, thanks to the existence of the workshop. Ewens and Drummond for example appeared again in October, and Malcolm again in November, his show consisting entirely of works made in the previous few months.[30] New filmmakers were also entering the schedules – Potter in August (?), Barbara Schwartz (Barbara Ess) in early November, Tony Rayns later in the month. Annabel Nicolson particularly remembered Barbara Schwartz's show: "Barbara … did an event in the cinema with bubbles. She showed several of her films and then handed round jars of bubbles and asked people to blow them. You could see the bubbles rising in the projector beam and the circles cast on the screen. Her work always had a beautiful quality of informality. Watching her films in the cinema was like watching them upstairs in the flat where she lived; images of her friends and people she was close to."[31]

Potter with her camera late '60s, courtesy the artist.

Visitors from Europe and America increasingly added to the schedule's mix. In April '70, Les Levine and Henry Howard with *Films of the Living Theatre* followed by two 'German Experimental Programmes';[32] in May, Warren Sonbert and an unannounced solo show by Stan VanDerBeek, (following a screening by him at the American Embassy). In June, John Chamberlain, (better known for his sculptures assembled from crushed car-body parts) showed his feature *The Secret Life of Hernando Cortez*, "filmed in Mexico with Warhol regulars Taylor Mead and Ultra Violet in various states of intoxication and undress" as the schedule promised.[33] Also in June, Taylor Mead himself with his *My European Diaries* and in August Albie Thoms from Australia with his feature *Marinetti,* then 'visiting filmmaker Shelby Kennedy' and a programme from the Italian Co-op.[34] Then a programme from X-screen in Cologne presented by Wilhelm and Birgit Hein, notably their own *Work in Progress, Tiel 1*, and at the very end of the month, solo shows by Kurt Kren and Peter Kubelka – eye-openers to emerging English structural filmmakers; evidence of like-minded artists in Europe.

The presence in the Co-op's catalogue of the New American Cinema Collection naturally enriched the contemporary repertory but I also discovered some early works by a few of the key American players in the distribution collections of the BFI, Contemporary Films and Connoisseur Films, so was able to assemble shows looking at the whole careers of Brakhage and others.[35] And during the year, Warhol's distributor Jimmy Vaughan had done a deal with Jonas Mekas and had become the sole source in Europe of a group of New American Cinema films (which shocked us; how 'co-operative' is this Mr Mekas?), so, through Jimmy, I was able to mount a Kuchar Brothers retrospective and Mekas programme too. And experimental animation remained a theme.[36]

*Hand-drawn poster by Biddy Peppin.
The 'documentation' was the
International Underground Film
Festival's catalogue, and consisted of a
plastic pouch containing sheets of paper of
various sizes and colours of printing,
incidentally demonstrating the capacity of
John Collin's print-workshop.*

The Lab cinema closed for a week in September '70 to allow us to decamp to the National Film Theatre for the International Underground Film Festival. Encouraged by Albie Thoms, who had been touring European Festivals with *Marinetti*, and by Simon Field, now a good friend, I had managed to persuade the NFT's controller Leslie Hardcastle and its chief programmer Ken Wlaschin to agree to host a gathering of all the experimental filmmakers we were in contact with, or had heard about, in the form of a non-competitive Festival. Non-competitive was important. Many of us felt the main weakness of the Knokke EXPRMNTL Festival was its link to sponsored prizes, and its hierarchy of 'in-competition' and 'out-of-competition' screenings. All should be equal; the purpose of a festival was surely just to show new work and to meet new people?[37] But running the Festival on a minimal budget was a challenge; we had no funds to cover the fares of visiting filmmakers and their families. Unable to offer hotel accommodation, we successfully appealed through *Time Out* for people willing to give a bed to visiting filmmakers. In the event, about 60 filmmakers came and we additionally screened the work of perhaps a further 20, and ran films morning, noon and night.[38] The weather was miraculously kind and there was a real sense of an international community being born. Another story…

After the Festival, the cinema at Robert Street saw a flurry of visiting filmmakers' screenings (people who had come for the Festival staying on

for a while to show more work) with 'Films by Etienne O'Leary'; 'Expanded cinema-video actions by Peter Weibel and VALIE EXPORT' and 'Special: Paul Sharits programme', all in the first weeks of October. In November we showed work from overseas that was now added to the Co-op's distribution catalogue: 'Canadian Underground', 'Australian Programme' and 'German and Austrian underground, and Storm de Hirsch's *Goodbye in the Mirror*. In amongst them, the pattern of screenings resumed much as before with 'Classics' and 'Cine-innovation', and an altogether new strand reviewing highlights from the Knokke EXPRMNTL festivals from 1958 onwards; a mini-history of avant-garde film in itself.[39]

The English Filmmakers series continued till the Lab closed, with in December a 'Seminar on Film as Information' led by Malcolm, 'films will include *Colour Motion Picture of the Whole Sky*, *Photo-elastic Stress Analysis*, *High Speed Flight* [and, memorably] *Movement of the Tongue in Speech*', then more by Mike Dunford, Al Deval and me. And in January a three-day blitz of out-of-town filmmakers: Keen again, a group from Cambridge including Robert Stuart Short and Tony Rayns, and makers from the new Oxford Filmmakers Co-op, including Phillip Drummond and Tim Cawkwell.[40]

Where did I acquire this crazy belief that a four-days-a-week two-shows-a-night programme of experimental film was a viable proposition? Jonas Mekas's New York Co-op Cinematheque which I had frequented in the summer of 1966 was one immediate model, but had fewer screenings; I was also aware of Jonas's plans for the Anthology Film Archives cinema

Cinema fliers designed by (1) Liz Ewens, (2 & 3) Fred Drummond. Kurt Kren filming Gunter Brus in the centre.

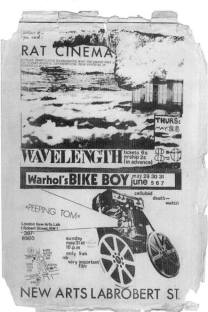

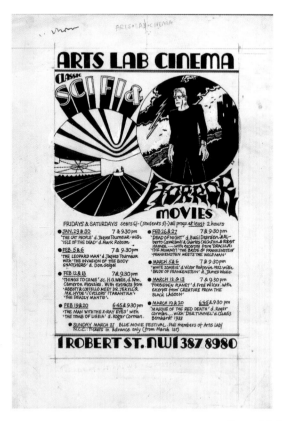

Artwork for flier by Biddy Peppin.

with its ambitious daily repertory, which opened in its first temporary space at the end of November 1970. (The Pompidou in Paris, which would run a comparable daily repertory based upon its avant-garde film collection, opened only in 1976–77).

But austerity was the other face of this rich feast. David Cleall provides a reality check, remembering: "tiny audiences, seats collapsing, films breaking down – silent films were always strictly silent and 'experimental' films were usually silent too and it seemed particularly cold all the time … Shows often started late and there were no introductions, announcements and explanations. Don't get me wrong I loved it, but often a tough ride."[41] But we did at least come *close* to proving that an artist-run space could successfully mount an ambitious repertory programme, despite an absence of financial subsidy.

In 1973, in what had become his regular column in *Studio International*, Malcolm would urge the Tate to take up the repertory challenge. It should follow New York MOMA's example and "build up a collection of film work, giving it the same status as painting and sculpture", and he outlined a vision which closely echoed our Robert Street policy. "There are three important areas for which the Tate could be the ideal context: (1) an historical repertory of avant-garde film, regularly presented as an aspect of the Tate's permanent art exhibition; (2) a regular series of showings by individual filmmakers, introduced by them, beginning with a complete review of home-grown production; (3) occasional special presentations of installation and cinema in the round, work prepared for the gallery situation."[42] Needless to say, Tate didn't respond, and one might add, still largely hasn't.[43] And when the London Filmmakers Co-op moved to its new home at The Dairy, Prince of Wales Crescent, following the Lab's closure at the end of March '71, it perhaps wisely reduced its offerings to two nights a week, one of which was usually an open screening.

By January 1971, we knew our time in the building was running out. We were all exhausted and in debt. My cinema programming dried to a trickle and Malcolm began the heavy task of organising the Co-op workshop's move to The Dairy. After the season of 'out-of-town filmmakers' (Keen and the Oxford and Cambridge filmmakers), in a last bid to make money we staged a 'Classic Sci-fi & Horror Movies series' with a closing Blue Movie Festival, this last perhaps a cynical response to the Arts Council's refusal to bail us out.[44]

Endnotes

1. (5 November) 'West Coast Programme' Ben Van Meter, Bruce Baillie, Woody Garvey, Scott Bartlett, Patricia Marx and Jordan Belson; (19 November) Peter Kubelka, Jonas Mekas, Robert Gessner, Malcolm Le Grice (*Yes, No, Maybe, Maybe Not*, perhaps its first screening), James Whitney, Fred Drummond (perhaps *Showerproof*'s first screening); (26 November) Ron Rice, Stan Brakhage, Storm de Hirsch, Steve Dwoskin; (3 December) Carolee Schneeman, Peter Gidal and the Fluxurs Anthology (10 December) *Scotty's Movie Jockey Show* (Swiz Events); (17 December) Ron Rice, Stan Brakhage and Bruce Baillie; (8 January) *Italian Co-op programme*: *Perforce* (Baruchello), *Scusate il disturbo* (Turi), *Verifica Incerta* (Baruchello/Griffi), *30 Metri per il 31 Marzo* (Bacigalupo).

2. Letter 18 January 2018. She continues: "By this time I was at St Martins as a post-grad student in the small film department, (just a tiny room in the painting department where Malcolm was teaching). It was on the top floor and had a view over the roof. I did some filming out there. I can't remember if my films were formally included in any [Lab] screenings … maybe I just asked someone to project them for me in the cinema (or did so myself)."

3. "*Mare's Tale* will be shown at the New Arts Laboratory cinema … from Thurs November 6th. The world premiere opens this 100 seat 16mm cinema." (It had been previewed in September at the Edinburgh Film Festival.)

4. Interview with Jackie Hatfield, REWIND, 27 October 2005.

5. To Simon Payne, 'unpublished interview with David Larcher, 25 May 2010, Stanhope Gardens'.

6. 'A CONVERSATION WITH A POET SOME TIME AFTER SHE HAS SEEN MARE'S TAIL THE POET BEING CARLYLE REEDY', *Festival of British Independents leaflet*, May 1970.

7. Lamarr's hidden career as an inventor would have been unknown to Tavel – she and composer George Antheil developed a radio guidance system for Allied torpedoes during the war.

8. Peter Gidal's solo programme memorably included the premiere of his portrait film *Heads,* now in the collection of the National Portrait Gallery.

9. Le Grice interviewed by Peter Mudie from his unpublished thesis *Structural/Materialist Film at the London Filmmakers Co-op: 1968–80*, 2001.

10. The contact was either through Carolee Schneemann or P Adams Sitney, I can't remember which; both used Victor's flat as a base when in Paris.

11. Mudie, ibid.

12. Email, March 2018. He continues "One exit [from the workshop] was through the cinema and [once] I came down after a session of several hours printing and processing; the door was always stiff so I gave it a great shove and fell into the cinema balancing (and probably dropping!) a pile of film cans, cursing at the fact the lights were off – until I noticed all these faces staring at me. A hasty rush across to the door, then being ambushed by Fred I think, who admonishing me for breaking into the Godard, or whatever it was . . .!"

13. 'The London Filmmakers' Co-operative Workshop – early experimentation with printer and processor', *Shoot Shoot Shoot*, Lux 2016.

14. Emails 19 September 2018, 4 October 2019. She continues: "Incidentally, and vitally to me, it was the Film Coop editing rooms – the pic syncs and later the Steenbecks, where I spent the greatest number of hours , often working in solitude through the nights on *Play* [1970] and later on *Combines* [1972] and *Thriller* [1979]".

15. 'Cinema – outstanding capital debts'. Robert St file. I have a suspicion that this was in part produced in an attempt to persuade Carla that we should have access to the Co-op's film library at a beneficial rate. John Lifton and I both resigned from the New Activities Committee around this time.

16. Later to work with the celebrated documentary makers Roger Graef and Alan King.

17. 'Down There on a Visit' *Festival of British Independents* (catalogue/leaflet), The Place, May 1970.

18. I can't remember who instigated the Viceroy Club.

19. 'Warhol's cowboys – happy doing things to frighten the horses' *Evening Standard* 15 January 1970. It was also positively reviewed by Derek Malcolm in the *Guardian*.

20. Email 13 December 2018.

21. In his book *Hollywood Babylon,* a claim now generally discredited.

22. *Blood and Sand* (Rouben Mamoulion 1941), *La Couleur de la Forme* (Hirsh) and *A Colour Box* (Lye).

23. 'Holland at Hornsey' More British Sounds, *Sight & Sound* v.39,n.3, Summer 1970.

24. Perhaps it was at the previous 8mm show in December 1969?

25. "The children in *Play* lived in my street and included two sets of twins. I put my two borrowed 16mm cameras side by side in my window and leaned out and gave them minimal directions. They sweetly complied, moving back and forth across the frame divide". Email 3 October 2019.

26. Email 19 October 2018. Potter credits Sandy Daley with introducing her to an avant-garde sensibility. Potter's first films (now lost) made with Daley's 8mm camera in 1964 were "edited in camera, Sandy walking back and forth in front of a white wall, tightly framed, then abstract shapes" (conversation 2 October 2019).

27. Women who showed at Robert Street / IRAT included: solo shows – Shirley Clarke, Naomi Levine, Maya Deren, Lotte Reiniger, Storm de Hirsh, Pat Holland, and in joint-shows: Chick Strand with Judith Reidel; Birgit (& Wilhelm) Hein, Corrine (& Arthur) Cantrill, Freude (& Scott) Bartlett, VALIE EXPORT (with Peter Weibel), Yvonne Anderson (& Red Grooms), Joyce Wieland (& Mike Snow) and in mixed group shows: Sally Potter, Annabel Nicolson, Germaine Dulac, Sandy Daley, Marie Menken, Arlene Gould, Jane Belson, Carolee Schneemann, Agnes Varda, Dore O, Pola Chapelle, Patricia Marx, Madeline Turtalot, Anais Nin (with Hugo).

28. Email 27 July, ibid. She was involved in the making of *Bettshanger, Kent 72*, (1972), on the successful miners' strike in Kent.

29. 'Filmmakers go home!' Simon Hartog, *Time Out* 20 August 1970.

30. Le Grice: *How to Screw the CIA or How to Screw the CIA: Part 1 – Spot the Microdot, Part 2 – Your Lips, Part 3 Lucky Pigs, Part 4 – Reign of the Vampire, Part 5 – Berlin Horse*.

31. Barbara Schwartz / Ess was George Craigie's partner at the time, so her 'flat' was the caretaker's room at the top of the building. Quoted in Annabel Nicolson 'Relating', February 1979, a collection of memories compiled at the time of *Film as Film* and the NFT festival *Film London*, but unpublished then, and eventually issued in part in the catalogue *Light Years a Twenty Year Celebration*, LFMCo-op, 1986. All the quotations are deliberately unattributed, but the speaker here is certainly Nicolson herself.

32. *Ten Years After* (Weis), *Alaska* (Dore O), *Cosmetic Hurt* (Winterberger), *Workers on a Golden Street, Sisters of Revolution* (Rosa Von Praunheim); *Eika Katappa* (Werner Schroeter).

33. Chamberlain, like David Larcher, was sponsored in his filmmaking by Alan Power.

34. Massimo Bacigalupo, Gianfranco Baruchello, Alfredo Leonardi, Guido Lombardi, Lucca Patella, Adamo Vergine.

35. For example in July, 'early and recent films by Stan Brakhage', and in September an 'Animation Marathon – Robert Breer – 14 movies', surveying his work from the 1950s to the present. Similarly, in August, 'The American Avant-Garde: Hillary Harris, Willard Maas & Marie Menken' drew on many different collections, as did two 'The American Avant-Garde: West Coast Programmes', the first of James Broughton, Frank Stauffacher and Sydney Peterson and the second of Bruce Conner, Robert Nelson and Ben Van Meter.

36. We projected Krazy Kat and Felix the Cat movies (from the '20s and '30s) in the gallery in May, showed an early Disney programme in June, two programmes of European pioneers in July, plus a 'Tribute to Max Fleischner' (Betty Boop, Koko the Clown et al.), a mixed contemporary programme in August. In September a tribute to the Yvonne Anderson and Red Grooms animation project The Yellow Ball Workshop and retrospectives of Norman McLaren and Oscar Fischinger. And in October – in perhaps the last of the series – the first showing in a long time of Lotte Reiniger's *The Adventures of Prince Achmed* with her more recent short *The Grasshopper and the Ant* (1954).

37. After Knokke, Jean-Jacques Lebel wrote to me: "We must have an underground festival – really free – within the next 6 months, don't you think? Where? How? We must gather the energies and visions – no more amateurish local or nationalistic efforts, now we have to wake up to the world charge, the world electricity. Perhaps London would be a good place …" JJL 6 March 1968.

38. Those crammed onstage at the concluding 'John Player Forum of Underground Filmmakers' included David Perry, Albie Thoms, Alf Hilsberg, Jochen Hamann, David Larcher, Peter Ungerleider, Helmuth Costard, Piero Heliczer, Patilee Chenis, Ole John, Jens Bukh, Steve Dwoskin, Gianfranco Baruchello, Peter Weibel, VALIE EXPORT, Hans Scheugl, Sheldon Rochlin, Mike Leggett, Fred Drummond, Malcolm Le Grice, Graeme Ewens, Peter Kubelka, Kurt Kren, Willum Fillum, Jos Schoffelen, Tony Rayns, Robert Short, Andrew Smyth, Tim Harding, Tim Cawkwell, Phillip Drummond, Mike Dunford, Al Deval, Barbara Schwartz, David Curtis, Jeff Keen, Carolee Schneemann, Ernst Schmidt, Dieter Meier, Klaus Schoenherr, Paul Sharits, Antonio Debernardi, Warren Sonbert, Silvio Loffredo, Massimo Bacciagalupo, Tom Chomont, Peter Gidal, Simon Hartog, Robert Leach, Kati Neiser, Wilhelm & Birgit Hein, Jonas Mekas, Werner Nekes, Dore O, and Otto Muehl.

39. *Knokke 1958* (1): *La Premiere Nuit* (Franju), *Opera Mouffe* (Varda), *Two Men and a Wardrobe* (Polanski), *Dom* (Borowczyk), *Gyromorphosis, Autumn spectrum* (Hirsh), *Chanson Sans Parole* (Gross), *Rotate the Body* (Turtalot); *Knokke 1958 (2) Reflections on Black, Way to the Shadow Garden* (Brakhage); *Mosaik in Vertrauen, Adebar, Schwechater* (Kubelka); *Eaux d'Artifice* (Anger), *The Little Island* (Williams), *Logos* (Jane Belson) ; *Knokke 1963 (1) Lifelines, Totem, Dance Chromatic* (Emshwiller); *Pat's Birthday* (Breer), *Breathdeath* (Vanderbeek), *Prelude DSM, Blue Moses* (Brakhage), *Chumlum* (Rice); *Knokke 1963 (2) Daybreak Express* (Pennebaker), *Scorpio Rising* (Anger), *Gondola Eye* (Hugo), *Cosmic Ray, A Movie* (Conner) *Towers Open Fire* (Balch/Burroughs), *Renaissance* (Borowczyk); *Knokke 1967 (1) Chinese Checkers, Soliloquy, Naissant* (Dwoskin); *Wavelength* (Snow), *Cybernetic 5.3* (Stehura), *Si l'inconscio si ribella* (Leonardi); *Knokke 1967 (2) Colour Me Shameless* (Kuchar), *The Bed* (Broughton) *Shaman – A Tapestry for Sorcerers,* (De Hirsh), *Jum Jum, Das Seminar* (Nekes); *Anima Mundi* (Israelson).

40. Drummond and Cawkwell were founders of the New Cinema Club Oxford.

41. Email June 2018.

42. 'Vision', *Studio International* , October 1973.

43. In the 1990s, the short-lived LUX in Hoxton Square would once again stage a six-days a week programme of avant-garde and independent film, brilliantly curated by Helen De Witt (with a parallel gallery programme of film/video installations curated by Gregor Muir). It, too, didn't last, scuppered by the involvement of a predatory property development company.

44. Films generously supplied by Pat Kearney, film buff and crucially, employee of Kay Film Labs.

Closure

Had we had the Robert Street building on a permanent basis, and had we achieved any Arts Council and BFI funding, might the Lab have prospered? I wonder. We were an experiment in co-operative organisation, but the glue that held us all together – the commitment to research and 'the new' – was often stretched to breaking-point by the frictions inevitable among creative people with competing agendas, and no financial support. We also lacked a Jim Haynes-like figurehead, to charm the outside world and perhaps, more crucially, to preside over each evening's activities as a benign host, to welcome people and make them feel at home. At Drury Lane, at least during its first year, that had been his unique strength. Drury Lane had also offered a rich nightly array of alternative events, suggesting most tastes might find something of interest there. At Robert Street this was only intermittently the case; sometimes the cinema was the only public space operating. Also, by mid-1970, the Robert Street cinema was no longer the only venue that could claim to be the home of British independent film in London. The ICA Cinema was becoming interested and The Other Cinema had just begun to organise screenings of international new cinema at different venues in London, including a Festival of British Independents in May '70 organised by Peter Sainsbury, Simon Field and others. Robert Street was also too far away from the West End for people just to drop in on spec. We were, in effect, a remote pilgrimage-site, dependent upon a dedicated audience – prepared to endure a sometimes bleak environment. And changes in staff made difficult such basic tasks such as getting 'listings' information to *IT* and *Time Out*, and even into our own schedules. Perhaps, if our financial circumstances had been less straitened, we might have addressed at least some of these issues.

Paradoxically, as John Lifton and I were withdrawing from the New Activities Committee in late '69, those members remaining set up a sub-group to explore 'premises based' activity – places were artists "were largely dependent upon arts laboratory type premises for performing." (Jenny Harris of Brighton Combination and I had earlier objected that this was unnecessary: "more than enough information for the committee's purposes had already been sent to 105 Piccadilly").[1] In March '70, this sub-group fed nto the Committee's *Final Report* the unsurprising recom-

London Region Panel of Representatives (New Activities)
OPEN MEETINGS IN THE ARTS COUNCIL March 2 - 6 from 4:00p.m. to 6:30pm (3:00p.m.
to 6:30p.m. on Friday)

MONDAY Danaan Players - theatre
 Sonor - mixed media/music
 Jim Pennington
 Space Structure Workshop *
 Can Theatre
 Beckenham Arts Lab (Growth) - Chaz Lippeatt *
 Action Space (Ken Turner) - environmental structures

TUESDAY Pentameter Cellar Theatre - mixed media
 Laura Magee
 Portable Theatre
 Carlyle Reedy
 AMALgam (Fred Drummond) - film
 Pavilions in the Parks
 Transmedia Explorations
 Malcolm LeGrice - film

WEDNESDAY Whole Earth Catalogue (Ald Moorcraft) *
 Robert Lagnado
 Chris Whitbread (Magazine)
 Peter Mahon
 Creative Aid Trust - performing/craft group*
 Wherehouse La Mama Company
 Geoffrey Goolnik

THURSDAY Marc Chaimovitz - film etc materials
 Jonathon Nicoll - film/event *
 People Time/Space (Roland Miller) - theatre circuit etc
 (Stroud Cornock)
 (Polyhedral Group)
 (Inter-Action)
 (BIT Information service)

FRIDAY Institute for Research into Art & Technology ++
 Principal Edwards Magic Theatre *
 John Kaine - chair for stimulating genitals &c. *
 Alan Davies - event in pavilion
 The Freehold Company
 Anita Mendel -
 Ian Breakwell/John Hilliard - materials &c
 Federation of Children's Books
 John Lifton
 (Printing Co-op - David Bieda, Tony Elliot, Mark Williams, Richard Neville)

* denotes demonstration by applicant with slides, projections etc.
++ IRAT's application includes member groups like the London Film-makers co-op

THIS PROGRAMME IS SUBJECT TO CHANGE
For further details ring 692-1700 or 459-1447
Representatives: Tim Platt (Co-ordinator), David Bieda, Su Braden, Marc Chaimovitz
and Guy Brett.

FINAL MEETING
TUESDAY MARCH 10th. 3:00 PM.
ARTS COUNCIL 105 PICCADILLY

An experiment in artist-led distribution of Arts Council funds; London based-artists were invited to attend this series of meetings to make their case and to witness the decision-making process. Collection of David Bieda.

mendation that such places were indeed worthy of support. But by the time the Arts Council took note, it was too late to help Robert Street. Adding insult to injury, the Committee's London Region subgroup – having decided not after all to hold a gathering or festival – empowered itself as an 'Artists Panel' to spend its £1,000 on making awards to artists and projects in the region – despite the total inadequacy of the funds available.[2] In March '70, IRAT/Robert Street and many of the artists associated with it were among the 34 artists and groups that duly applied for funds, hoping for crumbs. IRAT, which asked for £15,300 received £240, but Fred Drummond, Hoppy, Malcolm Le Grice, John Lifton, Ian Breakwell/John Hilliard and People Time/Space Theatre Circuit (Roland Miller) were among the 28 applicants who left empty handed.[3]

In December '70, I wrote an angry letter to Hugh Willatt at the Arts Council, moaning about its lack of support and lack of interest: "We at the Arts Lab would feel less bitter if the Arts Council, which apparently feels free to draw on the knowledge and influence we have as artists and technicians [a reference to our early participation in the New Activities Committee] had returned the compliment by showing *some* interest in how we ourselves apply our knowledge. But this has never been the case. Even when the Council requested a special evening of performances for their own information, [a reference to the specially-designed 27 February programme] none [of the Council Members] bothered to attend, giving their tickets rather to 'interested friends' …". The letter goes on to request an emergency grant to cover the cinema's debts, "at present approximately £750", and expresses the hope that Lab's equipment might be passed on at no cost to the Filmmakers Co-op. Ending, "please guide this appeal

to receptive ears."[4] Charles Osborne, then secretary to the Experimental Projects Committee replied, informing me that "the Council could not agree to making a grant simply in order to allow you to balance your books on closing. … If you can put in a fresh application for funds for a specific film project of some kind, such an application will be very seriously considered."[5] Had he wanted to be helpful, he might at least have suggested that the Co-op should apply for a grant to buy the Lab's film equipment for use in its new home (which would at least have cleared part of our debt), but he didn't.

In January, Biddy wrote a less emotional three-page letter to Willatt, copied to all members of Council and the chair of the Experimental Projects Committee, giving a very detailed breakdown of the Lab's funding history, its donations, its income from grants, its income from audiences and membership, this time asking for £1000 to help the Lab close its books free of debt. Osborne dictated an even briefer refusal. The case for New Activities had yet to convince those drawing up the Council's allocations. And perhaps the Council now felt no urgency, given the hostility attracted by the tiny amount of funding its Committees had already dispensed. "They Are Giving Away YOUR Money To Spoonfeed Hippy 'Art'" thundered a characteristically poisonous *Daily Mail* headline, citing Arts Council grants given to Alex Trocchi, B S Johnson, Jim Pennington and others. The *Mail* saw the Arts Council "now established as a patron of the underground-anarchist-drugs world", with paradoxical echoes of Goodman's fears about connections between the Drury Lane Arts Lab and *IT*.[6]

That was that. The Lab staggered to a close towards the end of March 1971 leaving debts unpaid, and individually we all moved on to other things. The demolition gangs moved in and London's Arts Lab experiment was over.

After Robert St's closure, some elements continued. Hoppy's TVX and the London Filmmakers Co-op moved to The Dairy, Prince of Wales Crescent, north London, and lived on in a succession of homes thereafter. TVX lasted into the 21st century having become the video workshop and resource Fantasy Factory; the Film Makers Co-op developed and evolved, serving for thirty years as Britain's most important artists' filmmaking and screening centre. Towards the end of the century it merged with London Video Arts (founded in 1976) and eventually morphed into LUX, which continues to serve and champion moving-image artists in the 21st century. www.lux.org.uk. Many of the fringe theatre companies involved in both Labs continued to thrive and many eventually fed into the theatrical mainstream.

Robert Street demolished (photos DC).

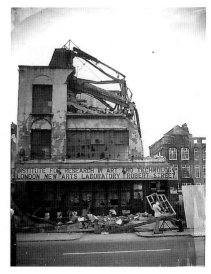

More prosaically, the financial plight of the Arts Labs spurred many of us involved to continue to make the case for public funding for the experimental arts. And certainly, much later, questions first asked at the Labs still remained important: how best might the State support emerging artists working with new media? how best to exhibit their work? and how best to build an audience for what were – until at least the 1990s – still very marginal art forms? The Labs were also early examples of the 'artist-led organisation', typically housed in temporary, short-life buildings only minimally adapted. It's a model that's still valid today, and indeed is vital for artists as they make their way in the often very alien environment of the professional art market.

Endnotes

1. Minutes of 6th Meeting of New Activities Committee, 16 December 1969. Michael Astor/John Craxton/Peter Jay were to visit Birmingham Lab; Grizelda Grimmond and Oscar Lewenstein to visit Brighton and IRAT, Alexander Schouvaloff and Aneurin Thomas to visit Liverpool. Astor unilaterally added Cambridge Arts Lab to the study.

2. David Bieda, Su Braden, Guy Brett, Tim Platt, Marc Chaimowicz were the panel members, elected at a public meeting at St Pancras Town Hall, 26 October 1969 (later with Hoppy rather than Marc Chaimowicz, as the 5th member).

3. An air of unreality attended both the applications and the week of interviews with applicants held at the Arts Council's 105 Piccadilly offices (2–6 March). John Lifton applied for £22,000, Hoppy for £2,000, Pavilions in the Parks £6,730 and so on, clearly making a point about the inadequacy of the £1,000 fund. There were however moments of humour: "Lord Goodman attended the final day of interviews and was intrigued by John Kaine's proposed 'chair for stimulating genitals, etc' [£28/13/6 requested]. The prototype promptly collapsed when he sat on it. 'Well, that's that then' said Goodman, laughing." David Bieda, conversation 18 October 2019.

4. Letter, 1 December 1970, Robert St file.

5. Letter 13 January '71. The Experimental Projects Committee was the New Activities Committee's successor.

6. *Daily Mail* 16 March 1970. Trocchi and Johnson's grants came from Osborne's Literature Panel; Pennington's £17 from the London Artists' Panel. Among the *Mail*'s many wild claims was that Peter Stark at the Birmingham Arts Lab had corruptly redistributed its grant to his friends. "I was outraged; I took it to Michael Astor who took it to Goodman and – somehow (probably Astor's own money?) my costs in consulting a libel specialist silk were covered. … Later Astor gave the Birmingham Arts Lab £1,000 from his personal Trust. It paid the rent arrears and provided £100 to each member of the committee/collective. I bought an IBM golf ball!" Peter Stark, Email January 2018.

Appendices

1. Drury Lane and Robert Street Workers' After-lives

Judith Clute – is still painting and print-making, and regularly exhibiting in London. With Biddy Peppin, she helped organise the pop-up exhibition *An Arts Lab Continuum* featuring work by six of the artists involved in Drury Lane and Robert Street (Spitalfields Studios, July 2018). www.judith-clute.co.uk *"The way we worked back then was with whatever energy and craziness the heat of the moment demanded. It was a laboratory of ideas"*. JC

John Collins – maintained his printing company and his passion for film and then moved to the USA and has become a Southern Gentleman.

David Curtis – was Film Officer at the Arts Council of Great Britain from 1977–2000 where he was responsible for funding artist's film/video production and exhibition. With Malcolm Le Grice, he founded a Study Collection of artist's film & video at Central Saint Martins, 2003 – www.studycollection.org.uk He has written books and articles on experimental film and curated film exhibitions including *A Century of Artist's Film in Britain* at Tate Britain, and *Midnight Underground* for Channel 4. He and Biddy Peppin are married.

Sandy Daley – In 1964 Sandy and her then partner Nicholas Quennell (Sally Potter's uncle), lent an 8mm camera to the 14 year old Potter, and performed in her first short formal films. After Drury Lane, Sandy re-turned to the USA where she made *Patti Having Her Knee Tattooed* (1971) with Patti Smith, Sam Shepard and Vali, and a series of *Cine Portraits* featuring Leonard Cohen, Edie Sedgwick, Gregory Corso, the Incredible String Band, Lucy Colella, Arthur C. Clark, Harry Smith, and Syd Barrett. She lives in New York and exhibits as a filmmaker and photographer.

Hugh Davies – continued to compose, create unusual musical instruments and played in the Music Improvisation Company (1968–1971) and Gentle Fire, (1968–1975). He was involved in the Artists Placement Group during the mid-1970s and remained attached as a researcher to Electronic Music Studios at Goldsmiths till 1991. From 1999 he was a part-time Researcher and Lecturer in Sonic Art at the Centre for Electronic Arts, Middlesex University till his death in 2005. Michael Nyman has remarked "It's a disgrace that Hugh's *Répertoire International des*

Hugh Davies with his Sho-Zyg instrument (photo courtesy Pam Davies).

Musiques Electroacoustiques / International Electronic Music Catalogue [MIT Press,1968] is not better-known." (Email September 2018).

Fred Drummond – became involved with Scientology, then inherited estates in Leicestershire and enjoyed a life of urban and rural development and management, notably resulting in the building of the New Lubbesthorpe Estate, near Leicester. He died in 2015, and posthumously had a bridge over the M1 motorway named after him.

Craig Gibsone – has lived at the Findhorn Foundation in Scotland since its early days. As one of the elders there, he remains active as a workshop leader, artist, potter and permaculturist.

Jim Haynes – continued to teach at University of Paris 8 Vincennes for 30 years. He was one of the creators of *The Wet Dream Festival* in Amsterdam (with fellow *Suck* editors). His published memoires include *Hello, I Love You! Voices From Within the Sexual Revolution (Handshake editions, 1974); Thanks for Coming! A Participatory Autobiography* (Faber and Faber, 1984), and *THANKS FOR COMING! ENCORE! a memoir,* (Polwarth Publishing, 2014). He established his celebrated open Sunday night dinner parties at his Paris atelier in 1978 and is the subject of *Meeting Jim*, a biographical documentary film (2018). www.jim-haynes.com

John Hopkins (Hoppy) – Continued to run video workshops, initially as TVX, later, with Sue Hall, as Fantasy Factory. In his retirement, his earlier work as a photographer in which he had documented the 1960s from the inside was rediscovered, and became the subject of a number of exhibitions. He died in 2015.

David Jeffrey – After Audio Ltd, in 1971 David accepted a technical position with The Department of Machine Intelligence and Perception (AI) at Edinburgh University, then moved departments to worked with Stephen Salter on the generation of electricity from Wave Power. He relocated to California in 1983 and work with Deep Ocean Engineering for the next 21 years, designing and building small submarines. He lives between California and London. *"My desire for an electronics workshop, and the print workshops, were in a way precursors for the current maker-movement. London has several 'maker spaces' where you can go and futze around with electronics and computers, as well as print, film, wood work, music - you name it. Although not exactly what I had in mind, I'd have been delighted with this outcome."* JD

Philippa Jeffrey – returned to Edinburgh with David Jeffrey in 1971, then following their divorce, spent seven years (1988-1995) in China working with her partner Chris Wheeler on educational linguistic projects for the Chinese government and the ODA/British Council, (the subject of their forthcoming book *To Tiananmen and Back: Seven Years as Birds of Passage in China*). She lives between Spain, France and London. *"… the Arts Lab provided a liberal environment not stereotyped by gender or sexual orientation. What was paramount was that an individual could contribute to the arts".* PJ.

Rosemary Johnson – I have not been able to find details of her later life.

Michel Julian – continued to manage 'IRAT' till 1976, and created a network of offices in five European cities for small and medium-scale theatres, which eventually became the European Theatre Co-ordinate. He was for a time managing editor / publisher of *Theatre Quarterly*, where he created the British Theatre Resource Centre, a member of the International Theatre Institute. He regularly wrote the 'International Theatre News' column in *The Stage*, and later held professorships in international theatre at both London City and Goldsmiths universities. He died in 2016.

David Kilburn – helped to establish advertising agencies across the world, and worked as a freelance journalist. He continued to publish *Green Island* and founded and ran The Tea Museum in Seoul, Korea where he also campaigned against the wholescale demolition of traditional houses. He lived in London and Seoul until his death in 2019.

Malcolm Le Grice – installed the Filmmakers Co-op's workshops at The Dairy while simultaneously establishing the film department at St Martins School of Art. He later created a media department at Harrow, University of Westminster before returning to Central St Martins as Head of Research. He has written widely on experimental film including the books *Abstract Film and Beyond* (Studio Vista, 1977) and *Experimental Cinema in the Digital Age* (BFI, 2001). As a film/digital artist he continues to exhibit internationally, and is represented in the permanent collections of the Centre Georges Pompidou, the Royal Belgian Film Archive, the National Film Library of Australia, and

Malcolm Le Grice in the Robert Street film workshop (photo Roger Hammond?).

the German Cinematheque Archive, Berlin and elsewhere. www.malcolmlegrice.com *The Arts Labs concept was timely – it changed what was expected at that time for art-MAKING and art-VIEWING. It particularly represented a move away from a strictly individualistic form of practice and its private gallery commerce ('commodity culture' – 'art stars'); it narrowed the gap between 'maker' and 'audience'. It opened up a space for a greater participation for the audience – not just physically as in the People Show, but psychologically through more intimate and engaged spectatorship",* something he has explored in his own art and as an influential teacher. MLG (Email July 2018)

Dianne Lifton – now **Di Clay**, continues to work as an artist in many media and now lives in France. *"The Lab was valuable as a place where one can take risks – put ourselves out there in the public domain, not too-much thought-through, nothing 'packaged', [so] vulnerable - somewhere to share radical ideas, challenging the status-quo of art and also, therefore, the accepted social and political norms … So, the spirit of that movement is still so relevant to this '21st century moment'.* DC

John Lifton – was an influential teacher at the Royal College of Art 1974–77. He continued to design computer interactive environments such as *Green Music* 'in which music is generated algorithmically in real-time from the natural electricity of plants' and more recently has developed his artistic practice through photography, exhibiting internationally. He is married to Pam Zoline and with her was one of the founders of the Telluride Institute, Colorado (1984–) which 'fosters the transition to a sustainable world', and in 2006, the Arts-Lab-like Centre for the Future, Slavonice, Czech Reublic, which 'supports cultural and environmental resilience'.

Carla Liss – returned to the USA where she continued to practise as a Fluxus artist. She died in 2012. Her work is represented in the Tate archive.

Jack Henry Moore – established Amsterdam's UFO-like Melkweg (Milky Way) club in 1970 with Kit Galloway and Dave Jones. He also generated a vast library of counter-cultural video recordings under the banner of Videoheads, based for ten years in the basement of Jim's Paris flat and later in Amsterdam. He died in 2014.

Annabel Nicolson – became a frequent cinema programmer at the London Film Maker's Co-op. She was a founder member of Circles – Women's Film in Distribution 1979, and has written on film and art, contributing to *Arts & Artists*, *Musics* and other journals. She published the artist's book *Escaping Notice* (1970) and the magazine *Readings* (1977). Her films, performances and artwork are in the collections of the Royal National Belgian Film Archive, British Film Institute, Canterbury University, Women Artists' Slide Library and the Victoria and Albert Museum.

Graham Peet – after IRAT, Graham attended Hornsey School of Art, then set up a community print workshop in Telford, and in the early days of Channel 4 made TV with young people. He worked on interactive media with Jubilee Arts in West Bromwich and was one of the instigators of the innovative Will Alsop designed Lottery-funded community arts project The Public, and was its exhibitions officer till 'austerity' closed it in 2013. www.thepublic.com. *"I was so impressed at the Drury Lane Arts Lab that you could just become part of activities. I helped make stage props with Will Spoor and learnt how to do light shows. After that I continued with the idea of access to the arts… The Public definitely had its conceptual roots in the Arts Labs and The Fun Palaces of Cedric Price and Joan Littlewood. I still think of the Arts Labs as a crucial if short lived experience".* GP (Email 14 Sept 2019)

Biddy Peppin – went on to teach Art History, latterly at the University of East London. She published *A Dictionary of British Book Illustrators: The Twentieth Century* with Lucy Micklethwait (John Murray, 1983) and *Helen Saunders 1885–1963* (Ashmolean Museum, 1996). She returned to full time painting in 2004, and holds pop-up exhibitions in London and Somerset www.biddypeppin.crevado.com *"The utopian ideas for which we fought fifty years ago at the Arts Labs, and which still inspire us, seem as far as ever from realisation. So (to quote a Paris '68 poster) 'La lutte continue'."*

Martin Russell– I have been unable to find any information about his post-Lab life.

Martin Shann – taught part time on the Pre-Dip course at Birmingham College of Art from 1970, then worked full time at Audio Ltd as manager following David and Philippa Jeffrey's departure, and afterwards at Joe Dunton Cameras Ltd, providing special equipment for feature films and television. He became Head of Development for Oxford Scientific Films making overhead camera systems including for the BBC Natural History Unit. He then became chief technical boffin at Aardman Animation, celebrated makers of *Wallace and Gromit*.

Will Spoor – became famous in Holland for his role as Snuitje 'the pearl thief', one of the two thugs (Snuf & Snuitje) in the Dutch television series *Pipo de Clown*. His Mime Theater Will Spoor continued till 1973, after which he founded the theatre groups Waste of Time, Inccoprodinc, No12 and Onk Theater Overal. He appeared elsewhere under his stage-name Fred Saels. He died in 2014.

Pamela Zoline – has continued to write and make art. She is married to John Lifton and with him was one of the founders of the Telluride Institute, Colorado, which 'fosters the transition to a sustainable world', and in 2006, the Arts-Lab-like Centre for the Future, Slavonice, Czech Republic, which 'supports cultural and environmental resilience'. *"The Labs represented a recognition that the art world needed an opening to riskier, more disruptive modes and to non-traditional forces and areas of focus (tech, women, peace, the environment)."* The Arts Labs came out of *"… a conviction that both the group of artists and the potential audience for art were less predictable and possibly larger than that allowed for by the establishment-bound status quo. … So we built a place for various kinds of encounter, fostering new and strange and sometimes useful stuff. We invited the world, and the world came in, and we had quite a party, rippling still."* PZ

157

2. 'Arts Labs & Related Phenomena / Addresses & News By Regions'

This listing of established and embryonic arts labs was probably based on research by David Bieda for an article for *Rolling Stone*. It was published in this unattributed form simultaneously in *IT*/66, (October 10–23 1969) and Nicholas Albery's *Arts Labs Newsletter*, appearing just as the Drury Lane Lab was closing and as Robert St's New Arts Lab (IRAT) was opening.

LONDON REGION ARTS LAB CO-OPERATIVE, co-ordinated by Nicholas at BIT. It includes:

BECKENHAM ARTS LAB: contact David Bowie at 460 6489.

CROYDON ARTS LAB: contact Dez Pawson at 15 St. Johns Terrace, Cross Road, Croydon (tel. 688 3601).

DRURY LANE ARTS LAB: 182 Drury Lane, WC2. (tel. 242 3407 for their programme).

EAST LONDON WORKSHOP PROJECT: contact Glen Thompson, 75 Cromwell Avenue, N6. (tel. 340 6852).

HOUNSLOW ARTS LAB: c/o Dave Cousins (lead singer for the Strawbs), 9 Tennyson Rd., Hounslow (tel. HOU 9219). Arts Lab meets fortnightly at White Bear Public House, Kingsley Rd.

INSTITUTE FOR RESEARCH IN ART &TECHNOLOGY / THE LONDON NEW ARTSLABORATORY: otherwise known as THE FACTORY, 1 Robert St., NW1. (tel. EUS 8980)

NORTH LONDON ARTS UNION: contact Mel Davies or Don Elwick, 26 Greenwood Gardens,N13 (tel. PAL 4824), On Mondays an Ideas Workshop, 8.00pm at the Haringey Arts Centre in Lordship Lane, N.22 (near Wood Green tube)

NOTTING HILL ARTS & COMMUNITY CENTRE: c/o Pete Dunn, 2 Powis Sq., Wll (tel. 229 1553). Poetry & Jazz, mixed media & musical events at The Crypt, 242 Lancaster Rd., Wll. On Wednesdays at 8pm (2/6 to get in)

RICHMOND ARTS WORKSHOP/EEL PIE ISLAND PROJECT: contact Grenville Sheringham, Flat 2, 188 Sheen Rd., Richmond, Surrey (tel. 940 7974). For the next few weeks, since they have no entertainment license yet, they are giving free 'private' parties every Friday night, 7.30- 12.00 (District line tube to Richmond, then bus to Twickenham Junction; or take train therefrom Waterloo. Cross over river & follow path to hotel).

WALTHAM FOREST ARTS GROUP: c/o Lee, 165 New Road, Chingford, E.4. The main activity here seems to be 'Pandora's Web Light Show'.

BASILDON ARTS LAB: Intends to gain premises: 'The premises we have in mind Is a disused fuzz station (believe It or not) which has been dormant for a year ready to be demolished in the distant future. Contact Colin, 71 Lamplits Lane, CorIngham, Essex, tel. Stanford-le-Hope 5754.

BEDFORD: UNDERDOG ENTERPRISES: contact Tony Quinn, 43 Deacon Avenue Kempston, Beds. The aim is 'to present activities, distribute magazines, books, posters, leaflets and launch own controversial and dynamic magazine, as well as opening an office/Information centre/shop/arts workshop'.

BISHOP STORTFORD ARTS LAB PROJECT: c/o Mark Harrison, TRIAD (a projected regional concert hall and arts centre), Southmill Rd. ,Bishop's Stortford, Hertfordshire (tel: Bishop's Stortford 56333). 'A youth group associated with TRIAD intends to establish an arts lab as there is likely to be abundant space here'.

NORWICH ARTS LAB: contact Diz Willis, 49b Surrey St., Norwich, Norfolk; or Bristows Book-shop, 4 Bridewell Alley. The Lab meets every Friday and anybody who wants to come and do their thing (read, sing, play, dance, etc) is encouraged to do so.

YARMOUTH ARTS LAB: tragic story of a Lab with premises and yet nobody in the area interested. They have a scout hut complete with electricity, washing, toilet, given to them by the Methodist church, and all they need now is people. Contact Martin Cody, 6 Aspley Road, Yarmouth (tel. Yarmouth 2876) or the secretary of Wild Pigeon Post, (tel: Martham 9274301

EAST ANGLIAN REGION ARTS CO-OP co-ordinated by Martin Rand, 1 Victoria St., Cambridge, (tel Cambridge 62973).

CAMBRIDGE ARTS LAB has been forced underground by the Council's refusal to allow premises at 1 Victoria Street to be used as a Lab — on the grounds that it is a residential area with no parking facilities. The Lab personnel have nevertheless taken up residence there and they say: 'should you wish to meet with us, please write or telephone first, and we can arrange a suitable venue. We are also holding gatherings — open meetings for any-

one wanting to come along — on October 7-11 inclusive from 10 till noon, from 1pm till 6pm & from 8pm till 10pm at Fisher House, the Catholic Chaplaincy Building, between the Guildhall &the Lion yard car park'.

THE SOUTH-EAST ARTS LAB CO-OP co-ordinated by Peter Davidson, 65 Oak Ridge, Goodwyns, Dorking, Surrey, (tel. Dorking 6259). Bringing out a regular information 'Sponsheet'.

THE BRIGHTON COMBINATION, 76 West Street, Brighton, Sussex (tel. Brighton 24596). At the moment the restaurant, discotheque and cinema are open, the cinema showing programmes on Fridays, Saturdays and Sundays.

CAMBERLEY ARTS LAB PROJECT scheme still survives, mail to Paul Crowser or Jill, 21a London Road, Camberley.

EPSOM ARTS LAB PROJECT, c/o Greg Dover, 27 Copse Edge Avenue, Epsom, Surrey (tel. Epsom 24894). A Lab for drama, progressive music, poetry, being launched with a dance last Friday in October.

FARNHAM ARTS LAB, contact George Collins, 327 Salamanca Park, Aldershot, Hants, (or phone Steve Bushell at Woklng 2576). There is usually an event every Friday — for instance, cosmologist Tammo de Jongh is visiting there shortly.

FREE ARTS CENTRE, WOKING, Ian Townsend, 6 Queens Court, Hill View Road, Woking. (tel Woking 62958), is looking for half a dozen people to help him get things going again.

GUILDFORD ARTS LAB PROJECT, contact Fred, Millbrook Cottage, 22 Quarry Street, Guildford, Surrey, or phone Transmutation at Guildford 71855, who report that a bunch of heads may be getting some music events together at the Stoke Hotel.

LIVING ARTS WORKSHOP, REDHILL; Steve Niner writes: "The workshop is now to have its own live/wax/shellac/music/lights thing on Fri-day nights. Poetry, theatre, media workshops and so on will happen on Saturday nights. The Modern Jazz Workshop, now a year old, will continue to provide the best in jazz on Sunday evenings. All events at the Greyhound, Brighton Road, Redhill." Details from Steve Niner, Old Kemp's Farm, Buckland, Bletchworth, Surrey (tel. Bletchworth 3620).

MATRIX ARTS WORKSHOP, CRAWLEY; the old army hut they were applying for has been given by the New Town Commission to Crawley's Karate Club. The hope Is that Matrix will continue, all communications to Sue Challis, 73 Hawkins Road, Tilgate, Crawley, Sussex (tel. Crawley 27275).

SOUTHAMPTON: Embryo Lab. People with Interest and Ideas contact: Rob La Frenais,73 Beltmoor Road, Upper Shirley.

SWINDON ARTS LAB, 69 Beechcroft Road, Swindon, Wilts, co-ordinator John Day.

WEYBRIDGE ARTS LAB PROJECT, c/o Nick Reynolds, 17 Grange Park, Horshell, Woking, Surrey (tel. Woking 62644). This Lab was operating inside a school in Newhaw, and is now stirring things up in the Weybridge, Chertsey, Adlestone and Byfleet areas.

WORTHING WORKSHOP, responsible for the World's First Bubble-In which was on TV of course. Saturday 19th October at 7.30pm at the Norfolk Hotel for only 5/- you'll get Entire Sioux Nation, + lightshow and discotheque. Lots of other things happening, for more details get onto John May, 16 Brookdean Road, Worthing (tel. Worthing 39401). They are opening a head shop and coffee bar mid-November.

THE SOUTH-WEST ARTS LAB CO-OP, co-ordinated by: BRISTOL ARTS LAB/ENDGINE, through Nick Lowther, 50 Archfield Road, Cotham, Bristol 6, (tel. Bristol 40035). 'At the moment this is a group of people, shops etc. ENDGINE is a co-ordinator not an arts lab, at least until premises are acquired. Arts Lab Trust has given us guts to go to Council etc. We include 'imprint' poetry magazine and the Axis Art Gallery. We are starting 'Anti-Institute' for people who have left school and don't want to go to the Tech, to take their A Levels. Also 'COUGH (UP YOUR THING)' is an information magazine started now, one sheet only, with reverse side a poster (1/- every fortnight), containing a list of second-hand shops, late-night eating places, groups, poster designers/printers, etc; plus a diary section of dates covering three weeks.'

THE BEAFORD CENTRE, Beaford, Winkley, N Devon (tel. Beaford 202). Every Arts Lab's dream situation: £10,000 a year to play with —theirs comes from the Dartington Hall Trustees. They describe themselves as a Devon version of Interaction, and they have a small touring theatre company.

CHELTENHAM ARTS LAB (no premises yet), c/o Cornelia Connoly, 93 Montpellier Terrace Cheltenham (or phone her brother Declan at 52826 work, 29070 home).

EXETER ARTS LAB; c/o Students Centre, Raul Street, Exeter, Devon. Main co-ordinator, John Martin, 26 Station Road, Pinhoe, Exeter.

ST IVES ARTS CENTRE GROUP; c/o Nicki Tester and AndrzeJ Jackowskl, Tregarthen, St Ives, Cornwall (tel St Ives 6085). They are an active group of about a dozen poets, designers, composers, painters, etc, who are looking for Lab premises. Nicki is organising the New Activities Committee £1700 festival for the South-West.

SOUTH GLOUCESTERSHIRE

LAB, otherwise known as SLAB or THE KINGSWOOD YOUTH VOLUNTEER FORCE ARTS LAB, c/o Andrea, 8 Royal York Crescent, Clifton, Bristol! They have an old pottery as premises, a building they got by being straight to the council, and one which by law the council must do up. 'The Lab Is basically a community/arts Interaction programme, not half as straight as you might imagine. Very organised and very human type social work going on.'

TORBAY ARTS LAB, 11 Swan Street, Torquay, a top-floor studio near Torquay Harbour, and able comfortably to hold 30 to 40 people. They are bringing out a second edition of their magazine 'Deviant'.

WALES

BANGOR ARTS LAB PROJECT 'still very embryonic", c/o Simon Partridge, 45 Bryn Lane, Beaumaris, Anglesey.

CARDIFF COMPANY/LOVE-BEAST PRO-DUCTIONS, c/o Paul Tinman, Cardiff College of Art, Howard Gardens, Cardiff, Wales. 'We are a small group of students who have started a workshop/production company involving theatre, graphics, intermedia events etc, etc.'

SOUTH WALES ARTS LAB, c/o. Kienan and friends, 89 Lake Road West, Roath Park, Cardiff. 'Doing things like experimental films. Nice people.' They mostly go from Newport Art College and Cardiff (where the Council is against them) to old church hall in Caerphilly, 7 miles outside Cardiff, where the Council are for them: a festival is planned there this month.

MIDLANDS REGION ARTS LAB CO-OP co-ordinated by Fred Smith from the BIRMINGHAM ARTS LAB, 318 Summer Lane, Birmingham (tel. 359 4192) October 25th the Lab is hosting a Regional Meeting for all those who want a share of the £1700

the New Activities Committee of the Arts Council Is spending In the Midlands.

COVENTRY: ARTS UMBRELLA, 18 Queen Victoria Road (tel. Coventry 25635 evenings). Been functioning twelve years. Opens every night and things happen many nights. 'But the buildings are there for you to USE. Groups/shows/poets/food, etc.'

LEICESTER ARTS LAB, been busy splintering recently. Allen Button remains and wants to start a film co-op — he's at 62 Babingley Drive, Leicester (tel. Leicester 65470 till 4.30pm). For SPLINTER contact Stuart Langford, 2 Southview Drive, Leicester (tel. 38988) or Richard Toon, 12 Barkby Road, Syston, Leicester (tel. 29011 ext. 26). For an attempt to start up a small BIT-type INFORMATION SERVICE contact Ken Weston, 2 Wayside Drive, Cadby, Leicester LE2 4NU.

LOUGHBOROUGH: S.M.I.L.E. (Some Men In Loughborough Explode) Is 'the Loughborough branch of the Leicestershire Arts Lab Organisation'. Address till new premises acquired Is: John Hayward, 106 Maple Road, Shelthorpe, Loughborough, Leics (tel. Loughboro' 2234, ask for Paul).

NORTHAMPTON ARTS LAB, c/o Janice & Richard Smith, 53 East Park Parade, Northampton, or phone Roy Civil, Northampton 37728.This is quite a new project that has unearthed about 20 people willing to help and for the rest is fighting hard against local lethargy. 15th Oct 8pm, poetry & music at the YWCA (6 piece Jazz group, 8 or 9 poets, small brass ensemble).

OXFORD RESURRECTED ARTS LAB PROJECT, contact Keith Armstrong, 16 Davenant Road, Oxford OX2 8BX (tel. Oxford 55309). Blackfriars Monastery in St Giles meanwhile remains the centre for Arts Lab-type

activities (tel. Oxford 57607, and Brother Simon Tugwell is the man to speak to).

STOKE ARTS LAB PROJECT, started with an Arts Festival and now the city council is responding to their desire to use an old Town Hall. Contact Jim Langden, c/o Students Union, University of Keele. Staffs.

THE YORKSHIRE OPEN WORKSHOP(CIRCUIT) co-ordinated by Al Beach, 9 Parklands Drive, Triangle, Halifax, Yorks (tel. Halifax 32220). Part of this circuit is Al's NORTHERN OPEN WORKSHOP, HALIFAX, of which the actual premises are in Cheapside, Halifax, consisting of the basement and ground floor of a warehouse — space that is used for dance, theatre groups rehearsing, but mainly for workshops, 'like a small St Katherine's Docks'.

BRADFORD ARTS LAB PROPOSAL; c/o Chris Parr ('Fellow in theatre at the University of Bradford'), University of Bradford, Richmond Road, Bradford 7, Yorks (tel Bradford 29567 ext 266). The Lab planned will be 'a marriage of technology and art'. Chris is in contact with Graham Watson who had rallied a group of people behind an earlier Bradford scheme, which got Graham into a great deal of trouble with his family and school. Graham lives at 30 Brantwood Oval, Bradford 9 (tel. 47974), but this is also the address of his father.

LEEDS ARTS LAB, co-ordination: Geoff Wood, Wood Dean, Dean Head, Scotland Lane, Horsforth (tel. Leeds 673411 ext. 248, 9.30am—6pm; tel. Horsforth 4981 before 9am and after 6pm and all hours at weekends). A very active Lab that Is prepared to knock together a touring show if any other Lab would like it. Their regular scenes are as follows (everything starts at 8pm and everything Is for free or donation only); MONDAYS: Jazz band In the front

room and Poetry and Contemporary Song In the backroom at the Grove Inn, Victoria Road, Leeds 11 (by City Square). A new film group is starting at the George IV Hotel, Commercial Road, Kirkstall. TUESDAYS: Classical and experimental music workshop at the George IV (check this one with Geoff). WEDNESDAYS: a blues and Jazz musicians' workshop run by Andy Sear (tel. Leeds 682946) at the George IV. And traditional Folk & Jug Band blues in the front room at the Grove, with modern Jazz in the back room. THURSDAYS: drama group at the Grove, and a different drama group doing a musical meets at the George

IV. At the week-end the scene is at the Peel Hotel, Boar Lane, with the Magic Theatre on FRIDAYS, Jazz on SATURDAYS and Jook Joy on SUNDAYS.

SHEFFIELD ARTS LAB PROJECT, c/o Richard Williams, Northern Folk Theatre, Barnford, Sheffield S30 2AJ.

NORTH WEST REGION ARTS LAB CO-OP, co-ordinated (till she can find someone else) by Wendy Harpe, who with Bill Harpe runs:

THE LIVERPOOL GREAT GEORGES PROJECT, a cathedral-sized building In Great Georges Street, Liverpool 1 (tel. ROY 5109). Contem-

porary arts/community centre. October 9th at 7.30pm Musica Electronica Viva Work-shop. Every Thursday 2pm—4pm play group for 3—5 year old kids and activities for their mums.

THE MAGIC VILLAGE, MANCHESTER; open every night, Cromford Court, off Market St Manchester 4 (tel. 834 5579). Every Tuesday concert from 7.30pm till midnight featuring local poets and musicians— no admission charge for members. Saturday October 11th, all night 7pm to 7am, the Third Ear Band and others (the 3rd Ear will be playing at 9.15 and 11.30).

3. Rob La Frenais & James Strangeways – On the Southampton Arts Lab

I was seventeen in 1968 and a suburban teenager when I first started frequenting Drury Lane Arts Lab. I street-sold *IT* and was pretty focussed on that underground scene in central London (starting with the folk clubs Bunjies and Les Cousins). I had decided to become an arts journalist (influenced by *IT* and a visit to Jasia Reichhardt's *Cybernetic Serendipity* at the ICA.) I visited Drury Lane (partly to buy cannabis) but also was drawn into the general ambiance. I remember lying on the stained soft floor in the basement watching Godard movies and seeing a performance by The Fugs who were visiting London at that time. I made friends with the projectionist, someone called Tom, and together we visited Ken Kesey who was visiting London and staying in Highgate (I had avidly read *The Electric Kool Aid Acid Test* by then). I also met Jim

Haynes at the *IT* office as an aspirant underground journalist and interviewed him much later in Paris.

However my desire to be part of all this was thwarted by a forcible move to Southampton (my father was relocated with the Ordnance Survey) and I was nearly thrown out of my Grammar school in Rickmansworth. Hence in around 1969 I was enrolled in Southampton Technical College to complete A Levels (which I needed as I had been accepted on a NCTJ Journalist training course in Portsmouth). But I kept my connections going with Drury Lane on visits to London. I was also influenced by meeting the legendary Hoppy (John Hopkins) at the Isle of Wight Festival and had decided that half inch video was the coming thing). I later went on to persuade him to teach me to edit at Robert St, which relationship continued on in

the 70's at Fantasy Factory with Hoppy and Sue. (I was lucky enough to find and visit Hoppy just before he died a few years back). Southampton Arts Lab was a one-off regional spinoff that I initiated along with someone called James (Jamie) Strangeways, (brother of the designer Christopher Strangeways) who later joined the Exploding Galaxy - then Transmedia Explorations along with Nigel Megson – Genesis P. Orridge. (I googled Jamie BTW and he turns out to now be an eccentric boat owner featured in *Grand Designs*).

Anyway we organised one manifestation of Southampton Arts Lab, part of a regional Arts Lab Diaspora (which famously, if you recall, included David Bowie's Beckenham Arts Lab) at the Student Union of Southampton University and for which we persuaded the Radio London DJ John Peel to

come down and MC. There would have been poetry, music and film, but I would have to find some people with a better memory to remember exactly who we invited. My arts lab-influenced life continued in the 70's in London when I joined the arts group Action Space (the co-founder Mary Turner has just died - see Facebook group 'Action Space Extended') and I went on to make and edit video for them before going on to found *Performance Magazine* . RLF 18 Dec 2018.

James Strangeways adds: I do remember some things: Denis Adams, you [Rob] and me organising with some others jazz and poetry evenings in local pubs with Natalie O'Neill our tutor, as well in the Student Union Bar. We published a magazine called *Damn* which we did for at least one issue in which we interviewed the Liverpool poets who appeared in a concert we ran at the university. Also John Fahey played. I believe we made quite a lot of money at this event but alas the treasurer skipped with all the takings and blew it attending the Isle of Wight Festival.
JS 8 July 2019

4. David Jeffrey - The Penis in Italy – an Arts Lab Adventure

It was 1968. At the Arts Lab Will Spoor had gathered a motley collection of performers and was looking for places outside London to put on shows. He received an invitation to a mime festival in Prague – which he accepted, but when we saw images appeared of Russian tanks in Wenceslas Square, even though we had no official word cancelling the festival, we deemed it sensible not to go. Fortunately, Will had also been invited to a one act play festival in Arezzo, Italy. We decided to take up this invitation and started preparations. To get to Italy we needed transport. A used Bedford van was purchased at the last minute …

But I'm getting ahead of myself. Who are 'we'? Will Spoor, a celebrated Dutch mime resident at the Arts Lab, Ellen Uitzinger, his partner and co-mime, Tony Crerar, another mime performer, Evan Parker, our saxophonist musician, Craig Gibsone, a multi-talented Aussie – painter, carpenter and on this occasion, performer, Philippa Jeffrey, who acted as manager, with myself (David Jeffrey)

and Martin Shann providing technical support and appearing briefly onstage. At this time Will had one well established piece, *The Art of Fugue*, which he had performed in many venues (fortunately, as it transpired later!) but in the spirit of the Arts Lab had worked up a new piece entitled *Experimental Mime*. This is what he had intended to perform in Prague and was now going to bring to Arezzo.

But before leaving the UK we had two university performances booked: the first in Southampton, then one in Canterbury just prior to leaving for the continent on the Dover ferry. So – the Bedford van. We were due to perform at Southampton on Saturday evening, and just before lunch on Saturday Martin and I took the van for its MOT – which it failed. We managed to repair the problem over the lunch break and it passed early in the afternoon – after which we drove to the Arts Lab to load the scenery and people. Which took a while. Now running late, we departed Drury Lane and got as far as Hammersmith before the van's next idiosyncrasy revealed

itself. A smell of burning and overheating brakes. Martin and I again set to and replaced the front brakes' hydraulic cylinders – another delay. However, no more problems until we arrived at Southampton - at about the same time as our scheduled performance was due to finish.

The promoters [Rob and James? Ed.] understandably were reluctant to let us perform so late, equally reluctant to pay us, and more importantly, refused to provide us with the promised sleeping accommodation. So we found ourselves in Southampton, late in the evening, low on cash with nowhere to go. Then we remembered that Philippa's parents' house lay roughly between Southampton and Canterbury so we phoned them and begged a floor to sleep on. They graciously agreed and we left Southampton.

The next image I have retained from this trip is the van, out of petrol, parked in the middle of a deserted bit of moorland, around midnight, with Evan playing saxophone at the roadside. Somehow we managed to hitch to the nearest garage and buy some petrol...

Evan Parker - photo Martin Shann

The van with Tony Crerar and David or Will – photo Martin Shann

Next morning we had a confab about the van and decided that Martin and I would buy some tools in Canterbury to fix its more obvious failings. We arrived there in good time, bought the tools and rapidly discovered our plans were over-ambitious. Another image: Martin and I working in a huge, deserted University car park, under a single floodlight, being gently drizzled on. The work took far longer than we had allowed for, and we had to interrupt it to go and put in our required appearance on-stage. But finally we did perform, put the van back together, got paid and were given places to sleep.

Early on Monday morning we set out from Canterbury. Although the van had not had the full rejuvenation planned, we had managed to get more power from the engine. Which exposed the next issue, a slipping clutch. We decided it was not so bad we could not live with it and continued to

Dover. The ferry must have gone smoothly, as I have no recollection of the trip. However, about 20 miles into France, the silencer fell off. At this point we seriously considered abandoning the van, with all our scenery (the bulk of which was a huge roll of cardboard – used in one of the parts of *The Art of Fugue, Cardboard Column Canon*) and hitching back before the next part fell off and stranded us even further from home. But we finally decided what the hell and kept going. From that moment on, apart from a puncture, the van gave us no more problems. Just the van.

We drove to Paris where my French family had a small flat. I phoned and they said come and stay. When I pointed out we were eight they back-pedalled on offering us all beds, but did feed us and gave us the key to their farmhouse in the Alps. Which lay on our route to Arezzo. We left Paris and drove on through the night, hitting the foothills of the Alps as dawn was breaking and finally reaching the farmhouse mid-morning. There we had 24 hours of relaxation in the sunshine, with cheese and wine and clear air and comfortable beds before the final leg of the journey. My recollection is that we started in the morning from France and drove until a puncture at 6:00 am the following morning a few kilometres short of Arezzo – we were all so tired by this point that nobody even left the van – we just fell asleep where we sat.

After a couple of hours we woke, replaced the flat tyre and drove into the town. It's a beautiful, well preserved small mediaeval town with the remains of a city wall and a wonderful plaza at its centre. Looking around we saw a poster advertising our one act play festival – and giving the program. We were due to perform that evening. Last of three performances.

Fortunately, for a while at least, things

went smoothly. We met the organisers who showed us to our hotel. We all went to bed and slept a few hours before our rehearsal after lunch. A word about the program: Will was more interested in performing his new piece, *Experimental Mime*, but found we had been invited on the strength of his more traditional, *The Art of Fugue*. Since neither was very long we suggested doing them both, and the management approved. We rehearsed – to the great entertainment of the stage crew. *The Art of Fugue* is divided into four parts, one of which is titled *Penis Invention*. It involved Will and Craig in lederhosen, each wearing a long 'penis' (actually a gourd, a Chinese musical instrument …) and strutting in a very macho manner, until they 'cross swords' and retire wounded. Very Rabelaisian. The stage crew had never seen anything like it.

Come the evening and we waited while the initial two offerings were performed. (The second was titled *Romeo and Juliet and the Plague* – real experimental theatre.) They both overran their time slot and it was not till midnight that we were finally able to put on our two pieces. But we managed

to keep our eyes open long enough and things went well. Both pieces behind us, exhausted but satisfied, we made our way to bed.

The next morning we and members of all the other groups met and socialised. Some groups had come from behind the Iron Curtain – it was a wonderfully mixed bunch. We learnt that reviews of the previous evening's performances would normally be published the following morning, but we could find nothing about us. However, a day later a review did appear, damning our performance as being more suitable for a sailor's brothel than a respectable theatre. The paper to publish this was the main church organ. It gave the official church position and set the tone for the other reviews, all of which united in condemning us. It's not clear how important this fact was, but apparently in the audience were young girls from a convent school, and had we known we might have hesitated to put on *Penis Invention*, although knowing Will he would probably have wanted to go ahead anyway. This was our first indication of the power of the church in Italy.

So we were pariahs in the eyes of the establishment. The other performers were all supportive, and town people too, but we got accustomed to the shrug accompanied by the words "the church – what can you do?" Later that morning Will and Craig were asked to go to the police station, ostensibly to collect their passports, but in fact to be arrested for obscenity, something we were not informed about for some time. But as soon as we heard we started responding. We contacted the British Consulate in Milan who sent someone to help us (not arriving till the following day), and found our cause resonated with the local Communist Party. Italy was then dominated by two political parties, the Christian Democrats and the Com-

munists. Arezzo had a Christian Democrat town council, and since they had invited us the Communists saw in the situation a way to embarrass them. We became a political pawn. The British Consular official duly arrived the following morning. Things were complicated by the fact that although we were a British group, Will was Dutch and Craig Australian. He managed to come to an arrangement with the two other consulates whereby he would represent his and their interests. Initially this official (name gone forever …) was unhelpful. He thought we were students and this was nothing more than a student prank gone wrong. However, we managed to show him a review of *The Art of Fugue* published in the London *Times*: this changed his tone. We became serious performers being persecuted for our art.

He was able to visit Will and Craig in prison. They had received no news of the outside world, had no idea of how long they would be held – seeing this English speaking representative, who apparently had some clout in the outside world, raised their spirits. Meantime, outside the prison, things were moving. The leader of the local Communist party, Sergio Zoi, happened to be a good English speaker (he had lost part of one ear in a scooter accident at Marble Arch) and he spent a lot of time with us. We were initially suspicious, seeing ourselves as no more than sacrificial offerings on the altar of Italian politics, but we soon befriended him and realised he could really help us. Amongst other things, he organised a town rally at the local library – this was very well attended. Philippa, the only Italian speaker among us, was able to address the crowd and let them know how we felt at this treatment.

Meanwhile there was consternation at city hall. Not only was it they who

had they invited us to Arezzo, the invitation was to perform *The Art of Fugue*. So they were squirming. On our behalf they employed a barrister to represent Will and Craig. We met him at a meeting Philippa and I had with the mayor. It was clear this gentleman had a very high opinion of himself, but we had no idea of how Italian law worked. Perhaps that was a requirement for a good barrister.

Exactly when the decision was taken I don't know, but we learned that the trial of Will and Craig was to be held the following Saturday (?). They were relieved as they had learnt some of the other prisoners had been held for months without trial. In their case it would have only been a week.

Fast forward to the day of the trial. It felt like the biggest event of the year in Arezzo. With half the town we all packed into the visitors' space in the mediaeval courthouse and were treated to a spectacle worthy of Gilbert and Sullivan. The high ranking police officers strutted back and forth in the bull pit between the court officials and the hoi polloi (us) – Will and Craig were brought in and we waved to them, throwing cigarettes (this was 1968) and yelling greetings. Pandemonium. Then the judges entered. Instantly order descended, cigarettes were extinguished, everyone stood up and was quiet as these three august persons made their way to their seats. It reminded me of nothing more than a scene from the Spanish Inquisition. They wore long robes but it was their hats that registered most. Like cardinal's hats, they were tall, imposing and served no purpose but to impress. They sat down, everyone else did likewise and the proceedings got under way. After a bit of discussion, the judges announced that due to the vulgar nature of some of the evidence, the trial would be held in camera. So

Craig Gibsone and Ellen Uitzinger in celebratory mood. Photo Martin Shann.

we all had to tramp out. Disappointment all round.

The court stood to one side of the main plaza. We installed ourselves in a bar opposite to wait for the summing up. A steady stream of town's folk came by to commiserate and buy us drinks. My feeling is that most of the local people were on our side but felt powerless in the face of the church. Their warmth was welcome. We felt among friends. After the main part of the court proceeding was over word came that we could go back in again, so once more a horde of Arezzo residents with ourselves (now quite merry) at the centre invaded the courthouse. As at the start of the day, the judges were absent and chaos reigned. We were again able to exchange loud greeting with the two defendants until the entry of the judges. This was the moment for the councils for the prosecution and defence to give their final speeches. Council for the prosecution drily and in a matter-of-fact fashion presented his case. He didn't talk long. The judges approved. Then it was the

moment for our council. His style was the opposite – verbose, long winded – my Italian is minimal but I got his reference to Kafkaesque treatment. As he droned on one of the judges took off his watch and was gently swinging it back and forth. (Did he have a mistress waiting?) Finally all the presentations were over and the judges retired to consider their verdict. I don't remember how long it took, but eventually they came back with their judgment. It was: Will and Craig both guilty! The penalty – 8 months prison and a fine. But for a first offence, a sentence of less than 18 months is automatically suspended. They are to be released immediately! *Immediatemente*!

We watched as Will and Craig were herded off to jail again. I turned to the British consular official. I said "the judgement was that they were to be released immediately" – he agreed. "But", I said, "they have been taken off to jail" – he agreed. You could almost see the wheels turning in his head. After a pause "But the judge

said they were to be released *immediatemente* – and *immediatemente* means immediately in any language!" The penny had dropped. And he finally had something he could do, something to make his presence worthwhile. He shot off in his little sports car and as the evening progressed he would periodically reappear saying variously "I have just seen the judges and told them *immediatemente* means immediately in any language!" – "I have just seen the police and told them *immediatemente* means immediately in any language!" – "I have just seen the head prison warden and told him *immediatemente* means immediately in any language!" Finally, late in the evening we were sitting in what had become our local restaurant when we again heard his distinctive cry, looked up and saw him beaming with Will and Craig in tow. After that things were anti-climactic. There was much celebration in the town, Sergio took us off to his uncle's villa for what would in other circumstances have been a memorable meal, in the rolling Tuscan hills surrounded by vineyards. The adjudicators in the one act play festival declined to make any awards on the grounds that the "tranquillity necessary for adjudication" was absent. The town council paid the lawyer's fees and the fine – the least they could do. After giving us such a hard time the van behaved impeccably on the way home. But the saga was not quite over – we had left a program at Philippa's parents' house, and on our next visit found it prominently displayed – but glued shut! Her father shared the court view that any mention of 'penis' was not suitable for family viewing.

DJ 16 December 2018

5. Jan Quackenbush - My play *Complexions* at the Drury Lane Arts Lab

The summer of '67 – while on Ibiza, writing a screenplay for Dutch TV producer Roeland Kerbosch (*Song for Celestine*) – a new friend, British, told me I would get help with my plays in England were I to look up an 'extraordinary' person – Jim Haynes. My friend gave me a letter of introduction to give to Jim. On a Sunday morning in early August 1967, I found his address on Long Acre, Covent Garden, and Jim answered my knock. I explained myself – Jim read the letter and was interested in my roaming about Europe with scripts in my backpack. He introduced me to Jack Henry Moore, who agreed to read my play, *Complexions.*

Jack and Jim told me that in this vacation month of August I should hasten to the Fringe Festival in Edinburgh where I could meet Jeff Nuttall and the People Show at St. Mary's Hall (a church), at the bottom of the Royal Mile. I couldn't miss them. And that Jeff and the People Show would free me of ever wanting to write narrative plots, 'traditional theatre'. They said that after the Festival I could come back to the Arts Lab where it was very possible *Complexions* would get produced.

I did all of that, in the adventurous course of which I had my first European professional production with the play, *Still Fires*, which I wrote there for two runaway children to whose plight I could relate. Max Stafford-Clarke agreed to produce it as 'mini-play' - (it ran about ten minutes) – each day for two weeks in the nine a.m. slot. I would be paid three pounds each show, of which I gave two to the actors, one pound each. It seemed a

big deal! Then BBC-Glasgow filmed it for TV!

Many adventures later I returned (with sleeping bag and pawn shop typewriter) to the Arts Lab. The liberated scene there – culturally, politically, emotionally - stunned me. I studied the People Show, had long meandering talks with Jeff – poet and teacher – with Mark Long, Mike Figgis, Laura Gilbert, and so many other performing artists, such as Tutte Lemko. Except for Tutte, working from memorized script, it seemed that the word of the era was 'improv'. Nuttall told me the People Show never acted from written scripts. I remember feeling that I could kiss *Complexions* goodbye.

BUT, as Fate, or Tarot cards, would have it, someone simply stunning came into the lobby one night. She seemed perhaps to be sixty, yet so theatrical in style that she was YOUNG! I asked at the ticket desk just inside the door, did anyone know her name? then across at the book stand, does anyone know who she is? until someone – Jack? Jim? – said, "Muriel Gantry." I turned to where she had been standing, but she was gone! But gone where? Someone in the know took me out into Drury Lane and pointed to an old apartment building down the road. She lived somewhere in there. The next afternoon, I went there, pushed doorbells until I found hers. "Is this Mrs. Gantry?" She answered in her inimical voice – dignified, resonant, with charm and warmth: "No, darling. This is Miss Muriel Gantry, costume designer".

She invited me to meet her on her landing. I knocked and she opened the door. "So you are a playwright? What kind?" I had no idea how to answer that, but I might well have said "a script-writer" to distinguish me from Jeff Nuttall's approach… But, unashamedly I pulled out *Complexions* and asked would she read it, would she consider performing it? [… *She agreed, and to perform it in her flat!*] … "Will you take tea with me?" she asked. … I told Jim and Jack. We agreed to mount the show, … [and *Complexions* – was born].

An especially memorable performance had the American folk singer/guitarist Tim Buckley in the audience with his two-member band – guitarist Lee Underwood, and conga drummer, C.C. Collins. They bought the last three tickets that night. They said they heard the show not to be missed. I remember Tim and others of us almost fleeing down the steps afterwards, once Muriel had retrieved her key to the door-lock from her bosom and let us out! The true end of the play wasn't with the applause but with our freedom! … No question about it, Muriel was a theatrical hit, a star! I felt then, and still do, deeply grateful to Muriel for showing so many colours of the play. When, later in the spring of '68, La MaMa produced *Complexions* in New York as a one-act on a double bill with my two-act play *Inside Out*, I felt confident that they would work artistically.

One final note, or curtain, as I look back upon it. Muriel's tour-de-force solo show seemed so unique, so captivating and brave, that in this she mirrored the whole 'scene' of the Sixties … of this pivotal era of the Arts.

JQ March 2019..

6. Mo Throp & John King – Footnotes to *Sketches From a Hunter's Album*

Mo Throp. We had no particular objective other than to show our work. As to the nature of the work itself it is probably true to say it was experimental, as most things were in 1968. A year of much world turmoil, particularly in the student world: student riots in Paris, the Hornsey Art School 'sit in' and on the world stage: Vietnam; civil rights; assassination of Martin Luther King. In our small corner of the world we were dissatisfied with our course. Since the summary and rightful dismissal of the course leader Peter Atkins (aka Kardia) in 1965, the course had no direction or sense of purpose and was ruled by autocratic Post Modernist sculptors William Tucker and Tim Scott who would brook no challenge to their particularly narrow interpretation of sculpture. To them, anyone making anything other than abstract sculpture was persona non grata. Several of us decided that such work had no relevance for anyone other than a few acolytes and sycophants and along with many others started looking around for more meaningful subject matter; total lack of content made such work pointless. John King proposed the title for our show after reading Ivan Turgenev's first book, *Sketches From a Hunter's Album* (1852) which in many ways, echoed our search for more meaningful content. Turgenev also seemed to be searching for his voice in this collection of short stories … We cannot honestly say that we had found a voice in this exhibition, but we certainly tried. MT October 2017

John King. We encountered considerable resistance from Tim Scott and William Tucker and some of the other staff. [My] pieces go right back to basics of sculpture as I saw them, making things out of plaster and string, applying colour, in this case at the beginning rather than at the end of the making process. Breaking - reassembling but not fixing; this was unacceptable to the Caro-ites, sculpture must be 'fixed', they preached. Hanging things from the ceiling, again strangely taboo at that time; sculpture had to start from the floor and work its way up. I never did really understand why. Similarly, sculpture was to be walked round, not into, like my 'installation', though word hadn't been used in connection with sculpture at that time. Strangely, the pieces were quite lyrical, again in keeping with the spirit of the age. Barry Flanagan said he thought the hair ones were dyed pubic hair. Very '60's. Michael Freed, the famous art critic was shown round when the basement pieces were arranged as an installation, I seem to remember he was quite 'intrigued', certainly not as dismissive as Tim Scott et. al. who thought I had gone 'off piste'. What I had done was take several of the basic 'rules' of Greenberg inspired Caro-isms and chucked them out of the window. Predictably, they did not approve, reiterating their dogma that sculpture was, x - y and z...

We received no feedback, though I do recall that Peter Atkins attended the opening but didn't say anything. I suspect that hostile words got back to St. Martins, judging from the reaction of the staff.

In conclusion, it's fairly true to say that we all felt a bit bruised by our St. Martins experience and that this exhibition gave a fairly accurate picture of our state of mind at the time. It's to be noted that the sculpture department had a rethink shortly after we left and instigated the A and B courses, the former being for conceptually oriented work and the latter for object-based work. It is sad that they saw this as the only two ways forward. Crucially, they needed to work out the relationship between encouraging creativity and teaching skills - the latter were woefully overlooked and resulted in an impoverished creative output. One only has to look at the output of the design departments in the same college to see what can be accomplished by incorporating both. Though the department undoubtedly produced some big name art stars that totally eclipsed their teachers in art world status, Gilbert and George, Richard Long, for example, they were totally ostracised by the staff when they were there. They succeeded in spite of the place. Standing up to the authorities in this way was obviously a good preparation for the real world. JK October 2017

Index